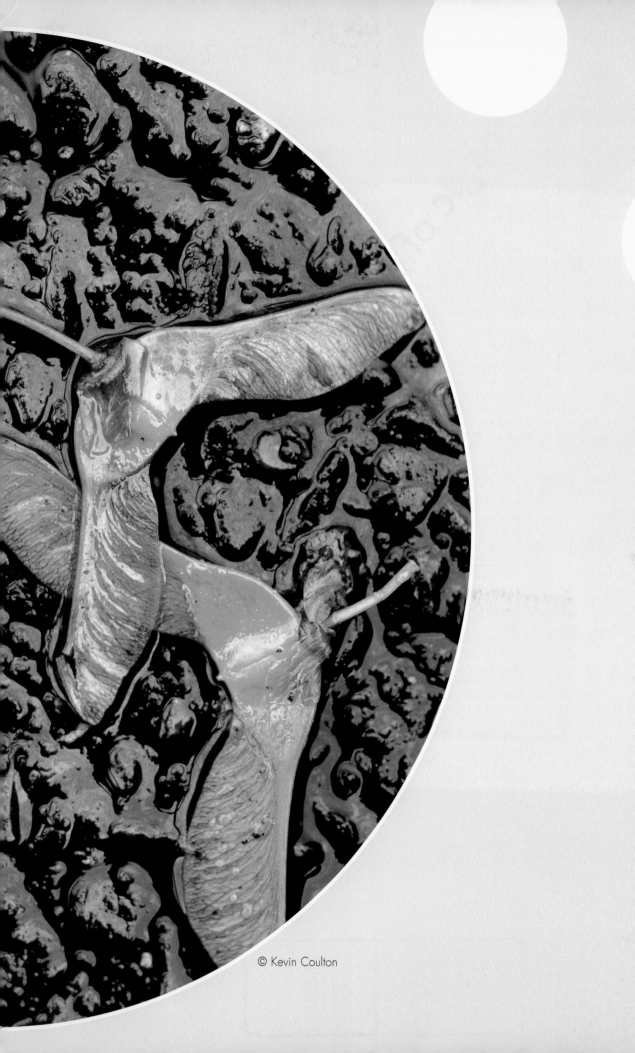

© Kevin Coulton

the magic of digital
close-up photography

Joseph Meehan

LARK BOOKS
A Division of Sterling Publishing Co., Inc.
New York

Editor: Haley Pritchard
Book Design and Layout: Tom Metcalf
Cover Designer: Thom Gaines
Associate Art Director: Shannon Yokeley
Editorial Assistance: Delores Gosnell

Library of Congress Cataloging-in-Publication Data

Meehan, Joseph.
 The magic of digital close-up photography / Joseph
Meehan.— 1st ed.
 p. cm.
 Includes index.
 ISBN 1-57990-652-4 (pbk.)
 1. Photography, Close-up. 2. Photography—Digital
techniques. I. Title.
TR683.M438 2006
778.3'24—dc22

 2005032332

10 9 8 7 6 5 4 3 2 1

First Edition

Published by Lark Books, A Division of
Sterling Publishing Co., Inc.
387 Park Avenue South, New York, N.Y. 10016

Text © 2006, Joseph Meehan
Photos on pagee 138-161 are © Ruth Adams.
Cover photography © Joseph Meehan, except for the red flower in the lower corner of the front cover, which is © Ruth Adams.
Photography © 2006, Joseph Meehan unless otherwise specified

Distributed in Canada by Sterling Publishing,
c/o Canadian Manda Group, 165 Dufferin Street
Toronto, Ontario, Canada M6K 3H6

Distributed in the United Kingdom by GMC Distribution Services, Castle Place, 166 High Street, Lewes, East Sussex, England BN7 1XU

Distributed in Australia by Capricorn Link (Australia) Pty Ltd., P.O. Box 704, Windsor, NSW 2756 Australia

If you have questions or comments about this book, please contact:
Lark Books
67 Broadway
Asheville, NC 28801
(828) 253-0467

Manufactured in China

ISBN 13: 978-1-57990-652-8
ISBN 10: 1-57990-652-4

For information about custom editions, special sales, premium and corporate purchases, please contact Sterling Special Sales Department at 800-805-5489 or specialsales@sterlingpub.com.

Dedication

To Eddie, Mel, and Richie;
good friends, ex-teammates, and
great memories.

contents

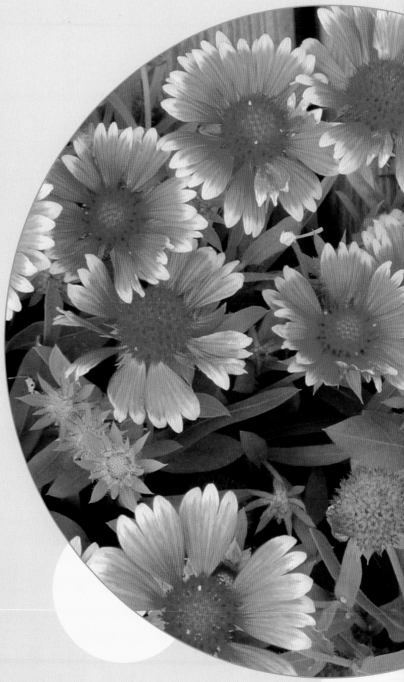

(A)DSCF0319.tif

(A)DSCF0327.tif

(C)DSCF0180.tif

(F)DSCF0353.tif

001a.tif

001e.tif

004a.tif

007a.tif

008a.tif

009a.tif

010a.tif

010b.tif

102-b .tif

D3CR0207.tif

D3CR0242.tif

D3CR0302.tif

DSC_0007y.tif

DSC_0157.tif

DSC_0161.tif

DSC_0163.tif

DSCF0005x.tif

DSCF0494.tif

DSCF0514.tif

DSCF0521.tif

DSCF0556.tif

DSCF0644.tif

DSCN0935.tif

Flower 023 D3.tif

Flower 035 D5 2...

Untitled-1.tif

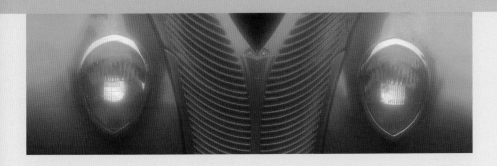

There is a special place I try to visit whenever I can with my camera. It is a place of unique perspectives, fascinating details, beautiful imagery and, most of all, discovery. It is the world of close-up photography. This world exists all around us, but to experience it requires refocusing one's vision from the wide scale demanded by hectic daily activities down to a much smaller and more intimate scale. For this is a world in miniature. To get there sometimes requires going down on one's hands and knees or looking through a magnifying glass to see what is beyond our normal vision. But most of all, it means we have to stop and look more closely at the small things around us and think of them as separate entities.

The world of close-up photography not only requires a different vision and perspective, it also requires a different way of taking pictures. Whereas, before we may have been concerned with using a lens wide enough or long enough to capture our subject, we now ask ourselves one basic question: can the lens focus close enough? Before, we measured distances in feet to infinity while the close-up world reduces working distances to mere inches or centimeters.

The digital revolution has given photographers new and better tools to delve into the close-up world. So much so that it is now easier for any photographer to capture such images with minimal equipment. For example, virtually all of the compact digital cameras that now dominate new camera sales allow us to get up close and personal with the press of a button. Digital cameras of all types also give immediate feedback on an LCD screen. This is a big help when composing pictures, especially when working with the more sophisticated close-up equipment such as macro lenses, ring lights, and tabletop arrangements with studio strobes. Then there are scanners, which provide yet another means of capturing parts of a subject while magnifying details. Finally, there is a wide range of software that gives us so much control over the final image.

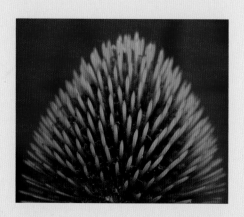

I have been fascinated by what my close-up cameras have been able to capture over the years, both in the field and in my studio. But in preparing this book, I quickly realized that my work was only taking in part of the potential subject matter out there. So, I decided to ask some very skilled photographers I knew if they would contribute their specialties in the form of featured inserts. Thus, in Chapter 1 you will see the work of Kevin Coulton, a professional water resources engineer and photographer. Kevin decided to aim his macro lens at the seemly innocuous drops of oil from our vehicles that merge into water runoff to engulf nature in an oily and yet strangely beautiful morass.

I have also always admired people who photograph the insect world populated by creatures that truly seem to be from another planet. Photographer and magazine editor, Rob Sheppard, shows how he has been able to capture these shy and flighty subjects with compact cameras, patience, and persistence in his Chapter 2 feature.

In Chapter 6, Ruth Adams explains how she is able to produce her famous images of various types of organics using a flatbed scanner. Ruth's stunning works are a combination of an eye for beautiful imagery and her skill at adding secondary lighting and unique backgrounds.

Joanne Urban also works with a scanner but takes a minimalist approach. She uses just the light of the scanner and later converts her subjects to the medium she loves so much, black and white. Her efforts to isolate the essence of her subjects from flowers to seashells appear in the final pages of Chapter 6 in an exquisite portfolio of black-and-white imagery.

My own contributions include features on dealing with the challenges of photographing a collection of miniature cars to getting up close and personal with flowers using dif-

© Ruth Adams

ferent types of lighting and close-up equipment to revealing the hidden details of an old panoramic photograph through the scanning process.

So, lets enter the close-up world in the following pages and consider the many subjects that reveal themselves to our cameras (and scanners). Experience the magic of close-up photography!

Joseph Meehan

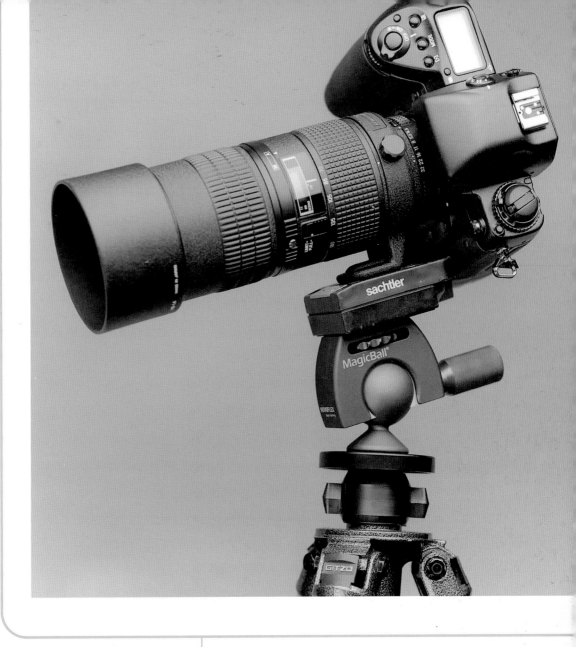

1

DEFINING
CLOSE-UP
PHOTOGRAPHY

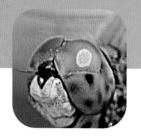

WHAT YOU NEED TO KNOW BEFORE BEGINNING

How close is close? The answer starts with you. How close do you want to be, how close should you be, and how close can you be? Until now, close, in the sense of seeing, has been defined by the ability of your eyes and the interest of your mind. You've lived all your life with your eyes and have a pretty good idea of their close-focusing capabilities. Unless you've been doing home experiments with genetic redesign or laser treatments, the closest your eyes can focus is about eight inches. For folks past forty, this distance may be a bit greater.

What does this mean? It means you can read the writing on coins, pull off the petals of a daisy confidently reciting the "she loves me she, she loves me not" ditty knowing the conclusion (you did figure out the conclusion didn't you?), thread a needle, or read the fine print on the video rental agreement. It means that until you got your digital camera, your close-up world was probably defined by the necessity of doing everyday things, and occasionally by

curiosity. But now, with digital camera in hand, you've become aware of the unexplored beauty and revelation—even the practicality—of small things. And to capture them, you need a camera that can get close.

So the question remains: How close is close? For me, some of the most fascinating subject matter reveals itself when you get down to just a few inches (or centimeters). What I like to call "the one-inch world," where we photograph things that are only an inch (2.54 cm) or so in size. Of course, there are also plenty of objects that are larger, and that, when isolated and magnified, are also just as intriguing to capture. In short, close-up photography offers a wide range of subject matter limited only by the curiosity of the photographer.

Close-up photography is about capturing a view of the subject that escapes our everyday vision. It reveals new aspects of everyday subjects. It can—and often does—make the mundane magical. For example, the scalloped edges of an

Elvis postage stamp, the intricate network of veins in the dying leaf of a rubber plant, or the flawless barbs of a bluebird's feather—through close-up photography, we unveil a level of visual detail that extends our understanding of and appreciation for a subject.

It is the miniscule details of the mundane that make the ordinary magical and turn a bystander into a performer. By choosing to photograph these details, you've yanked them from the crowd and placed them on center stage under a spotlight, where all eyes turn to evaluate their performance—and your casting ability. For example, in your close-up work, you may shift the focus from a field of daisies to a single bloom, where the line, position, and color of but one petal suddenly becomes apparent.

Close-up work shows that the beauty really is in the details. Working with jewelry up close instead of on a model shifts the attention to the craftsmanship of the piece, away from the distraction of the

THE RANGE OF CLOSE-UP PHOTOGRAPHY

model and his or her other accessories. Singling out a subject normally not seen by itself presents that subject within a new context. Of course, the subject must be capable of withstanding the scrutiny.

With the vast array of today's digital close-up equipment and accessories, you can photograph everything from a guppy to a geode. You will find many ways to produce a close-up image, often with the use of relatively inexpensive close-up accessories. As we will see later in the book, you can even use a scanner to capture extraordinary close-up compositions. Should you develop a passion for close-up work, you'll discover how specialized equipment, such as a macro lens and a ring light, can help you create the most intriguing and beautiful images. But, regardless of the equipment used, you must learn the critical techniques and considerations common to all forms of close-up photography. Master these "need to know" methodologies, and your close-up work will catch the eye of many viewers.

The subject matter of close-up photography is quite diverse. Some of the most common examples include the work of nature photographers, capturing everything from flowers on a bright hazy day to flying insects frozen in time with special flash devices. Visual artists have long recognized the beauty revealed by coming in close to a collage of small found personal objects.

Commercial photographers may slave away an entire week using a studio tabletop setup with a sophisticated digital SLR to create a 100 page product catalog of jewelry or computer connectors. Your neighbor may be an online auction fanatic who scours garage sales, then uses a consumer digital camera to show and sell the items online. You, me, and the rest of us often need to document our valuables (be they a collection of coins, stamps, or cameos) for insurance purposes.

Many people use a flatbed scanner to copy photographic prints, birth certificates, diplomas, drawings, and other flat art work. Some even use the scanner to creatively reveal three-dimensional objects. All of these approaches, in one way or another, rely on the methods and equipment of close-up photography. In short, this is a diverse area of photography with lots of practical applications that meet the need to document subjects, as well as unlimited possibilities for those who want to take a more creative photographic approach.

Photos © Rob Sheppard

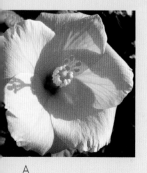

A

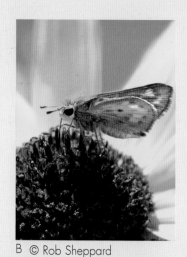

B © Rob Sheppard

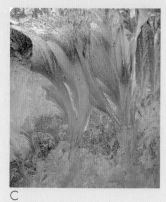

C

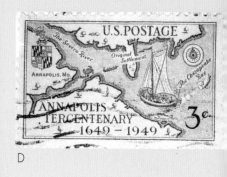

D

I

J

K (Photo courtesy of MK Multimedia)

L

Subjects for the close-up digital photographer are literally everywhere. One only has to take a different approach to viewing the world. Certainly, flowers have long been a favorite (A), as have insects (B), photographed here by Rob Sheppard (whose work is featured on pages 64-69). But the range of subject matter for close-up photography goes way beyond these two choices.

Consider, for example, other subject possibilities such as the patterns of crystals in window frost (C), the hidden artwork on a postage stamp (D), the intricate veins of a leaf (E), the smallest detail of a tiny craft creation (F), the remarkably uniform shafts of a bird's feather (G), the tiny writing on a miniature toy truck (H), or even the different shapes and geometry of individual water droplets on an automobile hood (I).

There are plenty of subjects that require only isolation to give us a new appreciation of their visual make-up, such as the wing patterns on a butterfly (J), the details of

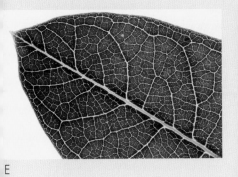

E

F

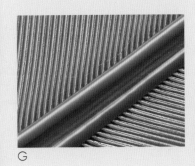

G

H

M

N

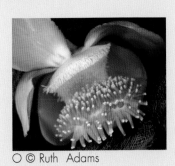

O © Ruth Adams

P © Joane Urban

a jeweled broach against a white background (K), a single mushroom on the forest floor (L), or the pattern of white icing on a chocolate cake (M).

Close-up up work is not limited to the use of a camera with close-up accessories and lenses. Desktop scanners can also be used to copy and enlarge the details of old photographs (N), as well as to capture three-dimensional objects such as these flowers (O) by Ruth Adams (featured on pages 138-161) and seed kernels (P) by Joanne Urban (featured on page 162-165). In short, there are a multitude of subjects all around us. We need only take the time to consider them with a close-up eye.

THE LANGUAGE OF CLOSE-UP PHOTOGRAPHY

Like any other specialty, be it a hobby or a profession, close-up photography jumps with jargon. In golf, you'd be wallowing in terms like club selection, course management, club loft, and metal woods. In gardening, it'd be bulb depths, growing zones, and deadheading. In close-up photography, you'll mingle with magnification, depth of field, lens selection, and subject distance—and that's just for starts! You might be one of those lucky people who lives to linger in the lingo. But if you aren't, keep in mind that much that follows can be learned simply by doing, by taking pictures. So read on, pick up what you can, and if you get lost, don't worry! Start taking pictures, and enjoy.

CRITICAL FACTORS IN CLOSE-UP PHOTOGRAPHY

Magnification ratio is the defining quality of close-up photography, but several other factors determine the equipment and the close-up technique you should use. The most important of these factors are depth of field, working distance, and camera movement.

Magnification

Since the defining process of close-up photography is isolating and magnifying the subject, we'll start by taking a look at magnification. Magnification can be expressed in a number of different ways. For example, the degree of the magnification can be noted by a multiple. Thus, 1x would indicate that the subject's recorded image equals its actual size. The figure 0.5x would indicate that the subject has been recorded at half its actual size, whereas 2x means the recorded image is twice its actual size. A more common approach is to express magnification as a ratio between the size of the

subject as recorded versus its actual size. Thus, a 1:1 ratio represents a life-sized recording, while 1:2 would indicate that the recorded image is one-half of the subject's actual size. A 2:1 ratio means that the subject was captured at twice its actual size. In general, this way of notating magnification ratio will be used throughout this book.

Before the advent of digital photography, magnification figures in terms of film photography were based on the size of the subject as compared to the actual size of the image of that subject recorded on the film. For example, in the case of a frame of 35mm film measuring 24mm x 36mm, a subject measuring 36mm wide would fill the whole film frame lengthwise if it was recorded at a 1:1 (life-sized magnification ratio). The problem with carrying this over to digital photography is that the sizes of sensors vary among different camera models. As a way of dealing with this, some manufacturers have opted to draw comparisons

with 35mm film in their advertise-ments. For example, the Olympus E-1 digital SLR camera uses a 4/3-type sensor. The 4/3-type sensor is small-er than a frame of 35mm film by a factor that doubles the effective focal length of the lens when compared to 35mm film. Thus, Olympus advertises that its 50mm Macro lens is the equivalent of a 100mm lens in 35mm film photography and can achieve the 35mm film equivalent of a 1:1 magnification ratio.

From a practical point of view, the LCD monitor on a digital camera rep-resents almost all of the area of the recording sensor. While the size of the monitor is not the same size as the actual digital sensor, it gives you a good idea of how large the subject is within a single frame. The same is true for the viewfinder of digital SLR cameras. Both provide a good idea of the relative size of the subject with-in the frame space of the sensor. It is probably safe to say that most pho-tographers are less concerned about the exact math of the magnification ratio and more about how the subject

looks in the final composition within the camera's recorded frame space. Consequently, they use the relative size of the subject and the way it looks on the LCD monitor or in the viewfinder to determine how much magnification within a certain com-position is enough for their purposes.

We can, however, use the various degrees of magnification to general-ize about the different types of close-up photography. The scale begins at a magnification ratio of about 1:10 in which the recording is one-tenth life size. Typically, this takes in sub-jects photographed on studio table-tops—small product work, flat work on copy stands (such as snapshots), very small paintings—as well as larg-er flowers photographed in the field. A closely cropped portrait of a per-son that takes in just the disk of the face is yet another example. The goal in all these cases is to come in close and isolate the subject to reveal detail not normally seen. You can photograph a subject at a magnifica-tion ration of 1:10 with a normal lens in its normal mode.

To get to, say, a magnification ratio of 1:4, however, you need a close-up accessory. The terms "macro" or "macro photography" describe a mag-nification ratio that falls between a range of at least 1:2 or 1:1 down to a 1:4 ratio. Actually, most technical man-uals define macro photography as beginning at 1:1 and extending to 4:1 (where the image of the subject appears at four times its actual size). Only one type of lens category is designed to specifically focus from infinity to a 1:1 magnification ratio— the macro lens. These special lenses, as well as other forms of modifying the close focusing ability of a lens, are cov-ered in detail on pages 52-63. Achieving magnification ratios greater than 4:1 presents some practical prob-lems when using general photographic equipment, and is really a specialized form of close-up photography requiring extraordinary equipment, often includ-ing the use of a microscope.

Explore Your Subject by Varying Magnification Ratios

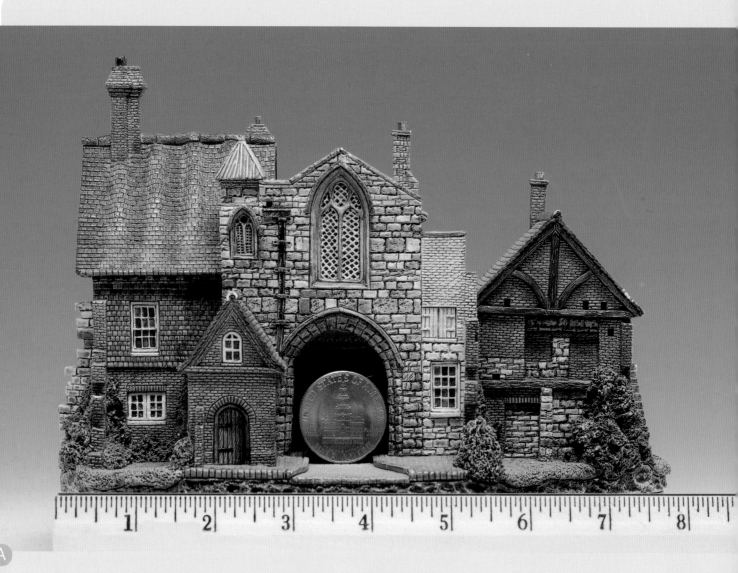

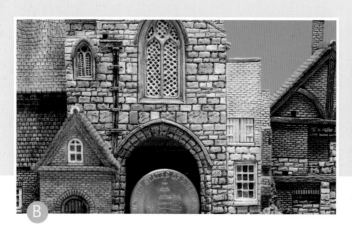

Changing the magnification ratio by moving closer to the subject does two things: It decreases the total area of the subject that will be recorded, and significantly increases the amount of detail that can be seen. In this example, a miniature of an early English stone house with a US 25-cent coin placed in the entranceway has been photographed at progressively greater magnifications until the remarkable detail in the model becomes apparent. The approximate magnifications ratios produced with a full-frame digital SLR are: 1:10 (A), 1:5 (B), 1:2 (C), 1:1 (D), 2:1 (E), and 4:1 (F).

Depth of Field

Depth of field tells you how much of your subject will appear sharp in a photo. Assume for the moment that you have drawn a straight line from the camera through the subject and on into the background. Depth of field would be that area in front of and behind your point of focus on the subject that appears acceptably sharp.

In normal distance photography, depth of field in discussed in terms of feet. If you take a picture of your daughter grooming the dog in the backyard, the depth of field could easily range from several feet in front of her to a hundred feet behind her. If you take a photo of the Alps while on vacation, depth of field could be miles (or kilometers, for those using the metric system). In close-up photography, however, depth of field is measured in much smaller terms. You might think of close-up depth of field as ranging from the thickness of your little finger to the width of your hand.

Three factors control and affect depth of field; all are critical:

1 APERTURE SETTING: As with normal range photography, f/stop affects depth of field. Specifically, the smaller the aperture opening (i.e., the higher the f/number), the greater the depth of field. Accordingly, macro lenses designed specifically for close-up work offer a smaller minimum aperture setting, such as f/32, as compared to comparable lenses designed for normal distance photography.

2 FOCAL LENGTH: The longer the focal length of your lens, the smaller the depth of field. For example, using a camera with a full frame (35mm-sized) sensor with a 70-180mm zoom lens set at 70mm at f/22 and focused at 2 feet (about .6 meters) will yield about two inches (5.1 cm) of depth of field, but if you change the zoom to 135mm, still at f/22 and at the same lens-to-subject distance, the depth of field shrinks to under an inch (less than 2.54 cm).

3 CAMERA-TO-SUBJECT DISTANCE: In close-up photography, depth of field shrinks the closer you get to the subject. For example, taking a picture at normal distances of about 20 feet (about 6.1 meters) or more with a setting of f/5.6 on a normal lens produces a sharp image where depth of field in front of and behind the subject is measured in feet (or meters). But place the lens a foot from your subject, and depth of field shrinks to less than an inch (2.54 cm).

In all forms of close-up photography, depth of field looms as the beast blocking the door to successful photos. Calling depth of field a beast may seem a bit strained, but in every close-up photo you will wrestle with depth-of-field problems. Learning how to tame depth of field and turn its shortcomings into a creative advantage may be the most important lesson of close-up photography. Although depth-of-field issues apply to all types of photography, nowhere is it more restricting than in close-up photography, and at no time is it more difficult to deal with than when you seek to capture the entire subject sharply.

Maximizing depth of field requires tradeoffs. What kind of tradeoffs? Use a smaller aperture to increase depth of field, and the tradeoff is using a slower shutter speed (risking picture blur) or a higher ISO (risking an increase in degrading image noise). If your goal is to maximize depth of field, then positioning the camera relative to the subject is also important. Set up the camera so that its image plane (the back of the camera) parallels an important subject plane. By making these two planes parallel, you maximize the depth of field and make it uniform from top to bottom and side to side in the picture.

With documents, photographs, and other flat subjects, achieving parallel camera and subject planes is easy. Figurines, flowers, insects, and other three-dimensional subjects provide more of a challenge. You need to find the angle that provides the best combination of depth of field and interesting composition. Consequently, the eternal quest for the close-up photographer is to find the best combination of camera placement, shutter speed, ISO setting, and aperture to render the desired presentation of the subject.

Working with Depth of Field

Controlling depth of field means controlling what will be in and out of focus. As the aperture opening becomes smaller, the depth of field (i.e., the area in acceptably sharp focus) becomes larger. This point is clearly illustrated when comparing image A, taken at f/5.6, to image B, taken at f/16. Depending on what aperture you choose, you can have a background that is in focus and integrated with the subject, or out of focus for a more isolated view of the subject. It is also possible to really isolate just a small part of the subject, as was done with the cupboard print pasted to the rear interior wall of the toy hamburger van (top, C) versus an all-in-focus treatment (bottom, C). While capturing the whole subject in focus is very often the goal of the photographer, as in the overhead

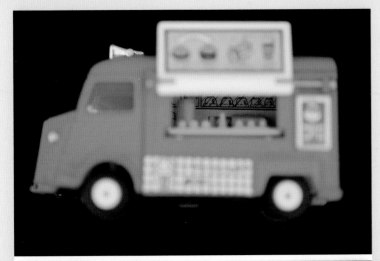

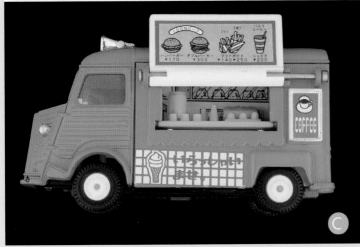

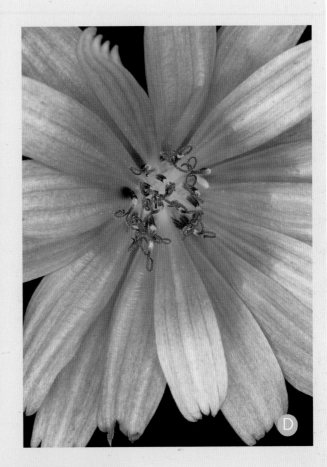

view of the flower taken at f/22
(image D), there are times when iso-
lating just a section of the subject
with a shallow depth of field, such
as f/5.6, provides a more interesting
view (image E).

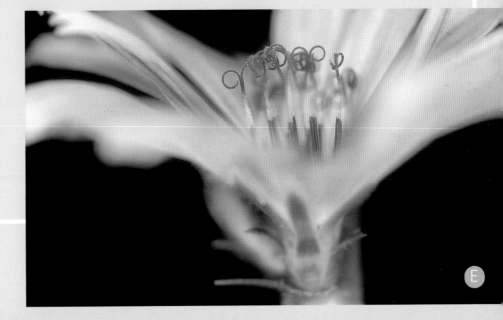

Working Distance

The distance from the end of the lens to the subject is known as "working distance". In the case of certain subjects, this distance is critical—butterflies, bees, katydids, frogs, chipmunks, and other small creatures will flee when you get closer than a few feet. And if you poke your lens in somebody's face to take a close-up portrait, you may get an unwelcome scowl. Plus, the closer you place your lens to the subject, the more likely you are to cast a shadow across it. So how can you achieve a working distance that neither disturbs the subject nor casts unwanted shadows? Think telephoto. With a telephoto focal length you can double or triple the working distance and avoid the problems caused by being too close for comfort.

On the other hand, small flash units specialized for close-up work and attached to the camera or camera lens typically have a limited field of coverage. Examples include a ring light, or single and double macro flash heads mounted near the end of the lens. (See pages 106-116 for more about shooting with artificial light sources.) All of these require a close working distance in order to evenly illuminate the subject. Move too far back and the picture will show significant light fall off at the edges of the frame. Also, if you work with higher magnification ratios, this will require getting closer to your subject, which means a consequential decrease in the working distance. As with so much in close-up photography, trade-offs are a fact of life, making it necessary to give some thought to how you are going to get the picture you want.

Steady Camera Position

Do you have an acquaintance who makes a big deal about everything? A squirrel runs in front of the car and it becomes a near-death experience. Well don't put me in that category when I tell you that the "big deal" in close-up photography is magnification. If magnifying the image is new to you then, as in life, you'll find that new experiences can result in unforeseen consequences. And although it's not a near-death experience, these unforeseen consequences are a big deal—at least for your pictures.

You see, magnifying the subject also magnifies something else—camera movement. When magnified, each little twitch or vibration from handholding the camera becomes an earth shaking movement that can blur the picture. The solution? A tripod. A tripod provides the stability that even the steadiest hand can't match. Alternatively, if your camera offers image stabilization, turn it on, and better yet, test it to learn the slowest shutter speed it's effective at for eliminating picture blur.

Although positioning a tripod is easy for indoor tabletop work, in the field it's quite difficult. Uneven ground, obstructing branches and foliage, and other obstacles sometimes make it difficult to position the tripod at the desired angle to the subject. I like to first find an angle for the photograph while handholding the camera, then position the tripod in that spot and mount the camera. A quick release plate that remains attached to the camera makes this much easier than detaching the camera from the tripod mounting screw each time, or moving the camera attached to the tripod as a unit.

Once you mount the camera on a tripod, you can further reduce picture blur from camera movement. Instead of pressing the shutter button with your finger, which jars the camera, use a cable release. Or, you can set the self-timer so the camera takes the picture several seconds after you press the shutter release button. With some SLR cameras, this has the added advantage of flipping up the mirror before taking the picture, thereby eliminating another source of vibration. If you are not using a tripod, hold the camera as steady as possible and use the self-timer to eliminate movement caused by pressing the shutter release. Alternatively, if you find yourself frequently working at ground level, a beanbag in combination with a remote shutter release or the camera's self timer might do the trick. Beanbags are especially useful on uneven ground where a tabletop tripod does not work very well for that worm's eye view of the subject.

One of the great frustrations of outdoor close-up work is wind. The great winds come under many names—hurricane, tornado, typhoon, foehn, chinook, sirocco—but in close-up photography, even the merest exhalation of breath can toss a flower like a palm tree in a hurricane. Waiting for that dead calm moment becomes a critical skill and technique. Every photographer who works outside knows that if they are patient enough, that moment of calm will arrive—or they use a makeshift windscreen, such as a piece of cardboard, to block annoying breezes. Such real world conditions require an unusual and extreme combination of persistence and patience on your part.

Let's emphasize two critical points:

1 You must be willing to take the time to position the camera optimally for both depth of field and composition.

2 You must set up the camera so it is held perfectly still, and not take the picture until the subject is perfectly still.

Hence, the creed of the close-up photographer: "Perseverance and patience!"

Tripods: Keeping it Sharp

A

erhaps the single most common reason a photographer fails to get a sharp picture is camera movement. The best way to avoid this problem is to use a stable tripod and make the exposure with either a cable release or using the camera's self-timer (image A). The choice of tripod is a very personal one, and there are certainly many to choose from. For example, Gitzo (image B) has one of the most complete lines, including the Benbo Mini Trekker which is specifically designed for getting close to the ground. There are also small tabletop tripods as in the Manfrotto 482 (image C), or this model made by Leica (image D). If you work very close to the ground, consider making a beanbag and using it as a stable platform.

I prefer ball heads on all my tripods (image E) and all my cameras, including compacts, are equipped with a quick release accessory, as opposed to the larger level operated platform standard tripod head. Other popular ball head models are made by Arca Swiss, Manfrotto, Novoflex, Gitzo Kirk Enterprises, and Really Right Stuff (see the Appendix on page 186 for contact information).

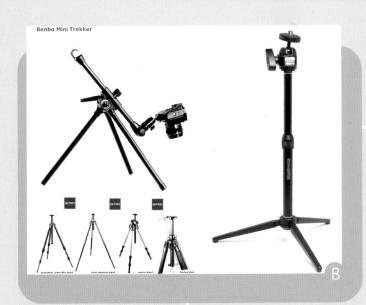

Benbo Mini Trekker

B

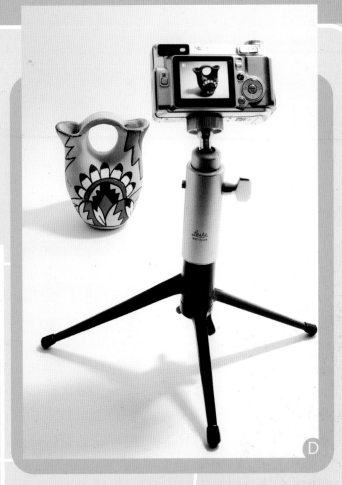

D

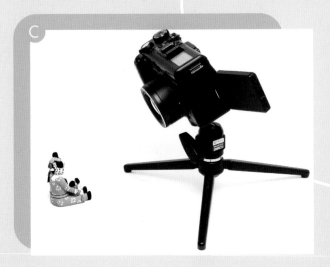

C

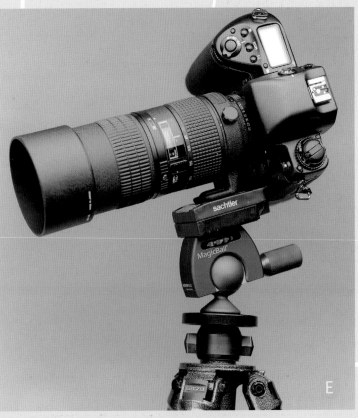

E

EXCEPTIONS TO THE "TRIPOD RULE"

When using a fast shutter speed to capture your subject, you may not necessarily need a tripod. Just how fast a shutter speed is required for a particular handheld shot is a matter of circumstances. A rough guideline for normal distance SLR film photography is that your shutter speed should be at least equal to the reciprocal of the lens focal length. For example, a 50mm lens requires a speed of 1/60 second and a 105mm lens 1/125 second for the average photographer to prevent the blurring effects of camera shake. In the case of close-up photography, even faster speeds are used to offset the magnification effect. Thus, for the 50mm lens set at a 1:1 magnification, doubling the shutter speed would be considered minimal. That is, 1/125 second instead of 1/60 second. The exact increase in shutter speed depends on how steady you can hold the camera. The best approach to figuring out the limits of handholding a camera is to run some tests to determine what shutter speeds work best for you at different magnifications.

Freezing subject movement becomes a more complex task the faster the subject is moving. Fortunately, the average outdoor close-up subject does not move very fast, unless of course you are trying to photograph outdoors in a strong wind. The most prominent exceptions would be flying insects.

Experience will quickly give you a set of guidelines for how fast a shutter speed to use on your favorite subjects under typical conditions. As a rule, I have found that 1/125 to 1/250 second with a digital SLR on a tripod at 1:1 magnification will freeze subjects such as flowers in a light breeze using a normal 50mm lens. A bee landing on the flower will, however, have blurred wings at those shutter speeds. Some nature photographers favor the use of a monopod, using a moderate to fast shutter speed in the 1/250-1/500 second range—a combination that gives them the ability to set up fast and work from many different positions. And remember, if you are patient, there will be a time when the subject stops moving in the breeze.

Using electronic flash as your main light source may also eliminate the need for a tripod. The short bursts of light from an electronic flash are brief enough to freeze camera movement and virtually all subject movement, producing very sharp images. In short, electronic flash in the studio or in the field just about eliminates the blurring effects of camera shake and subject motion. For those who like the look of flash in their photos, this would be the best choice. Photographers who prefer the way subjects are rendered in natural light need to follow the camera steadying procedures just discussed.

In summary, depth of field, working distance, camera stability, and camera position are the key factors you must manage and balance as you move in close to your subject. Careful attention to each of these factors is the key to getting sharp images.

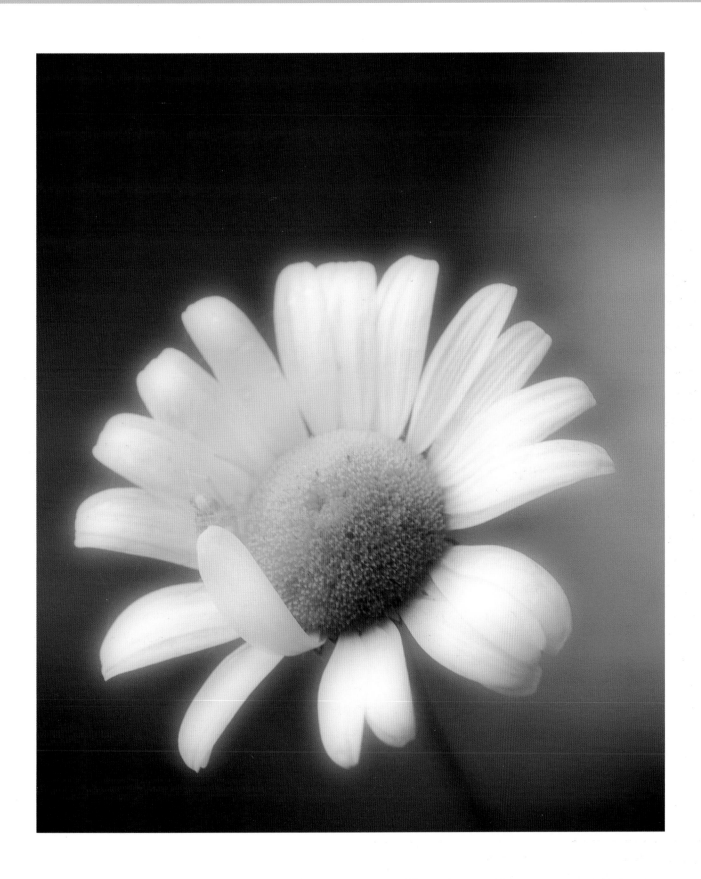

The Pollution
Photography of Kevin G. Coulton

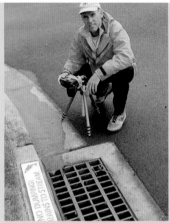

Portrait: © Kevin Coulton

first saw the close-up photography of Kevin Coulton while serving as the editor of a photography yearbook several years ago. His images had a beautiful but disturbing quality, dealing with an everyday problem that most of us probably never notice—the runoff of oil and other pollutants into our aquatic ecosystems. Kevin holds bachelor degrees in Civil Engineering and Landscape Architecture, as well as a Master's Degree in Hydraulic Engineering. He works as a registered water resources engineer, helping to plan and design solutions to improve the way in which we use and conserve aquatic ecosystems. He has extensive experience in designing storm drains, and this type of work has made him acutely aware of the type of pollutants—particularly petroleum products—that are washed away into storm drains when it rains. This pollution is not necessarily the result of large surface spills from industry and other mega sources, but rather from the cumulative effect of small drops of oil that drip daily from so many cars, trucks, and other vehicles.

An accomplished photographer, Kevin uses the techniques of close-up photography to document this insidious form of pollution. His images transcend the act of simply recording droplets of oil on the ground. On the contrary, his work has an artistic element that is both intriguing and disturbing as it brings us up close and personal with the machine droppings of our modern society. The close-up photography that drives his personal campaign for public awareness of this problem has been featured in media outlets from print to television. As described on his website: "The increasing public attention to his pollution photography, and the ensuing public awareness change is exciting for Coulton, as he is able to realize a unique opportunity to mesh his interests in photography and engineering for the purpose of making people more aware of a significant pollution issue."

For more information and images see:
http://www.kevincoulton.com/

Q & A with Kevin Coulton

Q: Your photographs could be described as beautiful renderings of an ugly subject. Do you compose your images purposely to capture the beauty in your subject, or is it just a result of documenting what you see?

A: I purposely compose the images so that they are realistic and appealing. My intent is to attract the viewer and then "hit them over the head" with the realization that they are really looking at pollution occurring on an immense scale on our streets and parking lots. I try to include a natural or human object, such as a leaf or cigarette butt, in the composition to help the viewer draw this connection.

Q: What sort of equipment do you use, and do you favor a particular type of light?

A: I use 35mm Nikon cameras and lenses with my favorite lens, a 105mm macro, and a sturdy Gitzo tripod. I made the change from Kodachrome 25 to Fuji Velvia film several years ago and have never looked back. I then scan these images and prepare them in the computer for use on websites, as well for print publications and other forms of media. After scanning (and only if necessary), I make final adjustments in color and contrast using Jasc Paint Shop Pro. I strive to create these images in the camera only when the light is right and use no filters and minimal digital adjustment.

Overcast days are the best to capture the subtle colors on the sheen of oil droplets or gasoline swirls. Wind, even the slightest breeze, can ruin an image that typically requires a long exposure time because of the lower intensity of overcast light. Another piece of unique equipment I have found useful—even essential—for this kind of work is an orange road cone that I place behind me in parking lots to reduce the chances of getting run over by a car while I am crouched over my tripod.

Q: What advice do you have for anyone wishing to do this sort of photography?

A: I have a unique passion for this kind of photography because I have academic training and employment in the analysis and management of storm water pollution. This experience gave me an understanding of the magnitude of the storm water pollution problem and led me to this unique means of public education over ten years ago when most were not aware of the problem. So, I guess my advice would be for an individual to have a passion for the type of photography they pursue.

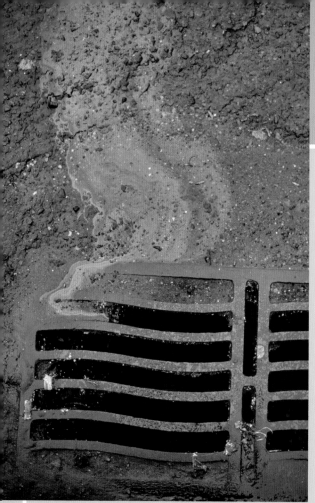
Blue Drain © Kevin Coulton

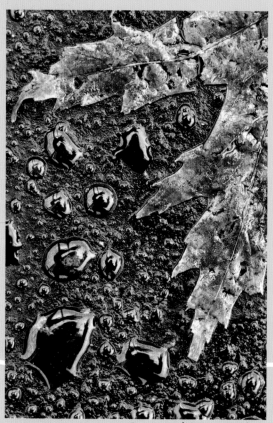
Brown Leaf ©Kevin Coulton

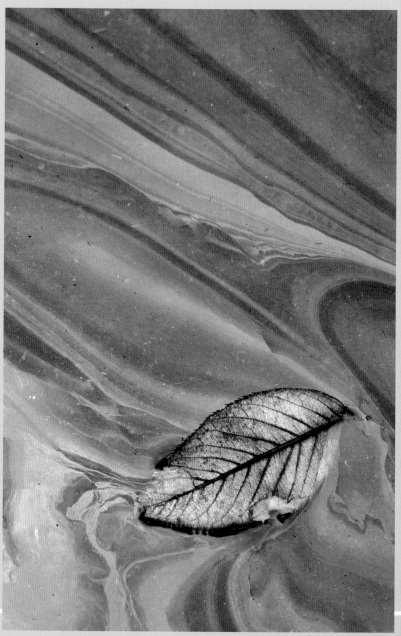
Dogwood Leaf ©Kevin Coulton

Droplet Silhouettes ©Kevin Coulton

Puddle Slick ©Kevin Coulton

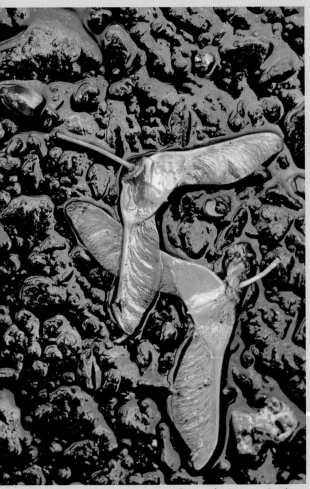

Maple Seeds ©Kevin Coulton

Red Leaf ©Kevin Coulton

2

CAMERAS,
LENSES, AND
CLOSE-UP
ACCESSORIES

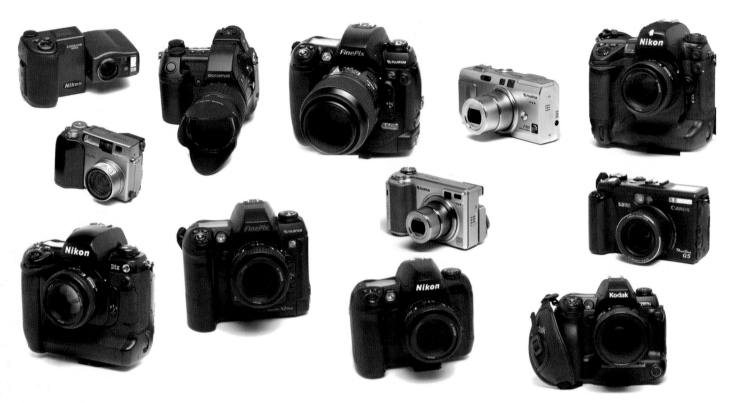

Since the 1990s, I have used a variety of digital cameras from five different manufacturers in my personal and professional close-up work and have found that no one camera does it all. There are times when a small compact camera is more than adequate, while under other conditions, I need accessories that only work with a professional D-SLR.

When I read that there are more stars in the universe than grains of sand on all the beaches of the world, I couldn't quite believe it and certainly couldn't comprehend it. I feel the same way when I look at all the digital cameras that are available on the market today—overwhelmed. There are hundreds of cameras, with hundreds, maybe even thousands of features. Each week brings new models.

True, hundreds of cameras are not quite in the same league as gazillions of stars, but it doesn't seem as far off as one might think when you factor in all the features. Inside each camera is a dazzling, often dizzying array of blinking, glowing, and spinning technologies, plus software and algorithms that unfold in a meandering maze of menus that offer dozens more choices and selections to be

made. Multiply the number of camera models times the number of features times the number of menu options and you still won't reach into the gazillions, but you may find yourself bewildered at the prospect of narrowing down your choices to a few models.

Let's take a look at your options in a leisurely and logical manner. It's safe to say that today's digital pho-

tographer can choose from many different cameras and accessories for close-up photography, and although the variations between cameras are many (and often subtle), you can focus on key features and functions that are critical for the type of close-up work you will be doing. When you condense your needs to, say, five key features, picking the best camera for those purposes becomes much easier.

Keep in mind that going digital doesn't require you to get a digital camera. If you're happy with your film camera, you can continue to shoot film and then scan it into the computer. I'll be the first to say, however, that you'll be missing out on the luxury of not having to process film, as well as on controls, such as different white balance and selective ISO settings, that digital cameras have to offer. In this chapter, we'll take a look at a cross section of the digital camera, lens, and accessory features that are critical to close-up work. Ultimately, it's up to you to decide which equipment choices best meet your needs.

The small sensors of advanced compact digital cameras deliver more depth of field per aperture setting than do the larger sensors of digital SLR cameras. Consider, for example, the depth of field in these three images all taken at f/2.8 with a 3.1-mexapixel advanced compact digital camera.

Compact Digital Camera or Digital SLR?

Choosing a digital camera for close-up photography depends solely on your wishes—oh yeah, and on your wallet. Even low-end digital cameras can take competent, sometimes excellent close-ups, and if you're just putting pictures of Mom's gnome collection up for sale in an online auction, almost any digital camera will do. But, if you're trying to sell stop-action pictures of a bullfrog snaring a dragonfly in mid-air, you'll succeed more often with an advanced setup—a digital SLR.

Digital cameras fall into two general categories: those that have non-removable lenses (often referred to as compact digital cameras), and those with removable lenses (primarily digital SLRs). The non-removable lens of a compact digital camera is permanently attached to the camera body. This permanent attachment is a huge disadvantage for the committed close-up photographer. On the other hand, a compact digital camera may suit you just fine if it's a second camera, or if your close-up work is occa-sional and fairly simple. So, let's give compact digital cameras their due. They can be quite versatile. I've taken and sold pictures with them—as has Rob Sheppard, whose portfolio in this book was taken with such a camera (see pages 64-69).

Hint: Two ways today's buyer can sort out the differences between camera models when looking to make a purchase are using resources on the Internet, such as Digital Photography Review (www.dpreview.com) and Steve's Digicams (www.steves-digicams.com), as well as checking out reviews and articles in photo magazines, such as Popular Photography, Shutterbug, and PCPhoto. These magazines contain camera and lens profiles and reviews, as well as articles on close-up photography techniques.

Advanced Compact
Digital Cameras and Available Light

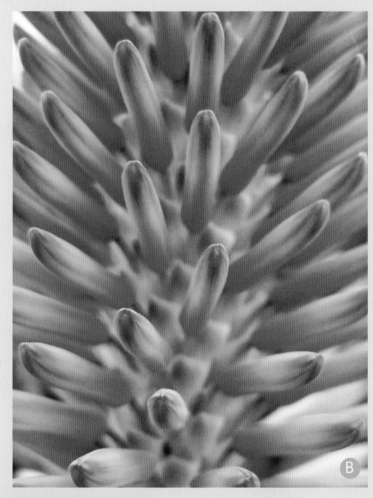

The decision to use flash as opposed to available light is often a question of whether there is enough available light for the picture. One of the strengths that I've found with advanced compact digital cameras is that their smaller sensors allow you to take pictures at much slower shutter speeds, as seen in these examples: a miniature football helmet collection (image A) shot at 1/15 second using indirect window light; a flower (image B) shot at 1/30 second by fluorescent light; raindrops on a spider web (image C) shot at 1/30 second in overcast daylight; a cat by the fish tank (image D) shot at 1/25 second by fluorescent light; and an ivory carving (image E) shot at 1/10 second by museum tungsten halogen light.

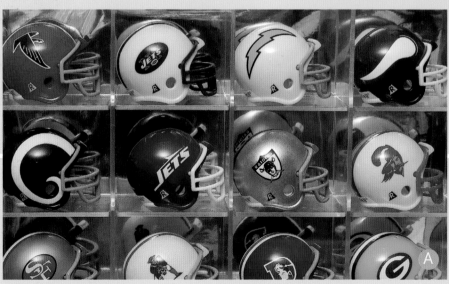

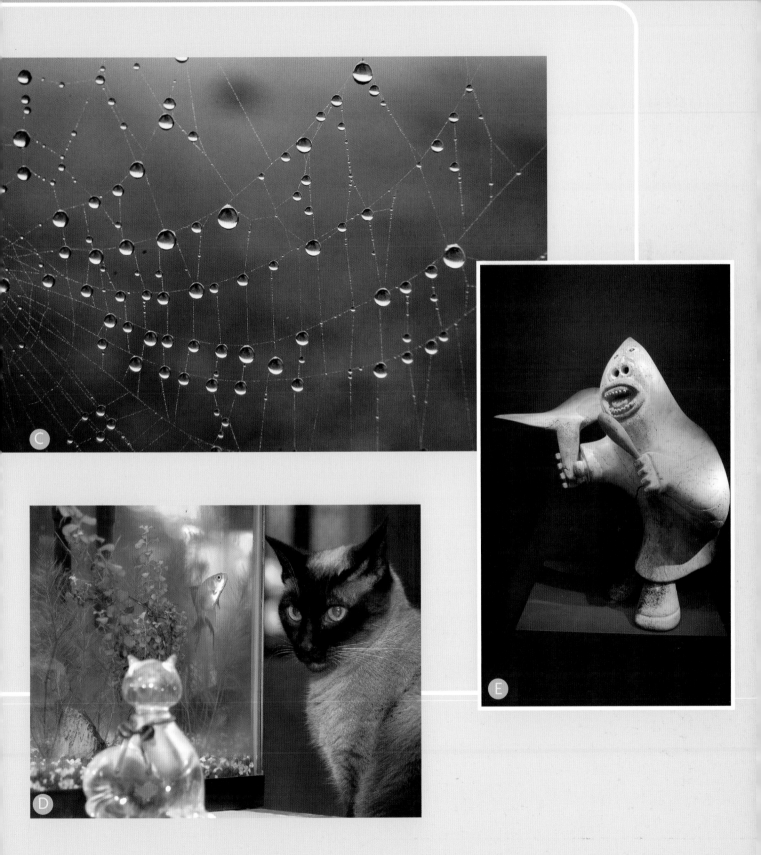

Non-Removable Lens Compact Digital Cameras

Most compact digital cameras sport a zoom lens; those that do are called digital zoom cameras. Such camera models range from basic "idiot proof" point and zooms up to very sophisticated cameras with long-range zooms, exceptional close-up capability, image stabilization, and almost all the functionality of a professional D-SLR. Suffice it to say, such a camera is capable of producing excellent image quality. Price-wise, compact digital cameras range from about one hundred dollars to one thousand dollars. Most cameras in the compact digital class have a maximum pixel count of between three and eight megapixels, whereas recent top-selling digital SLRs have broken the 16-megapixel ceiling.

As a group, compact digital cameras use smaller sensors than digital SLRs do, with some sensors measuring less than an inch (2.5 cm) across.

These smaller sensors give these cameras more depth of field than their digital SLR counterparts with larger sensors. For example, a compact camera capturing an image at f/2.8 might deliver approximately the same depth of field as a typical digital SLR lens set at about f/8.

One thing to be aware of with compact digital cameras is that most of them have two separate optical systems: the viewfinder and the lens. This may not cause a problem for photographers who use the camera's LCD monitor to frame the shot, as the "live" LCD monitors of compact digital cameras see exactly what the lens sees. However, for those that use the viewfinder on their compact digital camera, you may run into a problem known as parallax. The viewfinder and the lens on most compact digital cameras are typically separated by one or two inches (2.5 - 5 cm), with the viewfinder looking out over the lens, not through it. The viewfinder

and the lens are not on the same axis and, therefore, have slightly different perspectives that produce different views of the subject. The term "parallax" is used to refer to this discrepancy. At distances greater than a few feet (or about a meter), the difference between these two perspectives is slight and virtually unnoticeable in the resulting pictures. However, the closer you get to the subject, the greater the disparity in perspective until eventually it becomes a problem. That is, what you see in the viewfinder will vary from what you see in the picture when shooting close-ups.

Many compact digital cameras effectively deal with the parallax problem by allowing the photographer to use the LCD monitor (which shows exactly what the lens sees) to frame the shot. This monitor shows the subject in the same view and perspective that will be in the picture. In addition, most compact digital cam-

eras with super zooms (10x or greater) don't use optical viewfinders at all. They use an electronic viewfinder (often referred to as an ELF viewfinder) like those used in video cameras. ELF viewfinders show a tiny electronic image of exactly what the lens sees, like a mini LCD monitor seen through the viewfinder.

The Parallax Effect

A simple experiment will demonstrate how much of a discrepancy can exist between an optical viewfinder (that looks out over the lens of a compact digital camera) and the LCD monitor (which displays exactly what the lens is seeing). First, place your camera on a tripod and focus as closely as possible on a section of text, such as the page of a newspaper. Look only through the viewfinder when composing this picture and keep the LCD monitor turned off. Now, without moving the camera, turn on the LCD monitor. The difference between the two views represents the parallax discrepancy. So the lesson here is, when doing close-up work with a compact digital camera, use the LCD screen for composing.

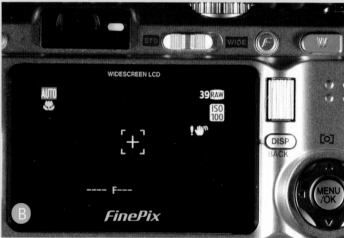

The two basic ways of close focusing with compact digital cameras are shown here. Pressing the close-up mode button (image A) will allow the camera to focus closer, and is usually indicated by the appearance of a flower icon on the LCD monitor (image B). Almost all compact digital cameras have a close-up option, but it usually restricts the focal length range of the zoom that can be used. Alternatively,

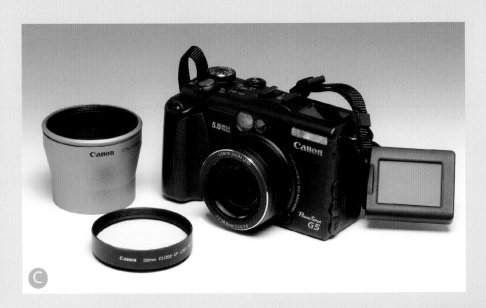

C

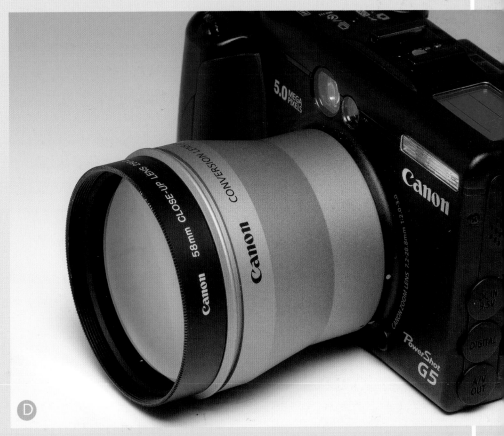

D

certain compact digital cameras make it easy to fit close-up diopter lenses to the front of the camera lens. For example, this camera (image C) has a special collar that screws over the lens allowing the mounting of a 58mm diopter (image D). Other advanced digital compacts have lenses with small threads that allow direct use of close-up diopters. With an auxiliary diopter lens in place, it is then possible to focus closer using the whole zoom range.

Using Compact Digital Cameras for Close-Up Photography

Compact digital cameras have a huge advantage—they're compact. Compactness may mean little in the studio, but when traveling or walking, hauling a twenty-pound bag full of gear becomes tiring. In addition to its small size and weight, a compact digital camera offers a few other advantages. Some compact cameras let you do full 1:1 close-ups—that's as close as most of us need to get. Plus, they offer other design features that make taking close-ups easy. Most have a close-up mode that instantaneously allows the camera to be focused nearer to the subject. The results from this easy-to-use option are generally good.

To activate the close-up mode, you just press a mode button on the camera or select it in the camera's menu. A small flower icon appears on the camera's LCD monitor to indicate that you are in the close-up mode. You then move the camera closer and closer to the subject, composing using the LCD monitor. (Again, don't use the viewfinder of a compact digital camera for close-ups; because of parallax, it won't accurately show the positioning of the subject—see page 45 for more details.) Lightly touch the shutter release button to lock the focus, then fully depress it to take the picture. If you cannot lock in the focus, then you have exceeded the close-up range of the camera. The exception would be if the subject does not have discernable characteristics on which the camera can focus. Depending on the camera model, you may find that, once in the close-up mode, your choices of zoom setting are limited. That is, the camera will probably only take close-up exposures at the shorter end of the zoom range.

My favorite feature for compact digital close-up work is what I like to call "the anti-worm" LCD monitor. Of course, it's not actually called that—it's called an articulating LCD monitor, and its multi-directional rotation capabilities can be very useful, indeed. With it, you can photograph things at ground level without sprawling out on the ground yourself (think mud, poison ivy, spiders) to get your eye to the viewfinder. Let's see a standard D-SLR do that! Don't underestimate the comfort and convenience that an articulating LCD monitor brings to close-up work. If your camera doesn't have one, practice your contortionist skills.

Another option for close-up work with non-removable lens compact digital cameras is to attach a close-up lens to the front of the camera lens. Close-up lenses are basically magnifying glasses that, when placed in front of a lens, allow it to focus closer, producing a magnified image. This is the same principle as when you use a magnifying glass in front of your eye. If you use a high quality close-up lens, the results can be very impressive. In addition, if you use the close-up lens with the camera in close-up mode, you can get even closer.

One of the biggest advantages of a close-up lens is that it allows you to use the telephoto end of the zoom lens on a compact digital camera. For example, the insect pictures by Rob Sheppard on pages 64-69 were taken with a close-up lens attached to a compact digital camera using the longer focal lengths to increase the working distance with these skittish subjects. (See page 59 for more information about close-up lenses.)

Interested in a compact model for your close-up work? If so, here's what to look for:

1 **Does the camera have a close-up mode?** Most do, but be sure that this mode will deliver the level of magnification that you want. The best way to determine this is to try out the camera at the store before buying it. Focus closely on a subject and watch the LCD monitor. (If you bring your own memory card, you can examine the captured images later on your computer.) If a hands-on demonstration is not possible, check the specifications to see exactly how close the camera can focus in the close-up mode. Some of these cameras can get as close as a few inches to give you "near macro" renderings. Sometimes you will see magnification ratios as part of the specifications for the camera but, unfortunately, not very often. So, the hands-on test is the best option, followed by the close focusing distance data. Also, determine if the close-up mode works at longer focal lengths. Most of these cameras will only allow you to use the close-up mode with the lens set at the wide-angle end of the zoom.

2 **Can the camera take a close-up lens?** Quality close-up lenses will yield very good results, but not all cameras can be equipped with these accessories. The big advantage, as noted earlier, is that with the close-up lens in place, you can usually shoot at any focal length on the zoom scale. If your camera is able to take photographic filters, it can also take a close-up lens.

3 **Does the camera have an articulating LCD monitor?** This is a real plus in general, but especially if your typical subjects are close to the ground, such as flowers and crawling insects. Articulating LCD monitors are also great for shooting subjects that are above you; you can angle the screen to easily frame the shot.

Digital SLRs

Digital single-lens-reflex cameras (or D-SLRs) open the door to a world of possibilities for the close-up photographer. The simple act of being able to change lenses depending on your shooting needs multiplies your photographic versatility exponentially. Instead of playing the British Open, with a single club (okay, five if you have a zoom lens), your bag now rattles with a full complement of clubs capable of extracting you from a pothole bunker or lifting your ball at a high trajectory for a softer landing on those enormous greens. Of course, photography shares with golf that the actual results depend on your mastery of the equipment.

Technically, what distinguishes the D-SLR from the non-removable lens compact cameras is not only the removable lens, but the use of a single viewing system. That is, the optical viewfinder "sees" directly through the lens, and therefore does not cause a parallax problem (see page 45). This is accomplished by having a hinged mirror in front of the sensor that reflects the image from the lens up into the viewfinder for your eye to see. When you press the shutter release button, the mirror flips up and the shutter in the camera opens to expose the sensor to the scene. Now you can see how the term "single-lens-reflex" breaks down: "single lens" refers to the single viewing system that uses the "reflex" action of the mirror to expose the sensitized media to light. The placement and action of the reflex mirror is what prevents the use of a live image on the LCD monitor of a D-SLR.

Most D-SLRs use a capture sensor that is smaller than a frame of 35mm film (24mm x 36mm). For example, a sensor that is referred to as being in "4/3" format measures 13.5mm x 18mm. Since the vast majority of lenses used on D-SLRs were designed to cover a full frame of 35mm film, the effective focal length of these lenses is actually longer when used on a 4/3 sensor (or any sensor less than 24mm x 36mm in size). Just how much longer is determined by the specific size of the sensor. For example, a 60mm f/2.8 macro lens when used with a camera that has a 22.4mm x 15mm sensor becomes the equivalent of a 96mm lens, or 60mm x 1.6—this particular sensor has a 1.6x focal length magnification factor. This "telephoto effect" repre-sents an advantage to the close-up photographer who wants a greater working distance, but there are also disadvantages. For example, when using a copy stand to photograph a larger subject, you may not have enough height to compensate for the fact that your normal 50mm macro lens now acts like a moderate telephoto.

A recent trend in D-SLR photography has been the introduction of "digital" lenses. Designed specifically to cover sensors smaller than 24 mm x 36 mm, a number of these lenses are now available from both camera manufacturers and independent lens makers.

D-SLR Cameras and Close-Up Photography

If you're serious about your close-up work, you really don't have much choice but to include a D-SLR in your arsenal. Although a high-end advanced compact digital camera can provide exceptional results, in the end it's no match for the firepower of a D-SLR. The D-SLR's greater exposure control, higher-quality sensor and ability to use accessorries that take you closer to the subject and let you light you subject better all combine to produce pictures of unrivaled quality.

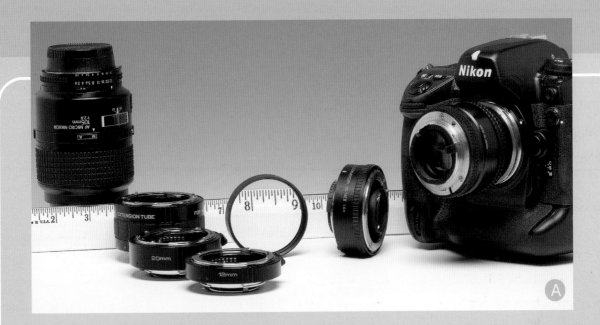

D-SLR Close-Up Options

Shown here are the six ways to get close with a digital SLR. In image A, from left to right, we have a macro lens, an extension tube kit (showing three different sizes that can be stacked together), a close-up lens diopter, a 1.4x tele-extender, and a camera with a reverse mounted lens using a reversing ring. Image B shows a camera with a mounted extension bellows. Each of these close-up approaches have certain advantages and disadvantages, as well as different cost factors. Pages 52-63 examine these in more detail.

TRUE MACRO LENSES VS. ZOOM LENSES WITH A "MACRO" SETTING

The mark of a jeweler is the magnifying loupe. For a doctor, it's a stethoscope, and for a coach, it's a whistle. A macro lens is the mark of a close-up photographer. And for me, a true macro lens is true love. In all ways optimized for close-up work, a macro lens will almost never let you down.

Macro lenses use an internal arrangement of lens components and a helical focusing mechanism that increases the distance between the optical elements and the sensor by simply turning the focus ring on the lens. This produces a close focusing range beyond what non-macro lenses of comparable focal length can reach. Their optical design is also highly corrected for focusing at a closer range, so the macro lens generally delivers the sharpest and best optical results. Typically, these lenses come in three focal length categories: normal (50-60mm), moderate telephoto (90-150mm), and long telephoto (180-200mm). There is also the specifically designed 70-180mm macro zoom made by Nikon and a whole bunch of zoom lenses that claim to have a "macro" setting. Keep in mind that the terms "normal" and "telephoto" as used here are really based on a full-frame (35mm-sized) sensor. If you are using a D-SLR with a smaller sensor, then the telephoto effect explained earlier applies. As the focal length of a lens increases, the amount of depth of field will decrease. So, your choice of focal length will influence how easy it is to isolate a subject from the background.

All of the major camera companies (and some independent lens manufacturers) offer single-focal-length macro lenses. Keep in mind that any general photography lens can be made to focus closer using close-up accessories. The drawback is that non-macro lenses are designed for general photography, and are not corrected for close focusing, as are macro lenses.

The Macro Lens Advantage

Macro lenses are the easiest close-focusing option to use since you can focus continuously from infinity down to (or near) 1:1 life-size magnification. This is a critical feature since it allows complete freedom for selecting how close (or far away) you position the camera to the subject. Other close-up approaches using either an extension tube or a close-up lens do not offer this flexibility since they only allow sharp focusing within a specific, limited subject-to-lens distance range. Also, by providing infinity to life-size focusing, macro lenses allow you to control the amount of magnification in the final picture. The closer you get, the greater the magnification.

Modern macro lenses and zoom lenses with a "macro" feature are usually designed to operate with all the advanced metering options available in the camera body, including advanced flash control functions, such as automatic fill-flash. Most also

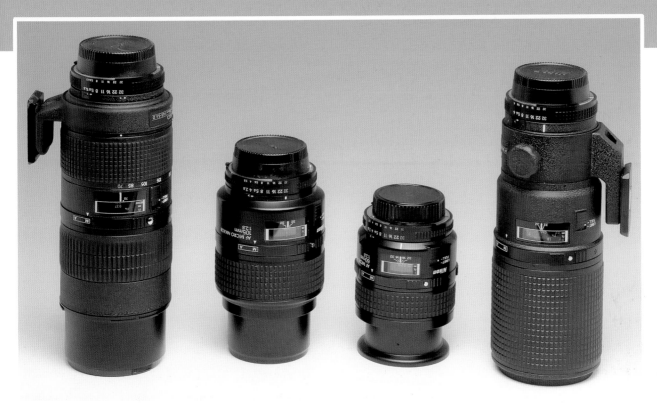

Pictured here from the left to right are a 70-180mm macro zoom lens, a 105mm macro lens, a 60mm macro lens, and a 200mm macro lens.

offer autofocus, which can be very helpful in certain conditions where you have to operate quickly, such as when photographing insects in the field. Autofocus is also a great help if you are handholding the camera. Close-up accessories can also be used with macro lenses to further increase the magnification ratios. In addition to their use in close-up work, true macro lenses are excellent for general photography applications. In short, they are among the sharpest and best-corrected lenses for all types of photography. The only feature they lack is the very large openings of a fast lens, such as a 50mm f/1.4 normal lens.

A Few Disadvantages

Single-focal-length true macro lenses are the most expensive choice for close-up work, with a street price range that can be twice or even three times the price of comparable focal length non-macro lenses. And since all of these lenses produce their results by increasing the distance between the optical elements and the camera body, there is some loss of light. This means either opening up the aperture, slowing the shutter speed, or increasing the ISO setting to offset the light loss.

When using a zoom with a "macro" setting in manual focus, the focus point will not be maintained when changing focal length settings.

You must refocus whenever the focal length ring is turned. As a general rule, zooms with a "macro" feature are not as sharp as comparable single-focal-length macro lenses. Furthermore, these zooms have maximum apertures that are one to two stops slower than a typical true macro lens. This makes for a slightly darker image in the viewfinder. It also means that you cannot produce as shallow a depth of field at the maximum aperture for isolating a subject from its background. And many of the zooms with a macro option limit the focal lengths that can be used in this mode. Nevertheless, they are often capable of producing very good close-up image quality.

50mm to 60mm
Normal Macro Lenses

Sometimes called the "universal macro camera," a normal focal length of between 50mm and 60mm can be used for a wide variety of applications. Specifically, it is the best choice for working off a copy stand, as longer focal length lenses restrict the field of capture. Most copy stands have enough height to allow a normal focal length lens to capture the whole area of the base-board. Alternatively, these lenses can also be racked down on the copy stand very close to a subject to capture tiny details (as long as you don't block the light). As a group, normal-focal-length macros are also the smallest and lightest macro lenses, which makes them the best choice for a number of situations, like when using small tabletop tripods, or an extension bellows where heavier lenses throw the set up out of balance. Normal-focal-length macros are also not as heavy as many other macro lenses, making it easier to use the camera set in the vertical position on a tripod, as opposed to heavier lenses that require a stronger head to

support them when the camera is placed off the tripod's center axis.

In small product photography, macros in the normal-focal-length range produce the most natural pro-portions and renderings of space between small subjects, props, and backgrounds. Longer focal lengths tend to compress distances between these elements which, in small prod-uct and still life work, is likely to make everything appear to be closer to one another (which may or may not be desirable). If you are using a D-SLR with a smaller-than-full-frame sensor, a 50mm macro becomes a moderate telephoto in the 90mm range. In most cases, this increase in focal length should not produce unac-ceptable compression of the spaces between subjects in your image, but you will need plenty of room to back up to take in the whole composition.

The weakness of the normal range macro is the limited working dis-tances at higher magnification ratios, especially 1:1. That is, you have to get too close for many subjects, such as invading the comfort zones of insects, or in the case of a very tight headshot of a person. There is also

the greater possibility of interfering with the light by casting a shadow over the subject, especially when working in natural light. Some pho-tographers will use a 1.4x tele-exten-der to convert a normal-focal-length macro lens to a telephoto. This increases the working distance, but at the loss of one stop of light.

90mm to 105mm
Moderate Macro Lenses

For many nature photographers, nirvana comes in the form of a moderate-focal-length macro lens. With a lens in the 90mm to105mm range, they can wander into the dew of an early morning meadow and capture lethargic butterflies clinging to timothy stems from a distance that doesn't startle these skittish creatures. They can turn a busy background of brown-eyed Susans into an impressionistic blur of color. Moderate macro lenses offer the best combination of working distance, size, and weight. You can mount them on a tripod or use them with electronic flash well away from live subjects. With their greater compression and less depth of field, they can throw busy backgrounds out of focus, giving pictures a look that many photographers prefer. It is hard to quantify such impressions, but the look probably derives from the combination of slight compression and tight compositions produced when using lenses in this class.

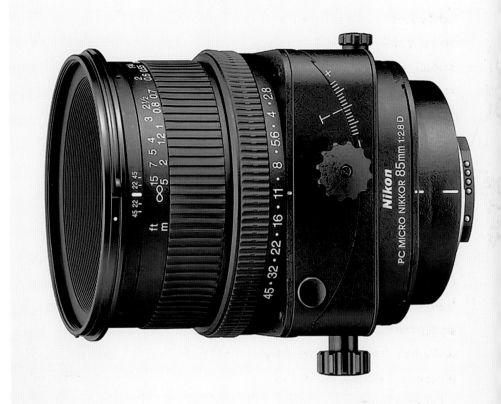

Besides conventionally designed macro lenses, there are also a limited number of specialized macro optics. These include the shift and tilt designs offered by Canon and Nikon (shown here). The optical design allows the lens elements to be moved independent from the rear section of the lens, similar to the movements of a view camera. As a result, it is possible to change the usual perspective relationships that exist with standard lenses and affect the depth of field independent of aperture settings. Such specialized lenses require additional knowledge concerning perspective and depth of field controls in order to use them properly.

180mm to 200mm Long Macro Lenses

Professional sports photographers and professional nature photographers share one big thing in common—a craving for fast, heavy lenses that cost as much as a motorcycle. Both types of photographers want to keep their distance so they don't interfere with the action.

Only a few macro lenses fit into this class. Even more so than moderate telephoto macro lenses, these long-focal-length macro lenses let you isolate a subject from the background. Plus, most use a tripod collar so you can easily rotate the lens from horizontal to vertical while maintaining the same position on the tripod's center axis. (Personally, I don't understand why this collar feature is not found among any of the 100mm macro lenses—it is very useful.)

Zoom Lenses

Manufacturers of zoom lenses tout their macro capability, but let's just say the macro feature of a zoom lens should clearly be a second choice to single-focal-length macro lenses for close-up work. Zoom lenses are a huge convenience, and offer exceptional versatility in everyday photography, but that versatility doesn't easily encompass close-up work. Zoom lenses with a "macro" option are not capable of producing a 1:1 magnification ratio. even on full-frame D-SLRs (let alone on cameras with sensors smaller than full-frame). without the use of extension tubes or close-up lens diopters. Also, when shifted into the macro mode, the focusing range of typical macro zooms is often restricted to a certain focal length or limited focal length range.

The optics of zoom lenses are designed for zooming to different focal lengths and taking pictures at a distance, but that doesn't mean you can't get good close-up pictures with a zoom lens. Over the years, zoom lenses with built-in close-up mode options have become better and bet-

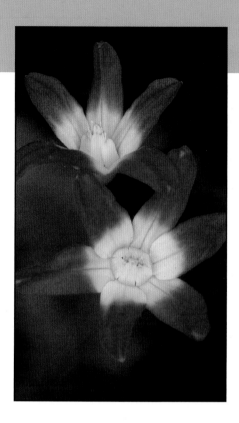

ter in terms of image quality, but just remember that, when greatly enlarged, the quality (mainly sharpness and contrast) of pictures taken with a zoom lens won't match that of pictures taken with a single-focal-length lens.

One interesting exception is the AF Zoom Micro-Nikkor 70-180mm f/4.5-5.6D ED made by Nikon. (Nikon labels all their macro lenses as "micro" lenses.) It focuses continuously from infinity down to its closest focusing magnification. This can approach 1:1 when the lens is used on a camera with a sensor that is full-frame.

A large number of zoom lenses claim to have a macro setting that allows the lens to focus closer. Once this feature is engaged, the lens is usually limited to only focusing at a limited number of focal lengths over a limited focusing distance. However, while using a macro setting on a zoom lens will not produce the same high quality images as a fixed focal length macro lens, the results can still be quite good depending on the overall quality of the zoom lens.

EXTENSION TUBES AND BELLOWS

Extension tubes and bellows are like shoe lifts and stilts. Both devices increase distance—in this case of the lens from the camera, increasing magnification. They can be used with any focal length lens, but work best with lenses in the normal to telephoto range. (Wide-angle lenses distort the appearance of close-up subjects.) You attach the extension tube or bellows to the camera body, then attach the lens to the other end of the tube or bellows.

Extension tubes are like shoe lifts in that they come in fixed increments to get you a little closer to where you'd like to be. Typically available in sets of three tubes of different lengths, you can use each tube independently or combine them. Bellows, on the other hand, expand like an accordion to give a continual range of magnification between the minimum and maximum focusing distances. They use a rack and pinion arrangement to increase the camera-to-lens distance.

Advantages

Rigid extension tubes are inexpensive compared to macro lenses. They can be used singularly or stacked together to allow the lens to focus closer and closer, producing greater and greater magnification. Some tubes maintain the automatic metering features matched to a particular camera brand. This is an important point, and you should check to see if this is the case before buying. An extension bellows costs significantly more, but is fully adjustable over a larger range. It gives a larger magnification ratio and can fine-tune the exact amount of magnification, unlike the fixed size of a close-up tube. Extension bellows can be equipped with a number of different lenses but the more common practice is to use a normal-focal-length macro lens or a darkroom enlarger lens in the 50mm range.

Disadvantages

Most extension tubes and bellows units operate only in manual mode for focusing; only a few models of tubes maintain automatic metering. Also, there are practical limits to how many tubes you can stack before the lens/tubes/camera body arrangement becomes unwieldy. If longer extensions are needed, the bellows is the better choice but again, this arrangement can also be, literally, a handful. For example, placing large lenses, such as a 200mm macro or a zoom, at the end of an extension bellows makes for a very cumbersome set up, and is really an impractical option.

Usually, long extension tubes or bellows arrangements benefit from the use of a focusing rail. The camera is mounted on the rail, and the rail's focusing mechanism is used in combination with the focusing function of the camera to give greater flexibility. Finally, when a series of extension tubes are used or a bellows is employed, the objective is higher magnification. This, in turn, means more attention has to be paid to a steady camera position, a reduced effective depth of field, as well as ever decreasing working distances. Also, long extensions lengths can reduce the amount of light by two or more f/stops.

CLOSE-UP LENSES

Have you ever gone to the grocery store and, with a sideways glance, sort of sneaked over to the revolving stand of reading glasses? Maybe even secretly tried on a pair or two? Or maybe you confronted things head-on and marched into the optometrist to get a prescription for graduated bifocals. If so, you might be able to identify with your camera. For real close-up work, some cameras need help—their own version of reading glasses.

Close-up lenses are an inexpensive way to boost your camera's close-up capabilities. They look like filters, screw onto the front of your lens, act like reading or magnifying glasses, and come in different sizes so one is sure to fit the front of your camera lens. 49mm, 52mm, 62mm, 67mm, and 72mm are the most common sizes.

Close-up lenses let your camera see things closer than normal. Just how close depends on the diopter strength (i.e., their magnification power). The most commonly used strengths are between +0.5 and +3.0. They come in two different versions, as well as in multiple strengths. The more basic (and less expensive)

version is a single element design, usually available in the following single strengths: +1, +2 and +3, with the higher number indicating greater magnification. These can be stacked together; for example, a +2 and a +1 equal the strength of a +3. Always stack the strongest lens in the combination closest to the camera. When using a +2 and a +1 close-up lens in combination, for example, the +2 lens should be mounted first.

Close-up lenses are available from a wide range from filter and lens manufacturers, such as Tiffen, Hoya, and Schneider Optics. Cost will depend on the lens size and quality, and may range from as little as $10.00 to as much as $30.00 or more per close-up lens.

The second type of close-up lens is a two-element achromatic design that also comes in different strengths; most use strength notations that are proprietary to the manufacturer. They are also recommended for use with certain focal lengths, and are superior to the single element versions in terms of image quality.

Advantages and Disadvantages

The main advantage of close-up lenses is that they are the only close-up accessory that doesn't reduce the amount of light, forcing you to adjust exposure by using a wider aperture or a slower shutter speed as you get closer to the subject. They are also the smallest and lightest close-up option to carry in your camera bag. The main disadvantage is that the single-element design often produces disappointing results, especially in the case of stacking two or more lenses of a less expensive brand. The achromatic close-up lenses, on the other hand, produce very good to excellent results, especially at the lower magnification range. This does come at a significantly higher monetary cost, however; the larger the size, the higher the price. Some 72mm versions cost close to $100.00. I routinely carry a +1.5 achromatic close-up lens and frequently use it when extra magnification is needed with a macro lens in the field.

Tele-Extenders

Designed to give your lens telephoto power, tele-extenders (also known as "lens multipliers" or simply "extenders") let you focus closer to your subjects. This one accessory gives you both telephoto and close-up power.

A tele-extender multiplies the focal length of the lens, typically by 1.4x or 2.0x. Thus, a 300mm focal length lens with a 2x tele-extender becomes a 600mm focal length. Nature and sports photographers commonly add tele-extenders to telephoto lenses to magnify distant subjects, be they gophers or golfers.

So why use one for close-up work? Because it lets you enlarge the subject while keeping your distance. A 2x tele-extender lets you double the size of a close-up subject without having to move the lens closer—quite handy for butterflies, birds, and other shy subjects.

Advantages and Disadvantages

The main advantages of using a tele-extender are the increase in magnification and working distance. The main disadvantage is the loss of light that comes with these lenses (1-stop loss with the 1.4x and 2-stops loss with the 2x). Also, light passing through a second set of lens elements slightly degrades image quality. As with close-up lenses, the more expensive the tele-extender, the higher the image quality.

Reversing Ring

Who as a child hasn't taken binoculars and looked through them backwards? The result? Minimification. Okay, so that's not actually a word, but instead of magnifying that distant sailboat, binoculars peered through backwards seem to send it miles away. If you catch on to where I'm headed you may be asking: Who would look through their lens backwards? A close-up photographer, of course. With a reversing ring you can turn your lens around and attach it backwards to the camera. With a normal or wide-angle lens, you'll increase its magnification ability.

This may be the least used approach to D-SLR close-up photography, in part because it decouples autofocus and autoexposure, leaving you to handle them manually. It also exposes the rear element of your lens to possible damage. And you cannot easily attach a lens hood or filters to such a lens arrangement. All the same, with a normal or, even better, a wide-angle lens, the results can be quite impressive. Depending on the focal length and sensor size, you'll likely achieve 1:1 and greater magnification.

THE TELEPHOTO CLOSE-UP

Would you like to use a 300mm or longer telephoto lens for close-up work? You certainly can, and you may even find the great working distance a telephoto lens offers a significant advantage. Plus, you can exploit the compression of a scene that a telephoto creates.

Many of these lenses focus close enough to fill the frame with medium-sized subjects, like a sunflower head. Add on some of the accessories we've just discussed, and you can get even closer. The large front elements on most long telephotos prevent use of a close-up lens, but you can use extension tubes and tele-extenders. Just keep in mind that you'll need to hold the camera extra steady, or use a very fast shutter speed to eliminate the camera motion that can blur a picture taken with a long telephoto lens.

With some very long telephoto lenses, it is possible to focus tight enough to achieve what amounts to a "telephoto close-up," as seen in these two photos. They were both taken with a 300mm lens using a 1.4x tele-extender. The soft focus effect used on the old car grill was added later in the computer.

MAKING YOUR CHOICE

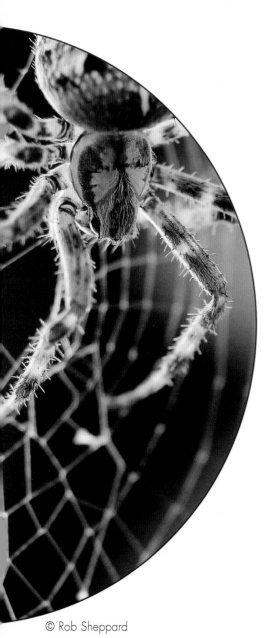

© Rob Sheppard

As noted earlier, you should choose a camera, lenses, and accessories based on your needs and budget. Consequently, the best first step is to identify the subjects and approximate magnifications you will be working with. Hopefully, some of the points covered in this chapter will help you to narrow down the equipment choices. Thereafter, a good search of test reports and articles should help you to make final choices that are within your budget.

There is a host of specialized equipment that is very useful for the more advanced forms of close-up photography, available primarily from small independent manufacturers. There are amazing lines of special brackets and other adaptations, many of which are useful for the close-up photographer, including everything from adjustable flash brackets to tripod ball heads and various quick release plates. I would also suggest doing a, Internet search for "macro photography" to bring up

the various sites that deal with this specialty. You should find plenty of information on equipment choices, including test reports, as well as chat rooms where you can get your questions answered.

As you become more involved in close-up work there may be a need to use specialized accessories such as flash brackets and quick release units. Two popular resources for such specialized equipment are Kirk Enterprises and Really Right Stuff. In addition to a range of "off the shelf" equipment, these companies will also often make a custom accessory for you, or modify one of their existing products to meet your needs.

If you plan on doing higher magnification work, consider using a focusing rail such as the lightweight model shown here (image A). These devices allow you to change the subject-to-camera distance by simply rotating a knob. This is a lot more convenient that repositioning a camera and tripod. In my studio, I use a larger multi-level focusing rail that gives me very refined control in extreme close-ups situations (image B).

BUGS! The Close-Up Photography of Rob Sheppard

Portrait © Rob Sheppard

© Rob Sheppard

many readers know the writings and photos of Rob Sheppard. Not only is he the editor of *Outdoor Photographer* and *PCPhoto magazines*, but he also wrote the best selling Lark Books publication, *Epson Complete Guide to Digital Printing*. Rob's background includes work as a naturalist, photojournalist, and commercial photographer. His personal photography encompasses a range of subjects, but he especially likes to photograph small insects using compact digital cameras. As you can see from the outstanding images in this section, his work combines attractive backgrounds with expressive angles that result in eye-catching portraits of these tiny subjects. I asked Rob to share some of his techniques for capturing these notoriously illusive subjects.

Q & A WITH ROB SHEPPARD

Q: How long have you been photographing insects, and why did you select them as subjects?

A: I've been fascinated with "bugs" for a very long time. Photographing them is almost like entering a science-fiction world with alien life. I love their shapes and forms; there is such an amazing variety in them. I love to photograph different types of insects wherever I go. They make great subjects—I've found terrific bug "models" from Minnesota to Peru.

But, if just the form and color of bugs interested me, I would probably set them down on a plain background and shoot with flash. Insects, to me, truly show a different view of life on our planet, on a scale that most of us don't normally see. They are very common, yet commonly overlooked. So I try

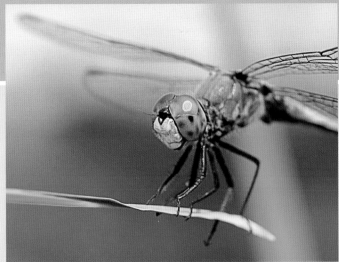

© Rob Sheppard

© Rob Sheppard

© Rob Sheppard

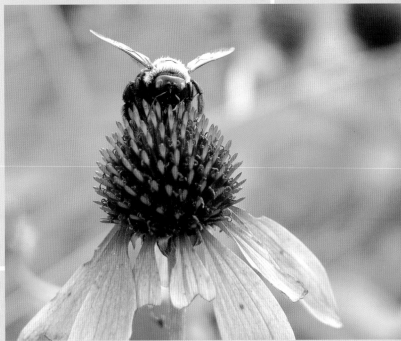

© Rob Sheppard

© Rob Sheppard

© Rob Sheppard

to go beyond a simple close-up that emphasizes only their looks. I want to show the animals in their habitat, in natural conditions, and respect them as living creatures sharing our planet. For me, a good insect photograph is not simply a "gee-whiz, look at the unusual critter" thing, but goes beyond that to show off an interesting form of life interacting with its environment.

Q: What equipment do you generally use and what have you found to be the most effective techniques?

A: I shot film for years, using an SLR and a macro lens, plus other lenses with extension tubes. I still use that type of equipment in digital, but I have found that the small, advanced compact digital cameras (also called advanced digital zoom cameras) have really expanded my close-up capabilities, and I use them for most of this work now. Some people call such cameras "point-and-shoots," but that's not right. Advanced compact digital cameras are very

© Rob Sheppard

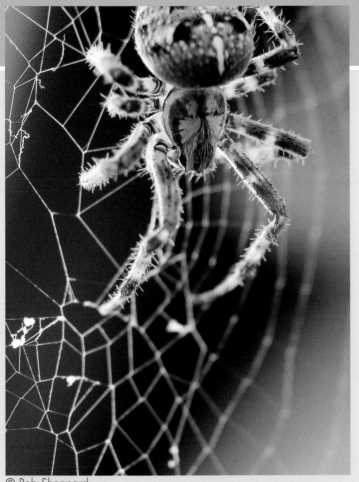

© Rob Sheppard

© Rob Sheppard

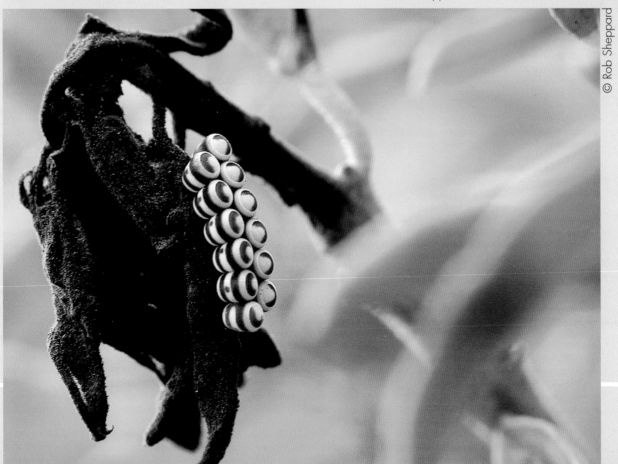

© Rob Sheppard

capable; they have most of the controls of a digital SLR, but they just can't change lenses.. These little cameras offer two excellent features that are unavailable on a digital SLR and help significantly with my close-up work photographing insects (and other subjects, too): the flip-out, rotating, live LCD monitor and the short focal length of the lenses. First, the advantages of an articulating, live LCD monitor are huge. The "live" part allows me to see on the monitor exactly what the lens is seeing. The articulating screen feature lets me position the camera in lots of places, then rotate the LCD monitor so I can comfortably see what the lens is capturing. I can put the camera low, high, even into bushes. I can get it into places that a larger camera could not go, plus I can get it low without me lying on the ground.

In addition, I don't have to put my head into the area being photographed, which means insects are less likely to be spooked. I've actually been able to photograph dragonflies sitting on a leaf by slowly approaching with the camera held out from my body. Admittedly, this can cause two problems—seeing the LCD monitor clearly and camera movement. I solve the latter with faster shutter speeds (even if I have to shoot at wider apertures). The first is harder to compensate for, but three things help: practice (you can learn to see the screen better), changing the angle of the monitor, and using an LCD hood.

The short focal length of the lenses refers to the actual focal length of the optics in millimeters. Most of these cameras will have a 35mm equivalent focal length given, which is very helpful for comparing angle of view, but this is not the real focal length. For example, you might find a lens with a 35mm film equivalent of 35-140mm, yet the real focal length is only 7-28mm. Such a lens is short in physical size and focal length.

These short focal lengths mean two things: easily built-in close-up capability and more depth of field. Most of these cameras will focus down to inches without any accessory lenses (although I usually use an accessory lens, as I will explain in a moment).

When actual focal lengths are 7-28mm, depth of field is quite high and a real benefit for close-up work.

I do like using achromatic close-up lenses with this work. Most advanced compact digital cameras have adapters that allow for the use of close-up lenses. Cheap close-up lenses, which look like filters, are not very sharp. Achromatic close-up lenses on the other hand, like those from Century Optics, Canon, Nikon and Hoya, are quite sharp and work very well. They make your camera's zoom lens into a zoom macro lens. These add-on achromatic lenses enable you to get within inches of your subject even with the camera zoomed to its maximum telephoto settings.

Built-in close-up mode settings for these cameras work best at wide-angle focal lengths and usually don't get you close enough for bug photos. Telephoto close-up capability is really important for insect photography, as it allows you to keep a little more distance between you and the subject.

I also find that manual focus settings are very helpful. Often up close, the camera's autofocus mechanism won't find the right spot to focus on, and you'll end up with the wrong parts of the insect being sharp. By using manual focus, I can lock focus to a certain point, then move the camera in and out until the insect is sharp. This isn't always easy, so I will take many photos, then check focus by reviewing the image on my LCD monitor (a real advantage to digital) before the insect moves away, if I can.

Q: What advice would you give readers who photograph insects?

A: The techniques I mentioned in my earlier answers—such as employing telephoto focal lengths with close-focusing capabilities, using manual focus, and carefully moving the camera close to the insect—are very important. Photographically, I think

it is important to look for light that shows off the insect. A digital camera really helps in the search for perfect lighting because, thanks to the LCD monitor, you can see immediately if you have harsh highlights and shadows, if the colors are off, or if exposure is a problem.

Always try to focus on the eyes. This is just like portraiture. Sharp eyes will make everything in the photo look better, but if the key sharpness misses the eyes, the subject will never look its best. This is why I typically take multiple photos of even a motionless insect just to be sure I got the focus right.

Photographing in the morning will often help because insects move more slowly in the cool temperatures. Dew also slows them down. But even active insects can be photographed with patience and perseverance. Keep slowly, gently following the subject, watch where it moves and move with it. Take lots of pictures. As I mentioned earlier, this is such a great advantage to shooting digitally—you won't waste any film!

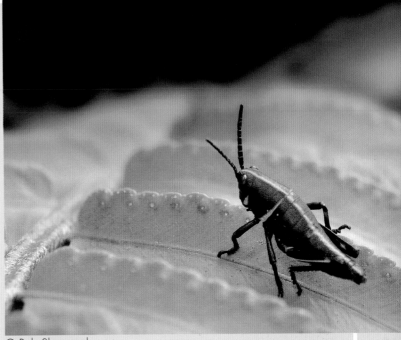

© Rob Sheppard

Avoid towering over insects so that you are silhouetted against the sky—that will frighten most of them. Also, be careful of hitting branches that will telegraph your approach and make the insect disappear. If you find your subject moves to the other side of a flower or branch, put your hand behind it, wave your hand gently, and the bug will often come back into view.

Insect photography can be fun and challenging, as much as any wildlife photography. Your heart beats faster as you photograph among flower-hopping bumblebees, you sense a joy in flight when chasing dragonflies, and every time you capture an interesting shot, you see and appreciate an important part of our world.

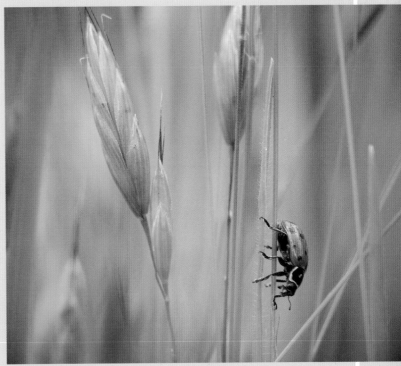

© Rob Sheppard

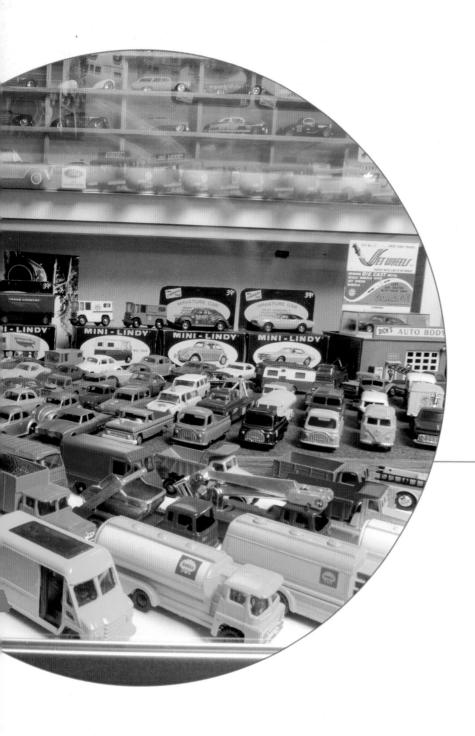

3 LIGHTING BASICS FOR CLOSE-UP PHOTOGRAPHY

A dark alley, an abandoned warehouse, a basement... the light goes out, a door slams, and screams erupt throughout the theater. The stage for another terrifying movie has been set. Light, or its absence, has always played a major role in the rhythms and activities of our lives. In setting the stage for photographers, light reigns supreme. And sometimes the presence of the wrong light leads to a terrifying picture and screams of frustration—from a photographic perspective, that is. Other times, the right light shines, and from it a wonderful picture emerges.

You might say that Thomas Edison is the forerunner of photographic light. He brought us into the modern world by making an electric lamp that pushed back the darkness, extending daily lives and ultimately leading to Harold Edgerton's invention of the electronic flash. You might also suggest that Ansel Adams is the forefather of manipulating light. He waited for the right qualities of light, manipulated those qualities before

they reached the film, further manipulated them as he developed the film, and manipulated them even more as he made prints.

Edison, in inventing light, and Adams in manipulating it, share the same traits: passion and perseverance. It took Edison over 3000 tries to find a material (carbon filament) and bulb combination that would consistently and lastingly glow when electricity was applied to it. Adams was renowned for spending days at a location (one could even says years, as he revisited some scenes over and over) to get the light that would reveal his vision.

The word "photography" itself derives from Greek words meaning "writing with light." Many writers achieve excellence by revising their work not once, not twice, not three or four times, but repeatedly until everything reads just right. And so it is for us light-writers. Success comes from knowing our equipment, choosing the right subject, and refining our artistic aesthetic. But radiating above

it all is the passion to reveal our subjects in all their glorious and wondrous details. Or, getting back down to earth, to show the mint condition of that Shirley Temple doll you plan to sell online. Whether you are passionate or practical, getting the right light is critical.

Creating, manipulating, or finding the right light requires an understanding of the photographic accessories that can alter light, and of the qualities of light that impart the effects—poetic or practical—that you desire. Let's first review the characteristics of light and light modifiers and how they can affect a close-up subject. Then, let's take a look at how the controls and inner workings of a digital camera interact with the characteristics of light.

THE PHOTOGRAPHIC QUALITIES OF LIGHT

Light strikes a scene, say a beach crowded with weekend sunbathers, reflects from the towels, umbrella, water, bodies, and sand, and reaches your camera where it enters the lens and is focused onto the digital sensor. Most commonly, reflected light originates from the sun. But it could also come from an electronic flash, a studio lighting setup, a candle, a campfire, or a lamp in your living room. Each of these sources of light has a set of physical qualities that singularly, or in combination, produce a particular "look." For example, if you photograph your two-year-old daughter sleeping with her head on your wife's shoulder, that the picture would look very differently photographed outdoors at noon versus by the setting sun, beside a candle, or with an electronic flash. The qualities of light affecting the appearance of your pictures fall into four categories: intensity, color content, contrast range, and light direction.

Intensity

The intensity, or brightness of light, derives from the power of the light source and dictates the aperture, shutter speed, and ISO settings you'll need to use for a correct exposure. Because of the various effects of different subject surfaces, the original intensity of the light source is significantly lowered by the time it reaches the camera. For example, most surfaces are irregular rather than smooth, causing the light to scatter in different directions so that only a portion of the original light intensity actually reaches the camera. Gray and black surfaces also absorb some light. The result of all this is a reduction in the intensity of the light by the time it finally reaches your camera. The aperture, shutter speed, and ISO settings then control the depth of field and how any motion will be dealt with, respectively.

The Inverse Square Law

The amount of light from a source decreases over distance following the Inverse Square Law, which states that "intensity is inversely proportional to the square of the distance." In essence, this means that light gets dim fast the further you move from the source.

As far as you're concerned, it applies only for artificial lighting, which is near the subject and can be moved over real distances. Unless you're a planet hopper, going from Mercury to Venus to Earth to Mars, you'll not see any falloff of light from the sun since it's 96 million miles away.

When using artificial light, however, you will indeed see the affects of light falloff according to the principles of the Inverse Square Law (see page 73). By moving your flash or tungsten light closer to the subject, you can take advantage of this principle to make the background darker. In short, how you position an artificial light lets you control the background illumination. Do you want it to be illuminated similarly to the subject? Then move the subject closer to the background and move the light further away. Want the background to be darker so the subject stands out? Then move the subject further away from the background and closer to the light.

Unlike irregular surfaces that scatter light, smooth and mirror-like surfaces mainly keep the light from scattering and thus produce extremely bright surface reflections. These shiny surfaces can be troublesome since their intensity records as an overexposed area. This is because a correct exposure is usually designed to properly record details and colors from the lower amount of light coming off of irregular surfaces. The extreme intensity of bright, smooth surfaces can "fool" light meters into giving incorrect exposures. Jewelry, silverware, eyeglasses, small electronic devices, plastic toys, coins, sweaty foreheads, dewdrops, and a variety of other smooth, reflective subjects pose both a problem in attaining correct exposure as well as in avoiding distracting reflections that steal attention from the subject. To deal with this problem, enlarge the size of the reflection causing its intensity to be lowered as it spreads out over a wider area of the subject's surface.

Light sources can easily be made larger by using light modifiers such as umbrellas, soft boxes, and diffusion screens. All of these devices have a much larger light field. This, in turn, produces a larger reflection with less intensity than a small light source, such as a built-in camera flash (which produces smaller reflections with much more intensity). You can also use a larger light source to begin with such as a bank of fluorescent lights.

There are actually two forms of bright reflections from smooth surfaces: glare and direct reflections. Glare occurs when a source light strikes a smooth surface and becomes polarized. A direct reflection (also known as a secular reflection), on the other hand, does not produce polarized light. Rather, it is a mirror-like reflection of the source that is almost as bright as the source itself. Photographers often employ a polarizing filter to mitigate or remove glare (such as glare from windows)

but these filters have no effect on direct reflections coming from bare, smooth metal surfaces. So if you are photographing polished metal jewelry, a polarizing filter will not be of any help. As I am about to explain, these reflections have to be controlled by using larger, even, "wrap around" light sources.

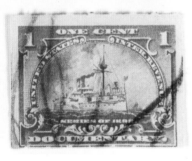

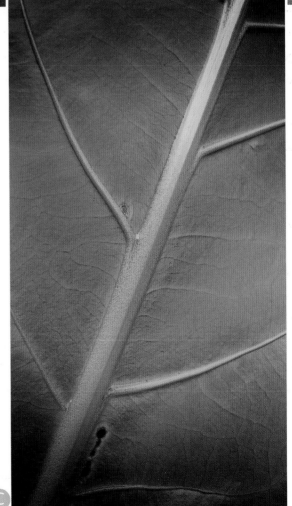

The surface of a subject determines how much of the source light will be reflected, as well as the intensity of the reflected light that reaches the camera. The exhaust pipes and other bare metal chrome parts (image A) reflect virtually all of the light that strikes them; this is an example of direct reflection. On the other hand, the irregular surface of postage stamps photographed on a copy stand (image B) scatters the light in all directions with no secular reflections. The leaf in image C also has an irregular surface that scatters the light, but some small glare reflection can be seen coming off of the semi-smooth upper stem.

Measuring light intensity is easy and requires little effort from you. Light meters have been built into cameras since the days of disco, are probably even more entertaining, and are definitely more enduring. You can use a handheld meter, but the meters that are built in to digital cameras, especially those found in D-SLRs, are quite sophisticated and offer options to handle most of your needs. Electronic chips with built-in programs enable these in-camera light meters to account for a variety of lighting and subject situations (and to adjust themselves accordingly if you use scene modes, such as Backlighting or Twilight). The whole point of a light meter is to enable you or the camera to set the shutter speed and aperture so that the correct amount of light (known as exposure) for a given ISO reaches the digital sensor. Too much or too little light will ruin the picture.

You can almost take light intensity as a given. Consider it like the road. It's simply there. What's important is how you navigate it. And in navigating light intensity, you can almost take it for granted that you'll achieve a good exposure. Almost. Although exposure can be a creative element, most of the time you will want to achieve an optimum exposure that reveals details in shadows and highlights, as well as recording the true color and tonality of the subject.

Be one with your piano. Be the ball. Artists and athletes alike acknowledge that making the instrument of their activity an extension of themselves is essential in achieving their highest accomplishments. Your medium is light, and your instrument may be the camera, but its soul is its digital sensor. While you may not become one with your sensor, understanding how it reacts to light may extend your photographic skills. A sensor responds to and records light linearly. An increase in light intensity results in a proportional and incremental increase in exposure density. A digital sensor charts the increasing intensity of light like a set of stairs— each increment in intensity being a tread on the steps.

Thus, the response "curve" for a digital sensor is a straight line, as if you laid a plank on the stairs that reached from the bottom to the top. This means that once the range (high or low) of the sensor is exceeded, no details will be recorded, and you will suddenly get "blown out highlights" that appear as white holes or "empty shadows" that appear as black holes. Film, on the other hand, only maintains a straight line response for part of the range of light it records (throughout its middle range). Then, in the shadow and highlight areas, there is a gradual reduction in the film's response. The result is that a film's response curve looks more like an "S," causing a more gradual falloff into shadow and highlight areas.

Photographers attuned to the tonality of their images may wonder why their digital pictures, unlike their film pictures, seem to abruptly plunge from dark gray into black or leap from light gray into bright white. Those with a less critical eye may not notice the tonality differences between film and digital pictures, but regardless of whether your eye is critical enough to see them, when you make a digital exposure, avoid over-

exposing the highlight areas. For truly critical images, use the RAW file format so you can take advantage of its extended 14-bit tonal response. This greater bit depth shortens the steps of your linear "stairway," lessening the abruptness of tonal falloff at the dark and light ends of your pictures.

Color Content

Light brims with color, even when it seems colorless. A spectral stew, white or "neutral" light bubbles with all the colors of the spectrum. Isaac Newton proved this. His prism experiment remains a classic textbook science lesson, frequently recreated by nature through rainbows, and by the late day sun striking my aquarium next to the window. Technically, the color of light is determined by the presence of different wavelengths within the light's energy spectrum. The main photographic light sources (sunlight, electronic flash, and photographic rated tungsten lamps) consist of three primary wavelengths that the human sensory system perceives as red, green, and blue. Together, these are called the "RGB additive primaries." This is because all other colors in light result from mixing together different proportions of these wavelengths. When all three wavelengths exist in equal amounts, the light appears neutral and is called "white light." If a light source with these equal proportions were aimed at a pure white wall, that wall would appear white to the average observer. It would also be recorded as such by a digital camera balanced for white light capture.

When the amounts of red, green, and blue wavelengths vary, the light shows some color. Many shifts in the color of light will escape your notice because your brain functions like it has an automatic white balance mode. Your camera, however, can capture these subtle color shifts. When you're in the shade on a sunny day, the light coming from the blue sky has more blue wavelengths than green and red, tingeing subjects with an extra shade of blue. Even to the naked eye (but more so to your camera), household tungsten lights overflow with red wavelengths. Most fluorescent lamps color their subjects with extra green.

The actual appearance of color in a subject is determined by which wavelengths are reflected and which are absorbed by the subject's surface. The general rule here is that a subject will reflect its own color or colors while absorbing all others. Hence, a red flower is the result of the red pigments in the flower absorbing blue and green wavelengths while reflecting red ones. A pure white surface, on the other hand, reflects all colors equally as does a pure gray surface. The difference between the two is that a gray surface will also absorb some RGB wavelengths. The deeper the shade of the gray, the more RGB light is absorbed. A pure black surface then absorbs all wavelengths of light.

The warm, cool, and neutral values of an RGB light source are often expressed in photography by using the mathematical values for the Kelvin temperature of the light. As the Kelvin temperature increases, the relative proportion of red to blue shifts towards the "cooler" blue wavelengths. For example, a clear blue sky measures at about 10,000 Kelvin (10,000K), whereas the "warmer," redder light at the end of a sunset is around 2000K, and average household tungsten lighting is around 2,400—2,800K. A neutral light source (where there are even amounts of RGB wavelengths) measures at around 5500K-5600K—this is approximately where direct midday sunlight is rated. In order to properly record a subject's colors, the white balance setting of your digital camera has to be set to match the color content of the light. Otherwise, there will be an undesirable colorcast that shows up particularly in neutral white and gray areas.

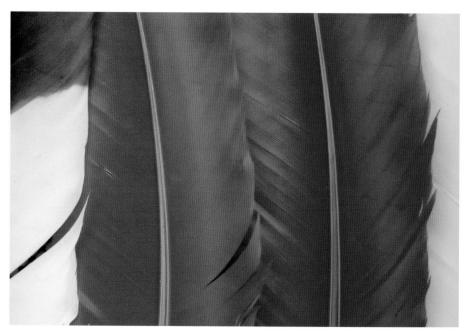

Colored surfaces will reflect wavelengths of their own colors while absorbing all other colors. Gray and white surfaces reflect all wavelengths equally, with the gray surface reflecting less light. Black surfaces absorb all light. The appearance of colors and monochromes in each of the feathers in the photo above is a consequence of this basic reflection/absorption principle.

Contrast Range

Snap. Punch. Flat. Dead. Photographers use terms like these to describe a picture's contrast—i.e., its range of tonality. Pictures with good contrast have snap and punch. Those with little contrast appear flat or dead. The scene itself has an inherent contrast based on the light illuminating it. Photographers typically divide a scene into three main light values that, together, represent the contrast range of that scene: shadow areas with details (not pitch black), midtone areas with full color values, and highlight areas with detail (not pure white). Each of these three light value categories plays a critical role in the look of a subject. The middle tone areas contain the key information about the color of the subject. Shadow areas extend the range of contrast at the low end by building in a sense of depth and dimension, as well as helping to define shapes and textures. Highlights extend the con-

Different light sources will often have different proportions of red, green, and blue wavelengths. This will render colors differently unless the digital camera's white balance is adjusted accordingly. For example, the top left rendering of a Macbeth ColorChecker test chart was taken using a strobe in a soft box with the camera's white balance set for flash to produce a good color rendering and a neutral grayscale. Keeping the camera's white balance set for flash, the test chart on bottom left was shot using tungsten modeling light, the top right was taken outside on an overcast day, and the bottom right was taken under commercial florescent light. Besides the shifts in colors, the varying light sources with their different Kelvin temperatures produced cool, warm, or green colorcasts.

trast range at the high end, further defining shapes and adding accent areas as with specular reflections. Ideally, a correct exposure will capture a range of shadows and highlights with details, while correctly recording all colors, especially those in the middle value areas.

Unfortunately in the real world, not all scenes will have a range of lighting contrast that is so ideal and that can match up favorably with the contrast range that the camera is capable of recording. For example, a close up of a figurine on a gray overcast day will produce a rather flat rendering in which colors seem dull and dimensionless. Much of this is due to the lack of any distinct shadow areas or bright highlight reflections to help define shape, texture, and depth. By the same token direct sunlight typically produces very dark shadow areas that lack detail, and burned out highlight reflections in smooth areas. While colors will appear vibrant, the overexposed areas will also deprive the picture of some of the color information. A close-up digital photographer needs to consider how much contrast is present in the scene and how it can be modified, if necessary.

White Balance, Color Correction, and RAW Files

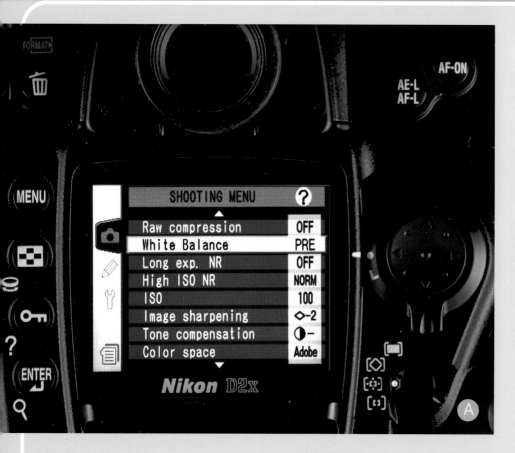

D igital photography lets you adjust color both before and after you take a picture. You can make the adjustments for creative purposes ("Wouldn't that lighthouse photographed during a midday lunchtime picnic look great if it caught the orange cast of a setting sun?"), or for capturing precise color ("Shouldn't that pink blouse be a bit redder?"). The most effec-tive way to control color in your image is to adjust the way color is recorded using your camera's white balance function.

The white balance function is roughly the digital equivalent of using color-balancing filters to match the color balance of a light source to the color balance of the film. Typically, there is a choice of different white balance settings for different light sources that are set by using the camera's menu (see images A and B). Even the most basic digital camera will have sever-al different preset white balance settings to match various light sources with different Kelvin tem-perature ratings. For example, your camera may have settings such as Sunlight, Shade, Cloudy, and so forth. In addition, the camera can be set to Auto white balance, which is designed to continually adjust the camera to the color of the light source in a given scene.

Higher-end digital cameras may also offer additional options for controlling color temperature, including dialing in a specific Kelvin temperature (image C) or using the camera's custom white balance function. Custom white bal-ance allows you to simply aim the camera at a gray or white card illu-minated by the light source and set

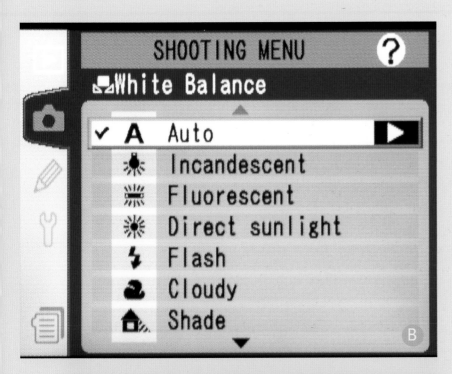

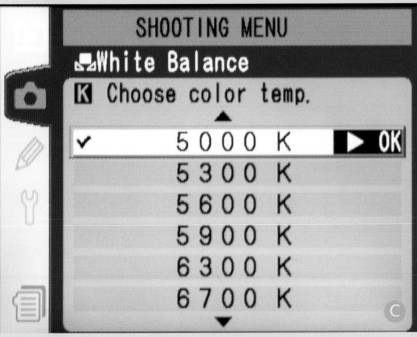

the white balance for that particular type of lighting. Your camera's software reads the colors being reflected from the card and adjusts the camera to compensate so subjects will appear as if they were photographed in white (neutral) light. (Consult your camera manual for the specific procedure for creating a custom white balance setting). While the Auto white balance setting is convenient, taking a custom reading will provide an even more accurate color balance when the light source remains constant. Many photographers, however, will use the Auto setting and then make whatever adjustments are needed later in the computer. Keep in mind, though, that when precision is required, using Auto white balance and making color adjustments later with image-processing software is less accurate than getting the color right straight from the camera.

Another option for controlling the color balance between the light source and the camera is to use the RAW file format to adjust the Kelvin temperature after a picture is taken. Unlike other formats such as JPEG, RAW files can be thought of as a "digital negative" that records the original light values as they were. Other formats will process the color information as part of forming a specific image file to save to your memory card. RAW files, however, allow the photographer to go back and make very specific adjustments in the Kelvin temperature of the original capture.

These changes should then be saved in another format, such as TIFF or JPEG, allowing the original RAW format file to be kept for future use. RAW also permits adjustments in exposure, shadow density, brightness, saturation, tint, and other settings. These changes can be made using the camera man-

ufacturer's RAW file reader software. There are also very good third party RAW file software programs, but be sure that any program you buy is capable of working with your camera manufacturer's proprietary form of RAW file (such as Canon's CRW files or Nikon's NEF files). Images D, E, and F were produced using the RAW file read-

er in Adobe Photoshop CS; they demonstrate how the color temperature of a captured image can be adjusted. In this particular program, changes are made using the temperature slider in the White Balance box on the right-hand side of the screen.

The RAW format also enables some very important means of controlling the final image beyond just

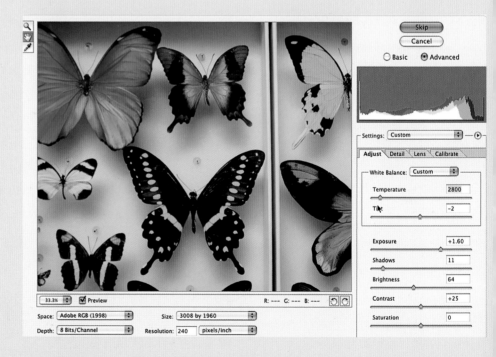

adjusting the color content. Unfortunately, not every digital camera can record in RAW. All D-SLRs have the capability to record RAW files, as do many of the higher-end advanced compact digital cameras. I always look for this feature when considering a particular digital camera. The good news is that more and more of the latest compact models are coming out with RAW file format capability.

Finding the Right Light

The type of lighting used to photograph a subject is critical to the way that subject will appear, as seen in this flower sequence, all taken with an advanced compact digital camera in close-up mode. Image A was taken at 11:00 A.M. on a sunny day, and the light produced harsh shadows and over-exposed highlights. Image B was taken about 30 minutes after sunrise (before the lawn sprinkler droplets had evaporated), and this light produced shadow and highlights areas within the recording range of the camera. There is also a better rendering of the shapes of the flower petals— good texture reproduction with a sense of three-dimensionality because of the sun's low angle. Image C was taken at 2:00 P.M. on cloudy day, which produced a flat picture that lacks dimensionality; there are no distinctive highlights and shadows.

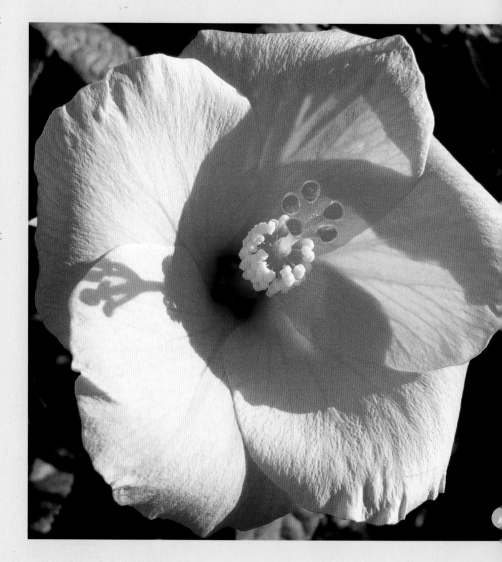

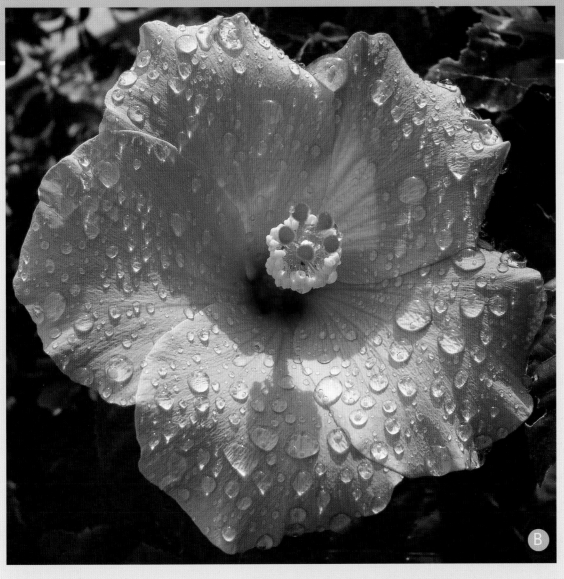

Controlling Contrast

Contrast is controlled primarily by the size of a light source and the direction of the light relative to the subject. You can also reduce contrast by lightening shadows with a fill light. Understanding these basic principles and applying them will make a major difference in the way you use either natural or artificial light.

In general, as a light source gets larger relative to the size of a subject, contrast decreases—the shadow edges and density become less distinct. In addition, the highlights become larger and more diffused at the edges, as well as less intense. Conversely, smaller light sources increase contrast; they produce dark, hard-edged shadows and smaller but very bright specular highlights.

The size of the light is relative. You won't deal with a light source larger than the sun—its diameter is 865,000 miles. But since it is just a small disk in the sky, it is actually a small light source producing high contrast with strong shadows. In close-up work, you'll deal with many light sources that are larger than the

sun relative to the subject, or through the use of light modifiers, convert the sun into a larger source. The "effective size" of a light source refers to the size of the light relative to the subject you are photographing. This really comes down to the size of the field of light that actually reaches the subject. The field is controlled by how close the light source is placed to the subject. The closer the light source, the more area of the light field from the source that is likely to fall on the subject. Thus, the closer you get to the subject, the larger the relative size of the light source. As the source is moved away, more and more of the light spreads out and misses the subject. This also produces larger shadow areas around the subject. Consequently, the proportional amount of the total light field now hitting the subject is much smaller. This has effectively made the light source smaller relative to the size of the subject. It also means a loss in light intensity according to the Inverse Square Law (see page 73), requiring an adjustment in exposure as compared to when the light was placed close to the subject.

Photographers classify the contrast of a light source into three general categories: "hard light," which has dark, sharp-edged shadow areas with strong secular highlights, "soft light," which has very low-density, graduated light shadow areas with diffused highlights, and "medium light," which has shadows of medium density with graduated edges and larger, medium-intensity highlight areas. There are also the terms "flat light" and "shadowless light," which are used to describe a situation in which there are virtually no shadows and very low contrast. The important thing to note is that you can control the amount of contrast for the look you want.

Want to take total control of the contrast situation? You can in the studio. Armed with artificial lighting equipment, the studio close-up photographer can create any range of contrast. To create high contrast, you would use a bare, uncovered strobe or tungsten halogen bulb. If you desire, you can spotlight your subject like one of the Wallendas walking the high wire.

To soften the contrast, you simply add a light modifier, such as an umbrella, a diffusion screen, or a soft box. Each effectively enlarges the light—the umbrella by reflection, the soft box by diffusion. The larger the light modifier, the greater the diffusion or reflection surface. Light boxes range in size from bread boxes to small tents. In all cases, the source starts out small and then as a result of the scattering action of these light modifiers, winds up much larger as it spreads out and radiates from the larger surface area of the light modifier fabrics.

Outdoors, with the sun as your source, your controls are patience and timing. Like an enormous soft box, cloudy days provide great diffusion and soft light. Partly cloudy days give you the choice of waiting for a cloud to cover the sun or to shoot with a bare bulb—direct sunlight that is. The same basic principles are at work. That is, start with a small and powerful source, the sun, and then rely on the presence of atmospheric conditions such as thin or thick clouds and haze as light modifiers. For close-up work, you can also use diffusion materials, reflectors, or a flash unit anytime to alter the contrast of the light. The diffuser will increase the size of the light to soften the shadow and highlights while a reflector will raise the light level in shadow areas. (See page 88 for information about light direction.)

The most popular studio light source today is the electronic strobe, typically used with umbrellas or soft box light modifiers.

Photo courtesy of the Alien Bees Division of Paul C. Buff, Inc.

Light Direction

Perhaps no factor will affect the appearance of your close-up subjects more than light direction. And the power of light direction emanates from the simplest of phenomena—the shadow. In close-up work, shadows can wreak havoc or reveal wonders. You may normally think of shadows as hiding things, which they often do, but small, even shadows excel in revealing. They reveal texture, tell of depth, disclose dimension, and add touches of black that seem to ignite bordering colors. With elongated shadows cast by sidelight, sugar crystals become boulders, Abe Lincoln's face on a penny becomes a palpable bas relief.

To experiment with light direction, position yourself so that your light source aligns to the lens axis (i.e., front light that shines head-on to the subject); shadow formation will be minimal, falling, for the most part, out of sight behind the subject. Front lighting minimizes the texture, depth,

and dimension of subjects. Now, move the light away from the lens axis to the sides, top, or bottom of the subject; shadows will appear, stretching and shrinking with the severity of the lighting angle. In general, the more extreme the angle of the light to the front of the subject, the higher the contrast and the more pronounced the texture.

You can lighten shadow density with reflectors. The most convenient to use are the "pop-out" types that fold up into compact packages. Most reflectors will always bounce less light to the subject than what is hitting them from the main light. This is because they scatter a certain amount of the light. The exception is the metallic mirror-like surface reflector, which may reflect virtually all the light that hits it. You can also see the results of fill light from reflectors and, with a little practice, judge just how much you want to raise the level of the shadows. The closer the reflector is to the subject, the more light reach-

es the shadow. Remember, however, that reflectors are dependent on another characteristic of light. Namely, that "the angle of incidence equals the angle of reflection." So, you have to position the reflector at the proper angle to the light source. Otherwise, the reflector will not catch the light.

Since the size of the subject in a typical close-up setting is limited, small pop-out reflectors measuring about 5-10 inches (12.7-25.4 cm) across are all that are usually needed. I always carry at least one of these with a black surface on one side and silver white surface on the other in the side pocket of my camera bag. The silver is used to fill shadows and the gobo black is used to block light to increase shadows as in an overcast shadowless day. For tabletop photography, you can make miniature reflectors that will sit on the table right out of camera view, or you can buy a commercially made set.

SUMMING UP THE QUALITIES OF LIGHT AND THEIR INFLUENCES

Intense light sources give the photographer more latitude for controlling subject and camera movement because they provide a wider range of choices in shutter speed as well as depth of field. High levels of light also let you take pictures using lower ISO ratings to maximize image quality. The color quality of the light (Kelvin temperature) influences the accuracy of color rendering as well as whether or not the mood of the scene is warm, cool, or neutral. The level of contrast gives the subject a certain look (hard, medium, soft, flat) as well as determining what range of light (shadows, middle tones, highlights) in the scene falls within the latitude of the camera's recording sensor. Contrast levels also affect dimensionality. Direction will then control how textures will be recorded as well as influence the sense of dimensionality through the formation of shadow length. Finally, the level of recorded contrast can also be affected with some camera models that offer high/medium/low contrast settings as part of the way they record a scene.

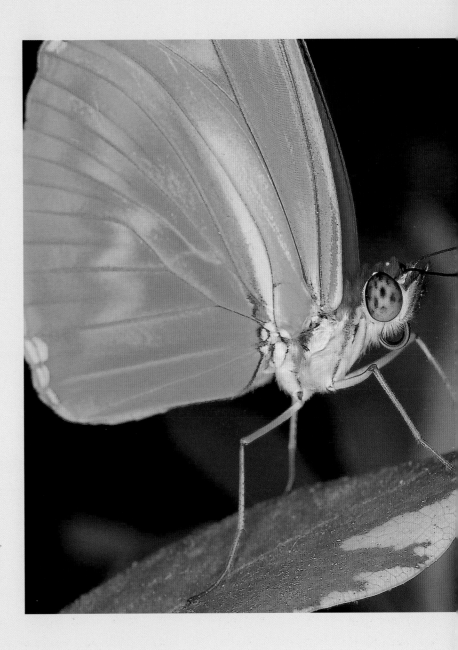

Reflectors and Diffusers

The two most useful light modifying tools a close-up photographer can use are reflectors and diffusers. Reflectors (image A) come in a wide variety of surfaces and are used primarily to brighten shadow areas so that more detail can be seen. Gobos are "negative reflectors" used to block light and build up contrast in flat light. The large umbrella portion of the figurine in image B causes shadows to form over the boy and girl on a bright sunny day. Using a silver/white reflector added fill-in light for a better picture. Lumiquest makes a set of table-top sized freestanding reflectors that are very convenient to use (image C).

Diffusers enlarge the effective size of a light source by scattering the light through its surface area (image D). In this example (image E), the harsh contrast of direct sunlight is reduced by the action of a diffusion panel held just over the subjects.

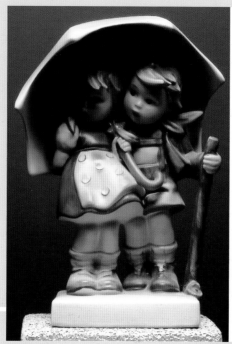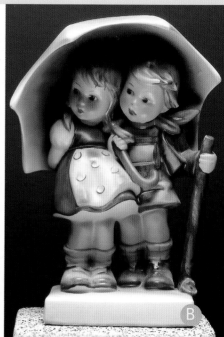

C

D

E

Documenting a
Collection of Miniature Box Cars

P opular Boston radio personality Joe Cortese (image A) began collecting miniature toy cars as a young boy. Specializing in the Matchbox Series, his total collection of all types of miniature toy cars now exceeds 6,000. Joe has always liked to display his whole collection and, over the years, has acquired a number of display cases and enclosed shelves housed in a single room. It is quite impressive to walk into his "collection room" and see virtually every car, truck, bus, motorcycle and their associated accessories, such as miniature gas

stations, all with their original boxes. Unfortunately, the highly reflective surfaces of the display cases preclude using flash (image B). Even without flash, these surfaces will act as mirrors as seen in image C. Also, the tight space of a display case with many cars bunched together means it will be difficult to isolate and detail a single item in the collection.

On the other hand, like most collectors, Joe has installed good lighting to show off his collection. He uses ceiling florescent lights that evenly illuminate the room. He also accents special areas of the collection with tungsten spotlights. The drawbacks are the typical green spike in the color spectrum of florescent along with the varying

Kelvin temperatures of florescent and tungsten lighting as, well as the rather low intensity of florescent tubes. Here's how I dealt with the problems associated with photographing the miniature car collection of Joe Cortese, using both a D-SLR with a 1.6x focal length magnification factor as well as a compact digital camera.

I first photographed as much of the collection as possible by turning off the tungsten spotlights and using only the available florescent light. The exception was in the picture of Joe Cortese (image A) in which the tungsten spots were used on him as accent light. The white balance of my digital SLR was set for florescent light and a tripod was used to prevent camera shake, espe-

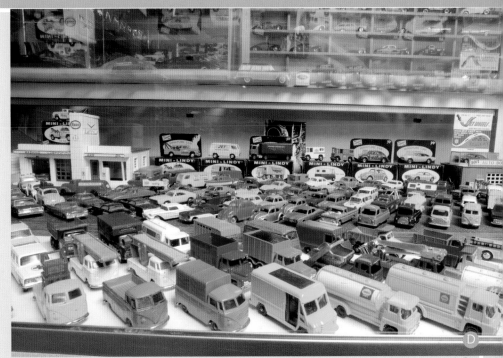

cially since I often had to use very small aperture openings such as f/16 and f/22 for maximum depth of field. Later, in the computer, I used Color Mechanic Pro to correct for any colorcasts that may have been present. Because of the reflective characteristics of the display cases, I used a wide-angle lens held very close to the glass. This meant that the camera would "see" very little of the glass front of the case reducing the possibility of recording any reflections. In addition, the effect of the wide-angle lens on the composition gave a more dramatic impression when the idea was to record a whole group of cars. So, here was a case where the use of a wide lens close-up worked for the composition. That is, the foreground was

exaggerated emphasizing leading lines into the background, as seen in image D. But, there was a bending effect on the lines in the field of view that typically happens when a wide-angle lens is used close up. I dealt with this problem by using Image Align correction software (image E) . This software allowed me to get rid of such the pincushion and barrel distortion effects, as seen in image F.

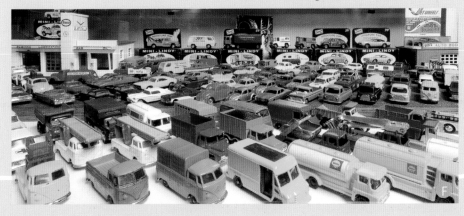

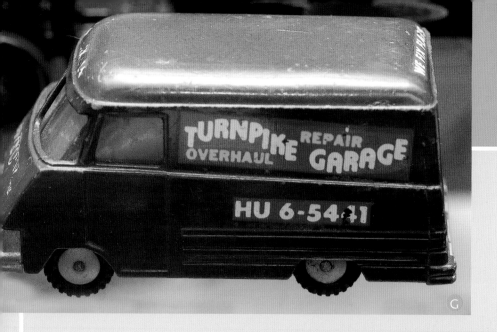

Once the larger group close-ups were done, I then tried to isolate a single car or small grouping of cars within a display case, again using the available florescent light. For this I used a 70-120mm macro zoom, although any zoom or single-focal-length lens that could focus close enough could have been used. An ISO sensitivity setting of 100 and shutter speeds as long as 1/2 second worked very well for all these available light shots. The shots I took using a compact digital camera (again on a tripod), also turned out nicely, as seen in image G.

Some of the cars in the collection were outside the display cases. That meant I could move around and use the camera handheld with a flash. Even though direct flash could be used, however, I opted for a bounce flash off the ceiling for two reasons. One was that the direct flash was more likely to increase the contrast levels, causing hard shadows and burned out highlights on these shiny metal surfaces. Also, the ceiling in the room was only about seven feet high (or about 2.13 meters), which meant that I would pick up quite a bit of light allowing for good levels of depth of field from a setting of f/8 or f/11 using an ISO setting of 400. This approach could only be done practically using

a D-SLR and a flash that could be directed at the ceiling. Setting the camera on TTL flash made for accurate exposures that needed very little adjustment later in the computer (see image H).

Even though I had used the available light to take the display case shots as described above, I also used a ceiling bounce flash for some display case shots. That is, I placed the lens as close to the glass as possible, sometimes and even touching the glass, while aiming the flash directly up at the ceiling. A black piece of cardboard was held against the front of the flash with a rubber band to prevent any light from hitting the front of the glass since this could cause a reflection into the camera. The ceiling bounce flash worked very well, covering the relatively small area of the close-ups and giving a complementary, even light with large subdued highlights and soft shadows, which is typical of a larger light source (see image I).

The last part of this project was to record certain subjects individually in a tabletop arrangement in order to show all views as well as smaller details, such as the writing on the side of a model truck. The lighting was a small soft box in a "lighting stall" using a graduated background with an ISO setting of 100 for maximum quality. This specific lighting arrangement is covered in the next chapter and the results can be seen in image J.

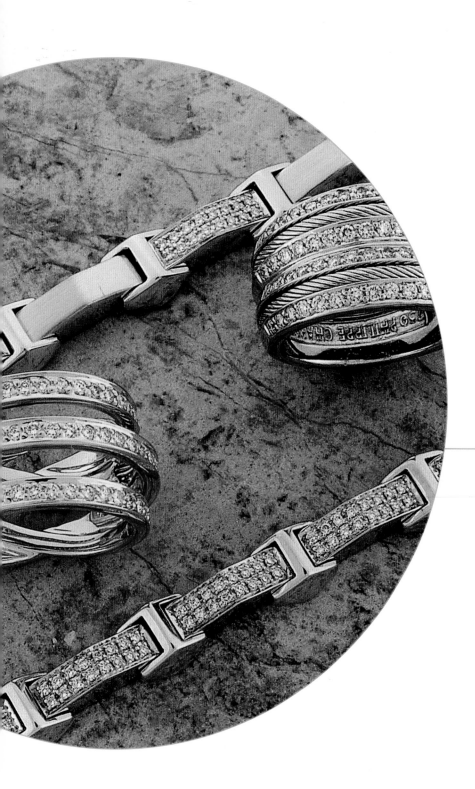

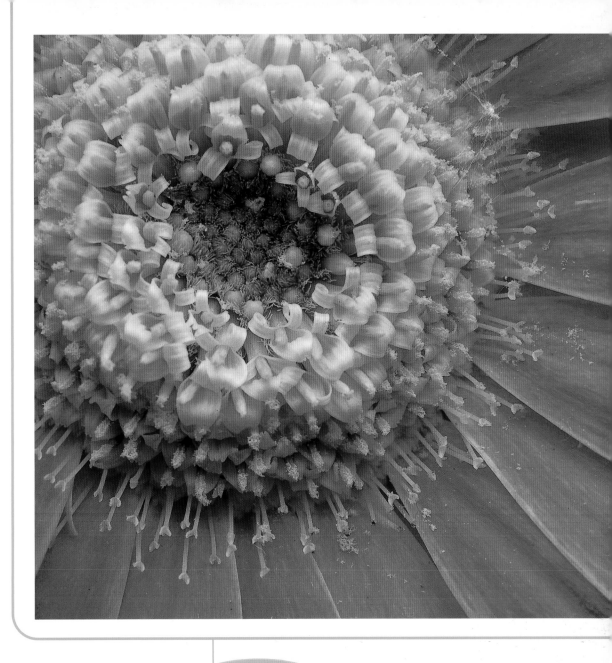

Natural Light: Setups 1 – 4

Technique. Tiger Woods has it. Coldplay has it. Yo-Yo Ma has it. Do you have it? Or maybe the question should be, does your technique further your vision? Poor technique can hamper even the greatest of talents. Once you've mastered the basic qualities of light and how they interact with your camera, you need to know how to use basic lighting techniques to display your subjects in a manner that matches your vision. This chapter covers ten close-up lighting arrangements for natural and artificial lighting. In each arrangement, the role of the four qualities of light will be noted where critical, as well as what types of subjects are best suited for the particular lighting arrangement. Don't hesitate to modify these suggested methods. Not only should you feel free to modify, experiment, or otherwise change the arrangements, you should take such liberties as a mandate to mastering your art.

Could there be a more powerful word than "natural?" Natural is an "in" word. From natural organic foods untouched by genetic manipulation and insecticides, to natural spring water, to natural fabrics, to natural skin care products—uncontaminated by the hand of man, natural is wholesome, healthy, and vital. And quite expensive.

But, the most natural substance of all is free: sunlight. It comes in a variety of forms, and is available outdoors and in all year long. Best of all, our whole being, especially our visual system, has evolved to respond to it. Reactions to it may be both instinctual and learned.

The downside is that you cannot directly control natural light. Unlike the three-way bulb in your desk lamp, the color, direction, and intensity of natural light won't easily yield to your commands. But you can control its contrast using diffusers and reflectors, as well as alter the recorded color range using the camera's White Balance function.

Although infinitely varied each and every day, natural light comes in two distinct forms: from the sun and from the sky. Bold, bright, harsh, overwhelming, but neutral in color, the midday sun scintillates as the single source of all natural light. But block the sun with clouds or a large object and the sky becomes the reflecting second source of natural light. Diffused, quiet, soft, withdrawing, and cool in color, skylight imparts a very different feeling to your pictures than does direct sunlight.

While most natural light subjects are photographed with frontal lighting, there are times when the subject can be positioned so that the light is behind it. In the case of a semi-transparent subject such as this flower, it will have the effect of diffusing the light as it passes through the subject, producing a soft rendering.

Lighting Setup
1: Direct Sunlight

Energetic. Vigorous. Light on steroids flexing its muscles. That's how the burning overhead midday sun often seems. Like a fair-skinned person who has yet to risk exposure to the summer sun, many photographers avoid it. Too much contrast. Too directional. Too opinionated. The harsh, direct light of the overhead sun can overwhelm subjects with large obscuring shadows and brilliant glaring highlights.

All true, but direct midday sunlight also paints colors as bright and vibrant. And since it's neutrally bal-anced, it reveals the true color of subjects. Whether you are photographing a sunflower or a painting of a sunflower, you'll achieve excellent color renderings. In addition, the strong contrast and directional nature of direct sunlight is excellent for recording textures. If you position the subject so light strikes it from the side, you'll emphasize its texture.

In the case of shiny art and three-dimensional subjects, you can reduce the high contrast with diffusers and reflectors. For example, holding a pop-out diffuser panel over the sub-ject will effectively enlarge the sun as a light source. This is a favorite technique of nature photographers working in the field. Another technique is to use a reflector to redirect light into the dark shadows to reveal the details within. Remember, however, that this will only lower the shadow contrast. Since you are not enlarging the light source itself, the level of contrast in the highlights will remain strong. I like to use a shooting stall (see Setup 6 on page 110) to lower the contrast of direct sunlight in a wind-protected environment.

Measuring natural light for a correct exposure can be done using either a handheld meter or the camera's built-in meter. The problem with using a handheld meter is that if you are using a macro lens, extension tubes, a tele-extender, or an extension bellows, there will be some light loss that the meter will not measure. Consequently, the better approach is to use the built-in TTL (through-the-lens) camera meter to read the light from a gray card held directly in front of the subject.

How do you get an accurate exposure in direct sunlight? By using an accessory called a gray card. Although most camera meters will give excellent results from meter readings of a normal scene, when you need precise, accurate exposure, use a gray card. Once you've arranged the composition, insert a gray card as close to the subject as possible and take a reading using the camera's meter in Manual mode. If the camera does not have a manual metering option, you can still meter from a gray card but you must lock in the readings—or note them and then set them on the camera. Many cameras let you use an AE Lock button to hold the readings from the gray card. Check your camera manual for details.

Since slipping a gray card—even a small one—into a close-up scene can be problematic, you may need to rely on the built-in camera meter's reading of the scene. Besides, how many butterflies will bravely hold their pose while you insert a gray card over their heads to take a meter reading? Today's in-camera metering systems are remarkably accurate, and if average tones predominate in your subject, you'll obtain a good exposure. You can also evaluate exposure by checking your camera's histogram on the LCD monitor. Or, you can shoot in the RAW file format so that you can adjust exposure by one or two stops later if need be. A third option is to bracket exposures by taking additional pictures at +1/2 stop, +1 stop and -1/2 stop, -1stop exposure settings.

As for what white balance setting to use when shooting in direct sunlight, the Daylight selection as well as custom white balance are both good choices, followed by Auto. I tend to shoot RAW files using Auto white balance with natural light if atmospheric conditions are prone to change, and then tweak the color temperature later in the RAW file software. If the light is consistent, I will often take a custom reading off of the white side of a gray card.

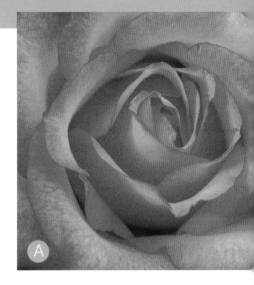

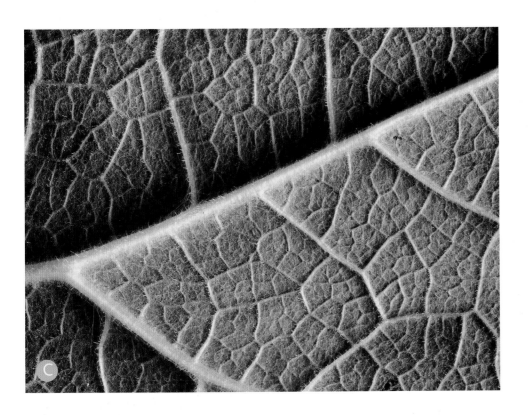

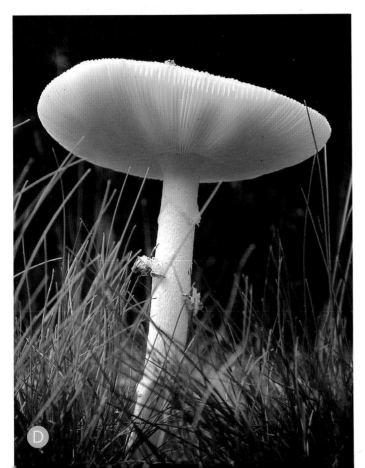

The contrast of natural light is controlled by atmospheric conditions. Bright overcast light and the light in shallow shade areas are characterized by shadow and highlight areas that fall well within the exposure range of a digital camera but with enough direction to produce shapes and contours (image A). On an overcast day with heavy clouds, contrast is greatly reduced so that even highly reflective surfaces have softer, less dense highlights as in the chrome motorcycle gas tank (image B). Notice the reflection of the clouds in the black areas. Bright overcast light, on the other hand, tends not to be very directional, but you can still pick up textures by turning the subject at an obtuse angle to the sky and using a gobo (black cardboard or fabric) to block any reflecting light from below, as seen with the veins of the leaf (image C). Small silver reflectors can help to add snap to the low contrast of an overcast day in the woods (image D).

Lighting Setup 2: Bright Overcast and Shallow Shade Areas—"Sweet Light"

Think of it as turning onto a newly paved highway, pushing your kayak onto a glassy lake, or spreading soft cheese onto a cracker. Think of it as the smooth, mellifluous tones of a classic composition... but in this case, it's light. Your light. More specifically, it's the even, bright light of a thinly overcast day. It's smooth, consistent, and reveals the glow of your most beautiful nature subjects.

It's the most favored outdoor light for photographers. It lacks the harsh contrast and deep shadows of bright sunlight. Instead, it offers a medium contrast level that reveals vibrancy while letting subtlety shine through. In the studio, its counterpart would be a two- or three-foot soft box used to create the smooth flattering skin tones in portraits.

As compared to the light in Setup 1, this light has less contrast but still enough to produce an excellent combination of moderate shadows and recordable highlights that give dimensionality to a subject. This light will also have good intensity to allow for plenty of depth of field as well as good color rendering.

Similar conditions are present in shallow shade areas that border direct sunlight. The light here is being reflected back into shade areas and producing some directional shadow effects. It is often tricky to find just the right shade area in which no direct sunlight is filtering through, as when standing under a tree at the edge of the tree's shade canopy. This sort of "shade light" will have a cooler color temperature as compared to the neutral temperature of direct sunlight.

Late and early daylight, within an hour or less of sunset and sunrise, offers you what's known as the "sweet light," or the "golden hour." Photographers treasure the quality of light at this time of day for its softness and flattering warmth. Unfortunately, it does not last long. Its fleeting conditions may make it more difficult to handle than an ice cream cone on a scorching day.

While it does last, these medium-light conditions are very easy to work with. Shadows flatter by gently sculpting features. Highlights define with a light burnish, like a lip-gloss that seduces without being sultry. No extra diffusion is required to subdue these highlights. In short, this is a

time to record well-defined forms and shapes without the danger of large shadows or burned out highlights obscuring areas of the scene. Colors are vibrant and the bright light lets you use smaller apertures and faster shutter speeds at low ISO settings. The only thing that may cause some concern is the color temperature changes as the sun rises or falls. The Auto and Daylight white balance settings are the best choices for this type of light, and Auto has the advantage of being able to adjust to the changes in color as atmospheric conditions alter.

This "sweet light" is also excellent for defining the subtle colors of flowers, foliage, and other natural subjects. Don't hesitate to take indoor objects outside to photograph them in this lovely light. You'll easily elicit the minute details of a toy car, a figurine, or antique needlepoint. This lighting excels for photographing any subject with an irregular or semi-smooth surface. Other good subjects include leaves, non-glossy or semi-gloss pottery, fabrics, stamps, documents, photographs, and paintings that have a semi-gloss surface.

Lighting Setup 3: Overcast or Deep Shade

Subdued, quiet, almost somber, overcast days and deep shade lack directional light sources and create very weak shadows. Contrast is low because the size of the light is literally the size of the whole sky. This is also a very cool light in which neutral white and gray areas will likely show a tinge of blue.

Unless colors are intrinsically strong, this light might render them dull. This is an ideal light, however, for photographing shiny, brightly colored, and highly reflective subjects such as gems, polished metal jewelry, silverware, shiny toys, and glass. Be prepared, though, for low intensity levels that require you to use slower shutter speeds or higher ISO settings if you plan to handhold the camera. Set the White Balance feature to the Cloudy (or similarly named) selection, or even Auto. If the level of overcast is unchanging, you might try taking a custom white balance reading, but be prepared to recalibrate if the light changes. In general, this is the least desirable of all natural light settings for the majority of close-up subjects.

The many forms of window light provide the close-up photographer with several choices. In image A, a large window on a sunny day spread indirect sunlight over a dessert table that was captured with a compact digital camera. For image B, a small window on an overcast day produced this very soft rendering.

Lighting Setup 4: Light from Windows and Skylights

Do you take the windows in your home for granted? Don't. I love the windows in my home, and consider every one a mini-lighting studio. Each has its own qualities that vary by time of day and season. If there is a classic lighting arrangement in photography, it's the north window. Almost since the inception of photography a century and a half ago, photographers exploited the soft, caressing lighting coming through their north-facing windows—or any window not admitting direct sunlight. Some of the most beautiful portraits taken by master photographers have been with window light.

There are basically three types of window light: (1) direct sunlight, in which the sun is shining directly into the room, (2) reflected sunlight in which the sun's light is reflected into the window, and (3) reflected skylight in which the sun is blocked by clouds, trees, a building, etc., and must reflect off the sky to enter the room. Direct window light has the same harsh contrast qualities as direct sunlight (see Setup 1 on page 99). You can, however, easily lower the contrast by using diffusion material, such as a commercially available pop-out diffuser or a piece of cheesecloth in single or multiple layers across the window. This diffused form of direct sunlight produces more acceptable shadows. You can position your camera and subject to use direct window sunlight as sidelight, frontlight, or backlight. (I love how the sidelighting effect from my windows draws out textures with just enough contrast.) You may need to use a reflector to lighten the dense shadow areas, especially at the part of the subject furthest from the window.

The two reflected forms of window light (those without direct sunlight) both provide a lower contrast, medium light. Reflected skylight provides the softest window lighting. One important characteristic of the two reflected forms or window light is that this light will tend to fall off quickly, so reflectors are a must for fill light to control shadows. If you add a small table or use a kitchen counter top near a window with some different background cloths, you have a simple but very effective window light studio. The lighting stall setup described on page 110 can also be very effective here, producing wrap-around lighting when positioned with one side open to the window, as well as providing an easy way to hold up fabric paper backgrounds.

Skylights are another excellent light source, as seen here (image A) in the corner of a kitchen using a simple lighting stall (see page110) to catch indirect sunlight. By placing a diffusion screen over the lighting stall (image B), direct sunlight through a skylight the light becomes even softer, with virtually no shadows and a reduced intensity in the highlight areas.

Artificial Light:
Setups 5 – 9

Artificial light sources give you one huge advantage over natural light: control. With artificial lighting, you can shoot anytime, anywhere, be it 3 A.M. or 3 P.M, on a rainy day or a sunny day, in the basement or in the living room. (Of course, I'd recommend a small, dedicated studio area where you store all your equipment.)

Although your camera likely has a built-in flash unit, consider it a last choice for close-up photography. Since it is positioned within the camera body, it usually doesn't provide even coverage for a subject that's right in front of the camera lens. In short, it simply doesn't offer you the control and versatility you need. Instead, opt for accessory camera flash units or studio strobes. With a separate flash unit, you can place it as close to the axis of the lens as possible or hold it off at an angle that is appropriate for the subject. You can also use multiple off-camera flash units and light modifiers to soften the harsh contrast of electronic flash sources. In general you will find that electronic flash lighting will produce the sharpest pictures.

With a D-SLR, you can use an extension cord attached to the camera's hot shoe or PC socket to trigger the flash. Or, an infrared trigger unit might be used on the camera's hot shoe to trip a matched slave unit set at an angle to the subject. (The options in using any of these off-camera flash arrangements are limited to more advanced digital compact cameras that have a hot shoe.) One trick is to use the built-in flash of a compact camera to trigger a slave unit while deflecting the in-camera flash from hitting the subject.

Technology saves the day when it comes to getting a correct exposure using multiple flash units. Dedicated flash units with through-the-lens (TTL) exposure technology literally talk with the camera to deliver the exact amount of required light to the digital sensor. The camera's computer will shut down the flash when the optimum exposure is obtained. This is pretty sophisticated technology to say the least. Most cameras require a hard wire connection between the camera body and the dedicated flash for TTL control, although a small number of the latest professional level D-SLRs now offer a wireless connection.

Alternatively, any flash set on the automatic mode will control the exposure through its own control circuit. In this case, the reflected light from the subject will be picked up by the built-in sensor in the flash to control the exposure without a TTL arrangement. In general, the automatic mode is not as accurate as TTL and often needs an adjustment in exposure. But you can check your camera's built-in histogram to verify accurate exposure.

You can also shoot using the flash and camera in Manual mode. In this case, use the aperture to control the exposure based on one of two means of measuring the light: (1) take an incident light reading with a flash meter in front of the subject aimed at the camera, or (2) check the in-camera histogram results using a trial and error approach. In a typi-

cal studio setting such as tabletop photography, flash metering of the incident light is generally used. If your compact camera has a Manual mode, then using a flash meter is a good option. Most on-camera flash units provide a means of lowering the flash output in increments of f/stops. That is, the + and - controls on the flash unit itself will raise and lower the output respectively if you want to maintain a specific f/stop setting.

With fill flash you can add more light to the main light (usually the sun) to lighten shadows. Depending on the look you want, set the level of fill light to between one and two stops less than that of the main light. Many flash units and dedicated D-SLRs have built-in programs that control the amount of fill. If this is not an option, then use the exposure compensation control on the flash unit itself to lower the light intensity. Fill flash usually gives pictures taken in available light more snap and a sharper look than just the available

light alone would provide. But be careful; too much fill light turns the look into that of a typical direct flash shot with harder contrast.

If you decide to specialize in close-up flash photography, there are several more options available to you, such as specialized on-camera close-up flash arrangements like ring lights and twin-flash set ups. Many are available with TTL control for specific D-SLR cameras. Made specifically for close-up work, these units offer finesse, not power. Like a two-year-old trying to toss a ball, light from these units won't reach more than a few feet. Don't expect to photograph subjects ten or twelve feet away—the light won't reach them. The ring light is a circular flash tube that mounts on the end of the lens. In appearance, it looks like you've stuck your lens into the center of a doughnut. The ring light delivers a very even field of light that surrounds the subject completely, provided you are not too far away. Subjects photographed with a ring light appear shadowless. This

lighting is especially good for extreme close-ups.

The twin-flash arrangement also gives very even lighting. More importantly, it gives you lighting control. With twin flashes, you can vary the lighting ratio between the two units to add dimensionality to a subject. The most specialized option of all is the fiber optic light units that deliver a very small focused area of spotlight to the subject. You can use one to add precise accent lighting.

When compared to the other close-up flash options, studio strobes look like a body builder clasping his one-year-old child in a single hand. They burst with power and, consequently, these units give you the choice of using small apertures for greater depth of field, even at the camera's lowest ISO setting. With their greater size and power, they cover a much

wider area and work with a range of light modifiers.

The most popular light modifiers are the soft boxes. You can move a soft box close to the subject for the highly desirable medium to medium-soft light effects with very even coverage. These boxes, along with umbrellas, can also deliver an even light in small product settings where there are several subjects. Using a shoot-through-umbrella positioned close to the subject is another option. That is, you can use an umbrella made of translucent fabric that is designed to diffuse rather than reflect the light that reaches the subject. So, along with the soft box, the shoot-through-umbrella can be positioned very close to the subject for a wrap around effect as well as making the background darker. Larger reflective type umbrellas, on the other hand, can supply a field of light that easily keeps backgrounds at the same exposure as the subject, as seen in the architectural model images. All this is best done in a room where light stands can be set up around a table top along with supports for a background.

Lighting Setup 5: Single On-Camera Flash

Keep it simple. That's a strategy that applies to business, personal relations, and rookie quarterbacks. What could be simpler than a single on-camera flash unit? Well, possibly no

The built-in flash on most cameras is not the best close-up light source since it is basically a small light source that will produce higher levels of contrast and uneven coverage of a close-focused subject. A more effective approach is to attach an on-camera flash unit and bounce it off of the ceiling or a large white piece of foam core held over the subject. The result is very similar to the light from a skylight. Be careful, however, of rounded black shiny surfaces, as these will tend to reflect the flash hitting the ceiling, as seen in the bumpers of this model car.

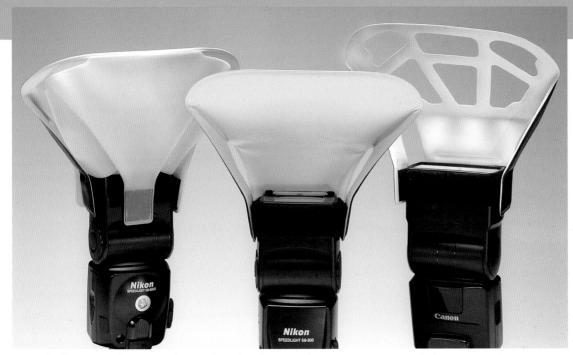

Special reflector attachments can be purchased and mounted onto your on-camera flash to create a bounce-flash effect without using the ceiling.

flash unit, but then we'd have nothing to talk about. The objective behind placing a single flash unit close to the front of the lens and in line with the lens axis is not only to fully illuminate the subject, but also to reduce harsh shadows. With this position of the flash, shadows will mostly be out of view behind the subject. The light from an on-camera flash is similar to that of direct sunlight; it produces great color, but not much subtlety in the shadows or highlights. It is not the best light with very shiny subjects because of the risk of blown out highlights.

Once you mount a TTL dedicated flash, you can concentrate on the composition. The one thing to avoid is trying to cover too large a subject, or moving too far back from a small subject. In both cases, light fall-off will be evident. Some photographers mount small soft boxes on the flash to spread the light and produce a medium light effect. One trick to deal with background shadows is to use a black cloth as the background. You can also arrange your subject far away from any background, which will result in a very dark or even black background due to light falloff.

As with all electronic flash arrangements, you can shoot handheld but it is often better to use a tripod. With the shallow depth of field in close-ups, even moving your camera a half-inch as you take the picture can throw key areas out of focus. Use a tripod to fix your position (and your focus) so you can concentrate on the composition. In the field, I often use a monopod in combination with a medium speed ISO setting. It makes it easier to find and hold a position for a particular composition without the bother of having to position a tripod.

Lighting Setup 6: Lighting Stall

The single on-camera flash arrangement makes shooting outdoors a lot easier when it comes to dealing with breezes and low light. Typical subject matter includes flowers, foliage, and insects. Textures are less pronounced with this head-on lighting but the colors will be the most vibrant possible.

Indoors, another alternative is bounce flash, but the ceiling has to be low or close to the subject. I used bounce flash to photograph some of the miniature cars on pages 92-95. If an on-camera flash unit can be turned toward the ceiling, the light bounces off the ceiling surface and sprays down over the subject to produce an even illumination, which works particularly well with semi-glossy objects such as the metal toy cars. The key is to pull back from the subject to allow enough distance for the angled bounce light to spray down on the subject. You also have to be careful of your flash showing up in dark shiny areas of the subject.

With natural lighting, the inclination is to not only dissect the qualities of the light, but to wax poetic about its possibilities. In part, that's because the subject of natural lighting is often nature—a monarch butterfly, the delicate blossom of a bloodroot, a raindrop poised to release from a sumac leaflet. And who doesn't love nature?

Artificial lighting more often invokes the practical and commercialized side of photography, and a different but equally fascinating behavior may show its face—ingenuity. Photographing close-ups of small products is known as tabletop work. Often, hundreds of shots may be required to create a catalog. Efficiency and speed rise to the forefront. Many tabletop arrangements for small products use three-sided enclosures to surround the subject. As noted earlier, these enclosures are called lighting stalls. Commercial versions range from a few hundred to a few thousand dollars, the more expensive kind having built-in lighting. I build my own. I have found a lighting stall to be the most useful

way of controlling light. It also adds a convenient background and, if used outdoors, helps to block any breezes.

Basically, a lighting stall surrounds the subject with side and back panels to either reflect light to the subject (white sides) or block any extra light from reaching the subject (black sides). You can also warm the subject by using a gold surface or cool it with a blue surface. The back panel can hold various fabrics or roll paper to form a background for the subject, and the size of the enclosure will depend on the size of the subject.

The level of contrast for umbrellas and soft boxes will depend on the fabric used. Silver linings produce the strongest contrast and a flat white surface produces the least. An added advantage of a lighting stall arrangement when working outside is that the walls provide an effective wind block. In this case, I have found that a larger enclosure works best as a wind block.

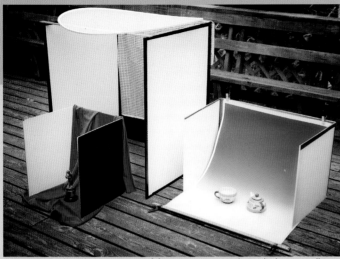

Taping together three pieces of foam core to make a lighting stall is one of the easiest ways of controlling the light for a close-up subject, as well as for providing a means to utilize all sorts of backgrounds, from fabrics to graduated color vinyl. Fill light is produced by using white sides; black sides assure maximum shadow density. The light source can be either a shoot-through umbrella, a soft box, or sunlight (with a diffuser placed on top in the case of direct sunlight). Once you are finished shooting, the lighting stall folds up for easy storage in a closet or behind a dresser.

Making a Lighting Stall

To make a lighting stall, tape together three panels of foam core so that the stall is free-standing. When applying the tape, allow three-quarters of an inch or more of space between the panels so you can fold the panels flat for storage. In the examples shown here, I used either gray or black duct tape with clips to hold the backgrounds to the top of the back panel.

I often use graduated vinyl backgrounds in 21-inch (53.3 cm), 31-inch (78.7 cm), and 42-inch (106.7 cm) widths. These vinyl "papers" are widely available from photo supply outlets. Determine what size background to purchase based on what size lighting stall you're building. Basically, you want your background to be about three times longer than the height of the lighting stall's rear panel. The width of the background should match that of the rear panel so the reflecting sides of the stall are right at the edge of the background paper.

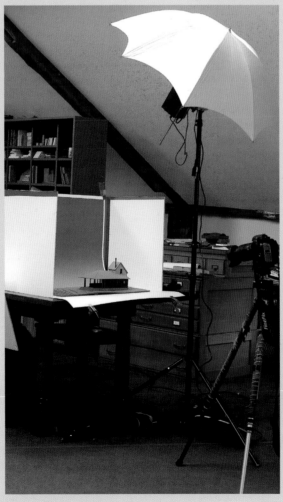

If the front of the background paper will not stay flat, or if you want a cove effect in which the front of the paper drops off, clip a yardstick on to the paper edge and let it fall over the edge of the table. This photo shows a typical tabletop lighting stall with the cove front (produced just with the weight of large clips) and a strobe in a silver umbrella as the light source. The umbrella has been raised up to assure that the background would not have any light fall-off. If you do want some light fall-off in the background, use a shoot-through umbrella that can be positioned very close to the subject.

A lighting stall can also provide a variety of different looks and effects with very simple changes. For example, small pieces of colored fabric can be draped just over the back panel for different colored backgrounds. You can also use materials with patterns that will be thrown out of focus to produce a soft geometric background effect... or keep them in focus for added visual interest! On overcast days, try draping black cloth over all three walls. Overcast natural light is notorious for its flat, shadowless rendering of subjects, but the black cloth creates interesting shadow areas. If you don't want to bother with fabric, you can paint the outsides of the three white foam core panels flat black and just reverse the sides when you want an all-black enclosure.

When using a lighting stall outdoors, set it on a table with the back panel positioned to block the breeze. In the case of direct sunlight, you can then place a pop-out diffusion panel or some other diffusion material over the top to cut down the high contrast. Small pop-up or tabletop reflectors can be used if necessary to fill in shadow areas.

You can use a lighting stall to control the appearance of shadows simply by varying the sides and bottom of the stall, as shown here in the images of a small woodcarving taken with a shoot-through umbrella (see page 112). In the picture on the left, white walls and a white floor were used for maximum fill light, which produced weak shadows and a wrap around lighting effect. In the picture on the right, the sidewalls and floor were black, which maximized shadow areas and produced more dimensionality through the formation of shadow contours.

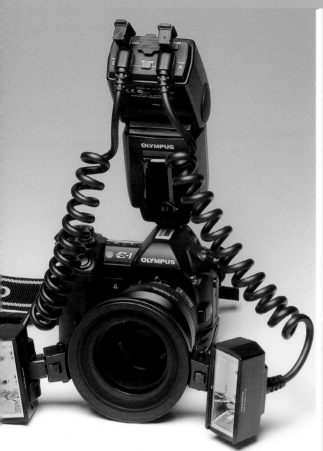

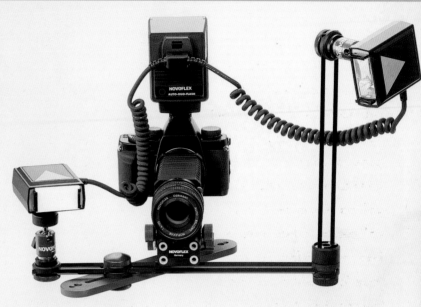

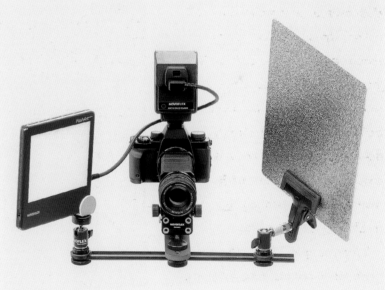

Twin on-camera flash consists of two small flash units that are mounted on a bracket that is attached to the camera. This allows the flash units to be set at about 45-degrees to the subject. Thus, the subject will be evenly illuminated, as on a copy stand.

You can also use the lighting stall on bright overcast days that do not require a diffusion panel. The background can be anything you want, from different colored fabrics to studio roll paper clipped to the back panel to form a sweep to the edge of the table. The one drawback to using a lighting stall outdoors is that it really is a bother when photographing in the field on uneven ground where rocks and other natural structures often prevent a stable set up. It works best on a table. Also, when used with direct sunlight that is being diffused, you are limited to the middle hours of the day when the sun is overhead. Once the sun starts to drop a bit, the sides of the stall will block the light and/or cause unwanted shadow areas.

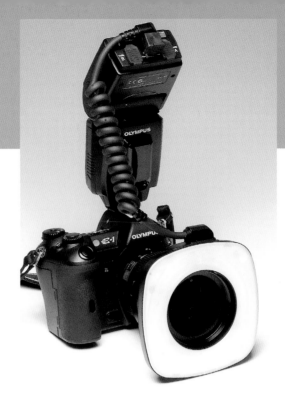

Ring lights are circular flashtubes set in a ring that is mounted on the front of the camera lens.

Lighting Setup 7:
Twin On-Camera Flash

The strategy with this set up is similar to that of a copy stand in that the two flash units are set on either side of the lens for even coverage. In addition, the power of these units can be altered for different lighting ratios to produce uneven light with some shadows to help define shapes and forms as well as texture. For example, one flash head can be set to deliver one-stop less light. Again, it is best to use TTL dedicated flash units.

Lighting Setup 8:
The Ring Light

Ring lights come the closest to a flash that is on the same axis as the lens. Their field of coverage is very even, but it is also very limited. In other words, you have to come in pretty close to the subject. As a result, the ring flash is very effective when try-ing to take extreme close-ups, such as magnification ratios of 1:2 to 2:1 (see pages 18-19 for more about magnification ratios). Some manufac-turers have created ring lights for their compact cameras, but for the most part, the ring light is really meant for D-SLR close-up photography.

When used at the proper distance, a ring light delivers a very even light that works well for subjects with largely irregular surfaces, such as flowers and fabrics. Shiny subjects, on the other hand, can often show blown out highlights. This circle-shaped flash can also show up in reflective surfaces, such as in the water droplets on the surface of the flower pictured here.

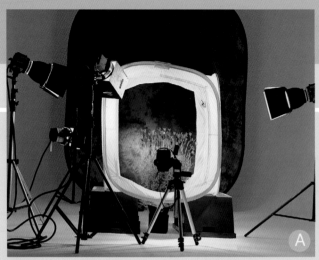

Image courtesy of Bogen Photo

The principle behind the lighting tent is to surround the subject with shadowless light. This type of lighting is most appropriate for highly reflective, smooth-finished subjects, from jewelry to silverware. Basically, all shiny surfaces will reflect the surrounding white material to produce large, soft, white reflections. Lighting tents come in a variety of sizes and shapes, from the three-foot square (approximately one meter) tent shown in image A, to tents that can handle smaller products measuring only a few inches as seen in image B.

Lighting tents are ideal for shiny objects such as this old pocket watch. I created the subtle glow using a Nikon Soft #1 filter on a 105mm macro lens.

The left-hand image of each subject shown here was shot on a copy stand (see page 166-183), whereas the lighting tent in image B was used to produce the shadowless effect seen in the right-hand versions of these subjects. Notice the different reflections of the light sources in the pearls.

Lighting Setup 9: Lighting Tent

A lighting tent is, just as the name implies, a tent that surrounds the subject. There are several commercially available lighting tents that come in a variety of sizes, and you can also make one yourself, such as by draping diffusion fabric or Vellum paper obtained from an art store completely around the subject and cutting a hole for the camera lens. The principle here is to completely surround the subject with a wall of white, shadowless light.

When it comes to very shiny surfaces made of bare metal, such as tools, pens, and jewelry, this is the preferred type of light to photograph them with. The best results occur when you place two lights on opposite sides of the tent. If you need to photograph highly reflective objects routinely, consider investing in one of the commercial boxes that use the lighting tent principle, as shown on page 121 ("The Box").

Lighting Setup 10: Copy Stand

The last lighting arrangement is for copy stand work. This form of lighting is closely tied to the design of the stand itself and the principles of copy close-up work. It deserves an in-depth exploration, and is thoroughly covered on pages 166-183.

Flowers: Up Close and Personal

I love photographing flowers, as do many photographers. Here is a sampling of flowers I have photographed using some of the lighting setups covered in this chapter. I primarily used a D-SLR with a 105mm macro lens. For the extra close-up shots (image B and Image G), I used a +1.5 achromatic diopter with a 200mm macro..

(B) Indirect window light was used here, with a reflector to fill in shadows around the petals.

(A) This was taken with a ring light.

(C) This flower was shot by window light on an overcast day with a Zeiss Softar #1 filter.

(D) For this shot, I used a strobe in soft box, angled head-on to the subject.

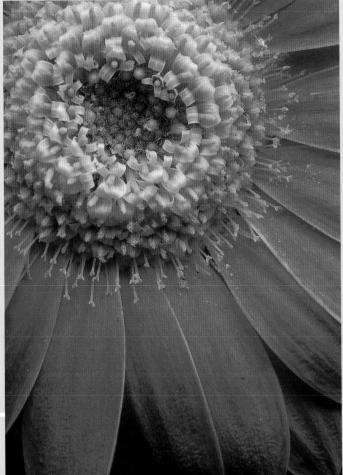

(F) Skylight window light lit this shot, with a soft white reflector just below the bottom of the flower.

(E) Here, I used strobe in a shoot-through umbrella just over the lens and close to the subject.

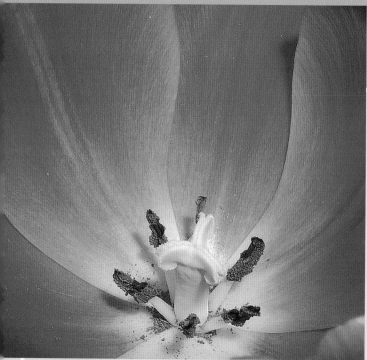

(G) I used direct flash mounted on the front of the lens in conjunction with a black background cloth to capture this image.

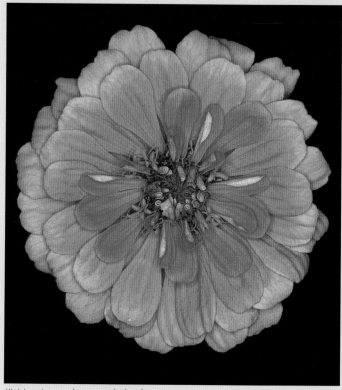

(I) Here's another ring light shot.

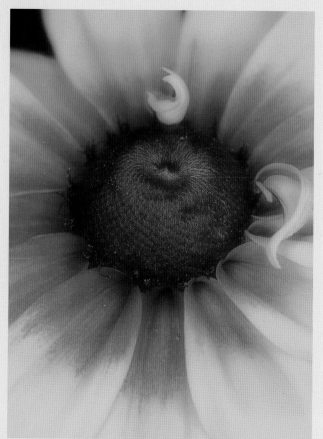

(H) This shot was taken on a hazy bright day with a Nikon Soft #1 filter.

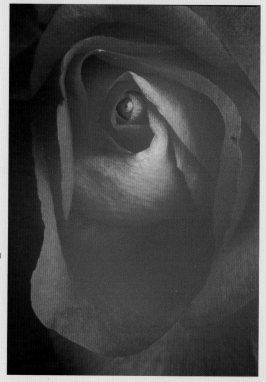

(J) Novoflex FlashArt was used here with a gobo panel (see page 90) to block any light reflecting back onto the flower.

Commercially
Available Small Product Tables

mK Digital Direct Inc. offers a line of some ten different lighting chambers that provide a completely even, wrap-around, continuous light source built into the chamber walls. This allows the user to easily photograph some of the most difficult subjects in close-up photography, such as metal jewelry and gems that have highly reflective surfaces. Shown here is a cross section of different subjects, along with one example of the lighting chambers called "The Box" (image A). Note the use of different backgrounds that can be inserted into the box in images B, C, D, and E.

In addition to the lighting box design, there are also a number of small product shooting tables or sweep tables that come with their own lighting.

A

B

C

D

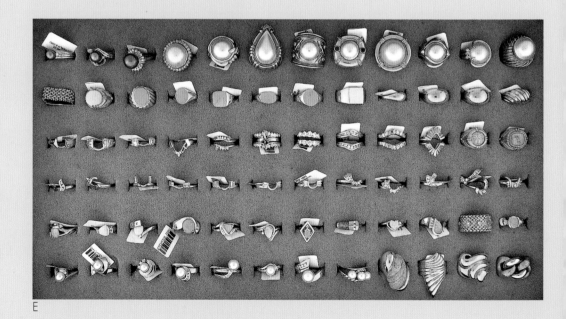

E

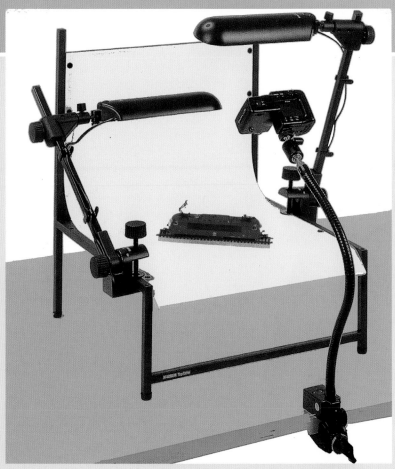

(F) Kaiser Table-Top Studio from HP Marketing

(G) Kaiser Studio in a Box from HP Marketing

(H) Cloud Dome Infinity Board Digital Lighting Kit from Omegasatter

5

BASIC
SCANNER
METHODS

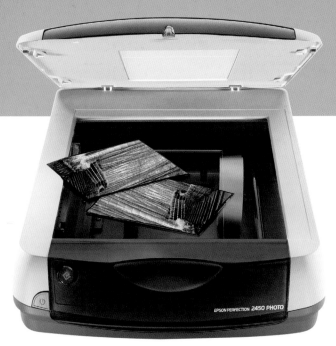

Flatbed scanners are designed primarily for flat, reflective art, though some models are also capable of scanning film.

FROM UTILITARIAN TO PROLIFIC

Plebian. Pedestrian. Prosaic. Those might be the words to describe a scanner birthed with a bureaucratic soul, but those with imagination far greater than mine recognized that the scanner's artistic calling had not yet surfaced. They saw the scanner as a specialized camera, one with a unique view of the world, if only it were allowed to step outside the boundaries of a copy machine.

Thus, imaginative artists have turned the flatbed scanner into a tool of creation. They recognized that its wall-eyed way of seeing flat documents could transform three-dimensional objects into digital art, and that further digital manipulation could create revelations that would be the talk) of the art world. Artists such as Ruth Adams (see pages 138-161) and Joanne Urban (see pages 162-165) have transformed the flatbed scanner into a specialized close-up camera to create beautiful images of three-dimensional subjects. Before we examine their art, however, let's look at scanners in their original and primary role as close-up copy devices of two-dimensional subjects.

Let's face it, digital cameras are cool. And they've made photography cool again, too, as it was in the beginning. After all, photography has transformed the world in many ways. It was the photography of William Jackson and others in the 1860s that led to the national park systems now around the world. It was the photography of Lewis Hines that led to child labor laws—still an issue in the world today. And it was the photography of Ansel Adams that helped kicked off an environmental movement. So when we pick up a camera, we feel like we're in good company.

When it comes to scanners, however, it's hard to imagine oneself in the shoes of a famous scan artist. Not too many of us know the guy in the basement of the bank who recent-ly scanned his one-millionth check. Designed for the rather ho-hum task of recording business transactions—sometimes millions of them—flatbed scanners feature many of the same "guts" as digital cameras do. But they lack the camera's sexiness.

Instead they became institutional bulwarks until, eventually, their utility was recognized as something desirable for the grassroot masses and they were optimized for home scanning—illustrations from encyclopedias for school reports, birth certificates and assorted licenses for personal documentation, legal papers for fond remembrances of the lawyers, spouses, and family members who inspired them. That sort of thing. Nowadays, scanners also excel at copying photographic prints, negatives, and slides.

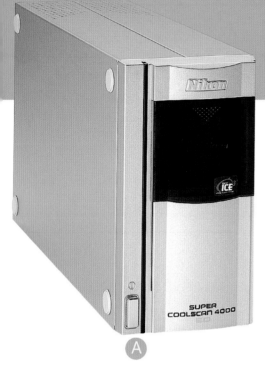

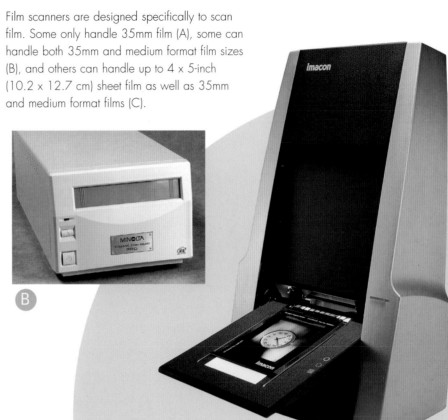

Film scanners are designed specifically to scan film. Some only handle 35mm film (A), some can handle both 35mm and medium format film sizes (B), and others can handle up to 4 x 5-inch (10.2 x 12.7 cm) sheet film as well as 35mm and medium format films (C).

A Scanner Overview

Scanners fall into two general categories: flatbed scanners and film scanners. Available from several manufacturers in a variety of models, consumer flatbed scanners excel at scanning flat things—documents, paintings, drawings, photographs, magazine pages, and so on. High-end flatbed scanners also excel at scanning film (negatives and transparencies).

However, when it comes to scanning film, few flatbed scanners can match pixels with a good film scan-

ner. Film scanners are designed with one purpose in mind: to enable you to print freckles as large as golf balls, whiskers as big as pencils, and gumdrops as big as doughnuts. Whether or not you want to make poster-size prints from a piece of film as small as a stamp, a good film scanner will have the high resolution required to make big enlargements from your 35mm film or slides. And if you're talking about medium format film, well, the enlargement possibilities are just that much greater! But providing such exceptional resolution and preci-

sion does not come cheap. Quality film scanners can cost up to ten times as much as flatbed scanners.

The big advantage to using a flatbed scanner is that you can scan anything you can place on the platen, which is usually about the size of a magazine cover. Film scanners are pretty much limited to scanning film—most commonly, 35mm film. There's not too much you can jam into the scanning slot that won't permanently ruin your scanner, so creativity is limited.

Flatbed scanners are very versatile. This model, for example, is capable of scanning not only reflective art but also transparencies and, with a range of special holders, film up to 8 x 10-inches (20.3 x 25.4 cm). Some models use a transparency window in the cover, but the model pictured here uses a drawer in the front of the scanner.

SCANNING REFLECTIVE ART

Mechanically, scanning is a straightforward process. You turn the scanner on, open the cover, place and align the item to be scanned facedown on the glass scanning bed, and close the cover. Some flatbed scanners include a sheet feeder so you can scan multi-page documents by feeding in sheets one page at a time without opening the cover. The most common flatbed scanners handle documents up to 8.5 x 11-inches (A4) in size. Larger models (usually labeled "XL") handle sizes up to 12 x 17-inches (A3). The bigger models cost much more.

As the scanner illuminates the document with a high intensity light beam, it slowly transports (or scans—

hence the name) a narrow bar of CCD sensors under the entire document area. As it moves, the digital sensors in the bar capture the light reflected off the document.

In the case of transparency scanning, the light source is usually in the external cover. As the light passes through the subject, it hits the same sensors used for recording reflective art. In both types of scans, the sensor information is simultaneously passed on to the scanner software in your computer which then reassembles the document and displays it onscreen.

Most 35mm film scanners have a slot opening in the front into which either a single 35mm slide or a holder containing a strip of negative film can be inserted. Some models can also be equipped with a stack loader to hold a number of slides.

Basic Technique for Using a Flatbed Scanner

While individual scanning software programs differ, most offer similar functions and tools to control exposure, contrast, color, tonality, and sharpness. All also provide one-button automatic scanning in which the software sets all key controls automatically. Higher-end software gives you refined controls over the scan as well as optimizing the hardware potential of the scanner. Some of this software can be pretty sophisticated, but in general, they all provide the key controls necessary to produce a quality scan. When you've completed the scan, open it in your image-processing software to make final changes in color, contrast, and brightness, as well as to prepare your image for whatever its final output usage might be.

Loading the Original Document

Clean the glass platen of smudges and dust. (Remember, every piece of dust and debris on the glass will show up in the captured image, requiring you to spend time retouch-

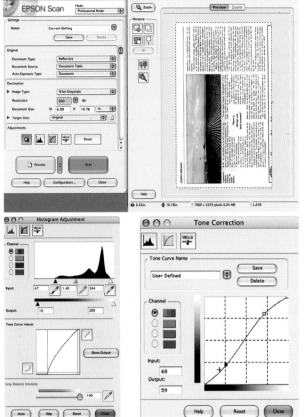

The first critical stage in the scanning process takes place during the pre-scan stage shown in the top dialogue box. Contained here will be a surrogate image of the original along with access to all the scanner controls. At this point, you can either opt for an automatic, one-button scan operation, or you can control the scan yourself. If you decide to control the scanning process yourself, then the main controls for color, contrast, and brightness will be through the scanner's histogram (bottom left), curves adjustment (bottom right), and color control section (not shown). Watch the effects in the display screen in the main dialogue box.

ing.) Next, remove staples and paper clips (if any) from the document so you don't scratch the glass. Place the document face down on the glass scanning bed and align it with the borders of the bed. Carefully lay the interior scan cover on top of the document (taking care not to move the document) and close the external scanner cover. The critical factor in this first step is that the document is completely flat against the glass.

The Pre-Scan

After you load the document, open the scanner software in the computer and make a pre-scan. The pre-scan is a quick, low-resolution scan that shows you a preview of the image so you can adjust software settings (and check that you aligned the document correctly) to make a high quality, full-resolution final scan. This is a critical stage, so let's go through it in some detail.

Type of Document: Before pre-scanning, set the scanner for the type of document. As previously noted, the most basic choices are between reflective and transparency art. Some scanners also provide more refined choices within these two categories, such as line art (graphs and charts), black-and-white negative film, color slides, or photographs. You may also be given the choice of using certain automatic settings. While many auto functions are quite good, manually adjusting specific settings such as color, exposure, and contrast will give you more control over the appearance of the final image. For now, though, let's assume that you have selected the automatic settings for the pre-scan.

Crop: After you pre-scan the picture, crop extraneous areas. Extraneous areas can give a misleading histogram reading, or otherwise lead you to make incorrect settings. In other words, image-quality information from the pre-scan should be based on the actual image—not areas outside of it. Also, when you view the cropping lines, you will see whether or not you have correctly aligned your document in the scanner. If there is a misalignment, then reposition the document and activate another pre-scan before cropping the document. (Alternatively, you can also correct alignment after the scanning is complete.)

Output Size and Resolution:

Assuming you have opted for automatic scan controls, you now have to tell the scanner two things: output size and output resolution. The size of the output is usually expressed in terms of a percentage. Thus, a 100% setting would mean the final scan would produce an image with the same dimensions as the original. A figure of 50% is one-half the original size and 200% would be twice the size of the original. Each type of output (inkjet printer, email, website, print publication, etc.) requires a specific resolution. For example, if the original is a matchbook cover for a collector's website, its size might be the same as the original (100%) and the resolution will be relatively low (a typical web resolution is 72 dpi). Thus, the original 2 x 4-inch (5.1 x 10.2 cm) matchbook cover will be reproduced at that same size (100%) at 72 dpi. If, on the other hand, you want to make an enlarged inkjet print of the matchbook, like twice its normal size (200%), then the final image would measure 4 x 8 inches (10.2 x 20.3 cm) at a typical inkjet full color output resolution of 240 dpi. (If the final output is for a full color publication in a book, you would set the resolution to the industry standard of 300 dpi.)

Try not to set resolution beyond the scanner's maximum "optical" (sometimes called raw) resolution, which indicates its true highest quality resolution setting. Although scanning software will let you set a resolution higher than its maximum optical resolution, it creates new "false" pixels (a process called interpolation) to achieve that extra resolution, so the quality may not match your expectations. As good as some scanners are at interpolation, the best results will come by staying within the maximum optical resolution of the scanner.

Brightness: The degree to which you can control the manual scanner settings will depend on the software you're using. The layout of the various software programs available on

the market today will vary, but they all share the following key controls: contrast, brightness, and color. Contrast and brightness are often handled by the Levels (or similarly named) tool, which displays all the data, from shadows to highlights, as a distribution graph, or histogram. If you have properly cropped your original document, this data will describe only the subject (as opposed to including extraneous information from outside of the document surface area). Using the Levels tool, drag the two outer pointers on the horizontal axis inward until they just touch either end of the graph. Now, move the center pointer left or right to adjust the brightness of the image until you are satisfied with the results.

Contrast: To adjust image contrast, use the Curves tool. When first opened, the graph appears as a diagonal straight line. You create a curve by clicking and dragging on the line in the tonal areas that need adjustment to improve contrast. You can control the overall contrast within shadow, middle tone, and highlight areas. You can also use the Curves tool to adjust exposure by moving the line higher or lower from its beginning point in the shadow, middle tone, and highlight areas. Be careful, though, as you change the shape of the curve and adjust the image contrast. Large changes may make the image look lousy.

Start by making small changes to the curve. As you do, review the histogram and make sure the shadow and highlight areas continue to reveal detail. Of course, don't rely solely on the histogram. Do the obvious and look at your image to be sure its appearance is pleasing and that it looks "right." Visually inspect the highlights and shadows to be sure critical detail is visible. As long as the scan captures details in these areas, you can fine-tune it later in your image-processing software.

Color: Usually, you are trying to make a copy with the same color values as the original, but not always. For example, if you are copying a yellowed black-and-white photograph, you may want to restore its neutral black-and-white tones. The color shifts on aging color prints are even worse. Most scanning software includes an automatic color function that to adjust poor colors. Better yet, some software includes a color restoration function aimed solely at improving those old faded color prints. Dorian Gray would have loved this software.

Image Sharpening: There are two schools of thought about when to sharpen an image. One assumes that the scanner software can do a good job, while the other prefers to leave the sharpening to an image-processing program. The best way to decide is to try both on some of your typical scans and compare the results. One distinct advantage of using image-processing software is that you can apply the final sharpening to the image after adjusting size, color, contrast, brightness, etc. Also, there are some very sophisticated sharpening software programs out there that are geared to cater to your specific output needs, from inkjet prints to website use.

A Note About Film Scanners

Since film scanners use either built-in guides or a holder, it's easy to align film when you load it. Thereafter, the steps to complete a scan are basically the same as the procedures for a flatbed scanner. Usually, you can set the film scanner for either negative or positive (i.e., slide or transparency) film, as well as selecting color or black and white. In addition, a film scanner likely supplies specific color scanning profiles for certain films, particularly for color negative films. This means you can select the specific name of the film you are scanning. The scanner then applies settings customized for that film to optimize image quality.

Set output resolution for a film scanner for final image size and use. For example, if you want to make an 8 x 10-inch (A4) inkjet print, set the output size to 8 x 10 inches (20.3 x 25.4 cm) and the output resolution to 240 dpi. You'll end up with about a 13 MB (megabyte) file. For best quality results, strive to stay within the maximum optical resolution of your scanner so it doesn't have to create lower quality, interpolated data.

USING YOUR FLATBED SCANNER AS A CLOSE-UP CAMERA

Most flatbed scanners excel at enlarging medium-sized, thin originals such as trading cards, paper money, diplomas, and snapshots, as well as sections of larger originals such as a map or a newspaper article with pictures. In the examples throughout this chapter, the goal was to match the original document in color, general appearance, and size. Another application for the flatbed scanner is making accurate records of items such as letters, diplomas, and similar black-and-white originals. Scanners generally excel in these kinds of reproductions. But watch out for halftone screens used for photos and for black-and-white line art cartoons. Old newspapers were printed using coarse halftone screens. Consisting of black dots, halftone screens resemble pointillist art (think Georges Seurat). When you enlarge a scan of a halftone photo, you also enlarge the dots, sometimes to the point where they become quite noticeable and distracting. Unless

you want your prints to look like a Roy Lichtenstein piece, work to suppress the halftone pattern. Check to see if your scanner software includes a "descreening" option that lessens or eliminates the dot pattern.

A good rule of thumb when scanning a newspaper photograph is to use an image-processing tool called Gaussian Blur to reduce the annoying dot pattern. Be sure to apply only a small amount of blur, however, so you reduce the screen effect without excessively softening the image. Also, you might want to compare the scanning of these originals in each of two capture modes: Line Art and Photographs (i.e., scanning as black and white only, or continuous tone). The results will depend on the original and how much midtone area needs to be captured. For an original made up of just black-and-white areas, such as a typed page, the Line Art selection is best because it eliminates any midtones (such as smudges), giving a very clean rendering. On the other hand, items such as newspaper articles with photographs or diplomas that have continuous-tone official stamps, seals, or

shaded borders require midtones in order to render the reproduction properly, so use the Photograph or Full Tone setting.

Finally, decide whether to scan the original in the black-and-white or the color mode. The document's condition may affect your choice. For example, if you're scanning a yellowed diploma, the black-and-white mode would show the yellowing as a light gray, and the color mode would pick up the yellow as shown in the original diploma. The choice is up to you.

Copying and enlarging photographs is one of the most popular uses for the flatbed scanner. It is probably safe to say that every family has lots of snapshots for which original negatives have been lost. You can also scan and share old photographs of deceased relatives. The procedure for scanning such originals is straightforward, using the Photograph mode prior to the prescan. Since many old photos have faded or become discolored, you probably should bypass the Auto Color setting in favor of making manual adjustments. However, check

your software to see if it includes an Auto Restoration function and, if so, give it a try.

Tips for Scanning Photographs

Make sure the surface of the photo is clean. Remove dust by
using a can of compressed air or a soft, clean cloth (such
as a microfiber cloth) that is safe for cleaning off the surface
of photographs.

A

1 Clean the glass platen on the scanner using the same meth-
ods and care described in number 1, above.

2 Set your scanner for color even for a black-and-white origi-
nal. This will give you more pixel data. Also, if you are making
an exact copy, the color setting will record any color shifts or ton-
ing in a black and white print, such as sepia tones.

B

3 If you decide to make color changes during the scanning
process, it is a good idea to also make a second scan using the
Auto function and compare the results of the two.

C

Besides two dimensional originals, flatbed scanners (and to a more limited degree, film scanners) can be used to scan three-dimensional objects such as those seen here in the scans of a fern stem (image A), a PDA (image B), and a 1906 tintype (image C), all taken with a flatbed scanner. The tiny leaf (image D) was done with a film scanner. In the case of using a flatbed scanner, the objects are carefully placed on the scanning bed. The film scanner requires that the objects be placed in glass slide mounts with the size of the original limited to the size of a 35mm or super slide mount (image E).

RESTORING OLD PHOTOGRAPHS

Repairing and restoring old photographs is a subject unto itself, and is beyond the scope of this book. An Internet search using such key phrases as "photo restoration techniques" or "photo restoration software" will yield plenty of information and choices in software methods, as well as books on the subject. In addition, many scanners come with software bundles that contain restoration software. There is also a unique set of software products that can do restoration work during the scanning process, automatically removing dust, dirt, and even cracks on certain flatbed scanners.

Re-Recording the History of a Town's Main Street

One of my commercial specialties over the years has been panoramic photography and, as such, I was intrigued by a 1910 panoramic print of the main street of the town where I live. I felt that the original, at 4 x 14 inches (10.2 x 35.6 cm), was much too small to convey the detailed information that could be seen if one looked at the old photo under a magnifying glass. (This detail can be seen in the section of the original shown in image A.) So, I scanned the original in two overlapping sections, making use of the maximum optical 1680 dpi resolution of my flatbed scanner (image B). I then combined the two scans using image-processing software to create one complete image. The capture was made using the scanner's color mode, but I then desaturated the color in my image-processing program and enlarged the image ratio to be approximately 2 x 8 feet (.6 x 2.4 m).

After cleaning up the scratches and other flaws, as well as adjusting the contrast, I then sharpened the merged original (image C). Next, I toned it brown and made the final 240 dpi print (image D). Town First Selectman Val Bernadoni holds the original panorama in front of the final display print hanging in the town hall (image E).

Main Street, Salisbury, Connecticut (circa 1

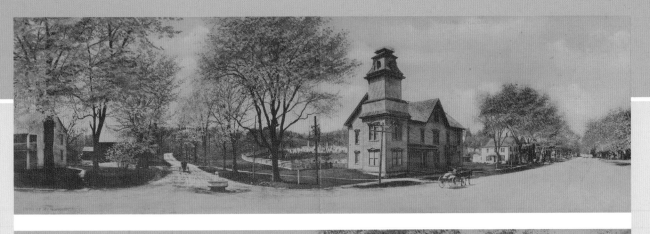

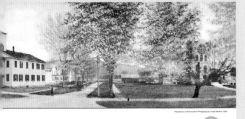

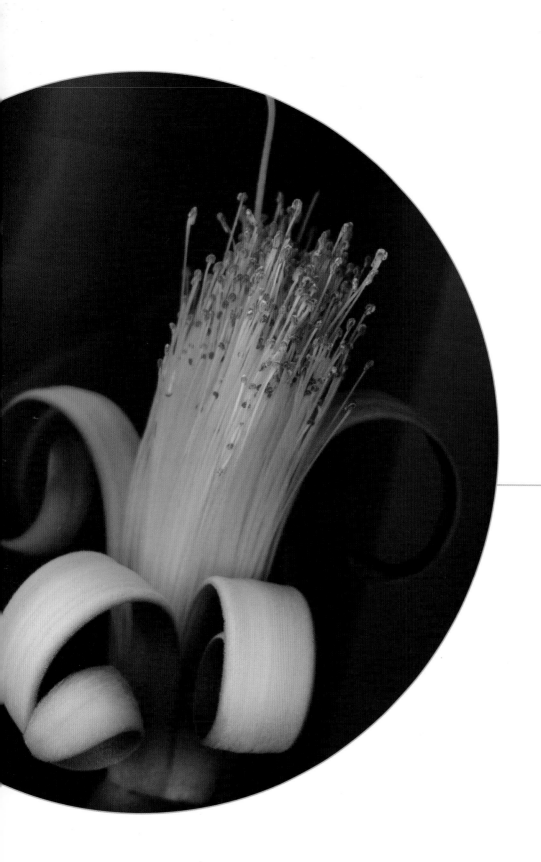

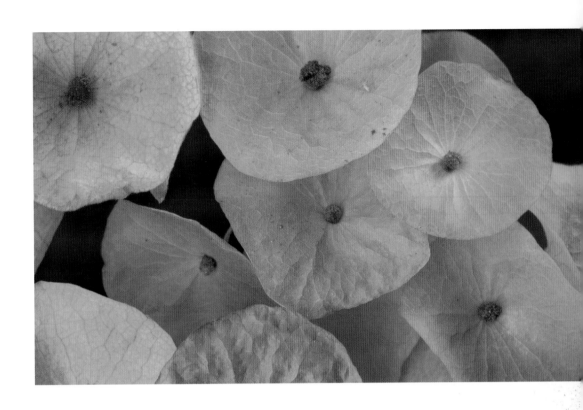

6 Using The Scanner as a Close-Up Camera

by Ruth Adams

I first met Ruth Adams many years ago and was quite impressed with her wonderful close-up images of flowers produced by using a flatbed scanner. Today, she is an internationally recognized artist known for combining modern imaging technologies with the traditional sensibilities of a photographer. In particular, Ruth has been a pioneer in the use of the flatbed scanner as a camera to make images of three-dimensional objects. Her use of innovative techniques such as secondary lighting and varied backgrounds has helped extend this form of close-up photography into its own art form. In this chapter, she explains her technique and provides examples of her work that I am sure will cause anyone who uses a flatbed scanner to look at it in a new light. Ruth is an assistant professor of photography and digital art at the University of Kentucky in Lexington. To see more of her work, visit: www.ruthadamsphotography.com.

Joseph Meehan

OVERVIEW

In the previous chapter, the emphasis was on using scanners to make copies of two-dimensional subjects such as documents and photographs. For me, however, the flatbed scanner is really more than just a two-dimensional copy machine. Indeed, here is a device that, with a few modifications, can be used like a large close-up camera for creating still life compositions. After all, how much closer can you get to an object than placing it directly up against the lens of the camera? Once an object is placed on the scanner glass, the CCD array/lens is mere inches away from that object. The scanner can then digitize the subject at life-size, twice life-size, three times life-size, or even greater magnifications depending on what output resolution is needed and how high a scanning resolution the scanner can deliver.

We must keep in mind, however, that the flatbed scanner was designed to capture flat documents using a closed cover to hold the subject completely flat. In my work, I use subjects that are three-dimensional, such as flowers and other organics, and scan them without using the scanner's built in cover. In addition, other background materials and light sources are employed to introduce effects well beyond the typical, even illumination and neutral, flat background of two-dimensional scanning. Finally, I will often make a series of scans and combine them into a final image. In short, I push the flatbed scanner beyond its intended purpose. This means having to be aware of the limitations of the scanner configuration. In particular, the restricted depth of field and the fact that its light source is really limited to covering a very thin subject held close to the glass. On the other hand, there are creative ways of extending these limitations to produce the kinds of compositions contained in this chapter. I would also add that the images I have produced using a flatbed scanner certainly do not represent the final limits of its expression. On the contrary, this technique is really just that—a technique. It is up to the individual photographer to then apply his or her own creativity in the selection of subject matter and forms of composition.

CONSIDERATIONS AND PRECAUTIONS

Before we start into the step-by-step procedure for using the flatbed scanner as a close-up camera, let's consider a few things that are very important to the whole process:

1 First, you need to be extremely careful when placing three-dimensional objects on the glass of a flatbed scanner. The main concern is to prevent any scratching of the glass, so when placing objects down on and removing objects from the glass, do so with care.

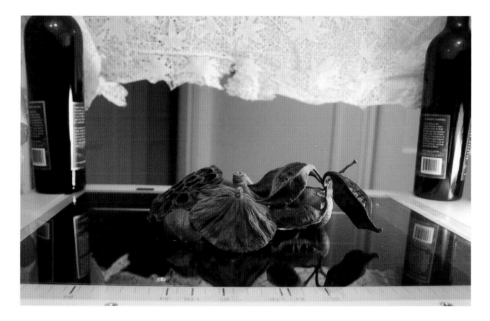

2 Second, look out for dust and other small particles that will typically appear with subjects such as flowers. The best approach here is to use a large blower brush to push small particles off the glass.

Shown here is one of the many arrangements I use to introduce a background (in this case white lace) and secondary lighting (here, a studio strobe's tungsten modeling light) with the cover of the flatbed scanner removed. The appearance of the background is controlled by its distance from the scanner glass (as explained on page 143), and the light can be positioned anywhere around the sides of the scanner for different secondary lighting effects.

3 Third, you might want to consider the advantages of a scanner with a larger bed. I currently use a flatbed model with an extra-large 12 x 17-inch (30.5 x 43.2 cm) scanning area. I learned early on that the objects I wanted to scan were often too big for the more common 8.5 x 11-inch (21.6 x 27.9 cm) area of a typical desktop scanner.

4 Fourth, a real plus is if the scanner's exterior cover can be removed. This makes it much easier to introduce other light sources and special backgrounds above the scanning bed.

A point of departure worth noting is how flatbed scanners produce the final resolution for a subject. The scanning action is different from that of most digital cameras, in which the light focused through a lens is recorded instantaneously by a small, stationary sensor. Scanners, on the other hand, record data progressively as a bar containing both the light source and CCD sensors move across the subject.

I like to think about scanner resolution and magnification in terms of the final output. For example, if a scanner has a true optical resolution of 1600 ppi across the whole recording field, and the inkjet printer that is going to produce the final print has an output resolution of 200 dpi, then the scan-to-print ratio is 4 to 1. This 4x reproduction would also represent the maximum print size you could produce without calling on the software to interpolate the data (i.e., make up new pixels when the true resolution of the scanner is exceeded). If the software in a 1600 ppi scanner were set to scan at 3200 ppi, the image could be scanned in at a 5:1 ratio, and a print up to five times life size could be made. Of course, this larger print size would be the result of interpolation (since the scanner's highest optical resolution was actually 1600 ppi, in this example), which raises the possibility that the image quality might not be as good as if the scanner were operated at its maximum resolution of 1600 ppi.

SETTING UP

My first step when working with a new scanner is to determine whether or not the top can be removed. Most external scanner covers will pull straight up and off of the scanner. Some scanners come with a cable that attaches the top to the scanner body. First check the scanner manual to make sure this cable is not necessary for reflective art scanning, in which the light source is under the glass bed. (Usually, when a cable is attached to the scanner cover, it means the cover contains a separate light source that is used when scanning transparencies.)

All of the images in this chapter were done using the reflective art function of the scanner without a cover in place. If the top cannot be removed, the next best arrangement is to open it wide enough so that it is completely out of scanning range. Make sure, however, that it is stabilized so that it does not accidentally drop down and damage the objects. If the top cannot be removed completely, its white under side can be employed as a reflector to bounce light back into the still life setting. Be

aware, however, that a scanner "sees" (i.e., records) in an ever-widening V, so it is possible that the top edge of the cover will be visible at the edge of your scanned image if it only opens wide enough to be perpendicular to the glass.

The main reason for removing the top is, of course, to allow three-dimensional objects to be scanned without being flattened, but I have found that this also allows me to introduce additional lighting and backgrounds for more of a three-dimensional effect. The first scanner artists—who did not use this technique—tended to create very flat looking art, even when working with three-dimensional objects. Part of the reason for this was that early scanners did not "see" very well if the object being scanned was not touching the glass. The interesting thing I found when I started scanning objects is that modern scanners can actually see quite far. That is, they will record something far away if it is well-illuminated with secondary lighting, such as in the case of a background. Backgrounds will not be in sharp focus, however, since the dis-

tance from the recording sensors exceeds the scanner's depth of field.

One of my first scans included a fluorescent bulb (see Figure 1). Granted, the bulb was not in focus, but the scanner was still able to record it. I soon discovered that as long as I used enough light from an external source, the scanner could see as far as I needed. Not only that, but focus could be controlled by moving things farther away from the glass to make them less sharp or, conversely, by making sure they are touching the glass to ensure the highest level of sharpness. The disadvantage to this way of controlling the point of focus is that there is no way to get an object that has great depth to be completely in focus. So far, I have not had a problem with this "disadvantage," as I like the look of very shallow depth of field compositions. The good news is that scanners are getting better and better at seeing farther off of the glass, and some even have an option to choose a focus point that is just below or just above the plane of the glass. This gives more flexibility in selecting which parts of the image are in focus

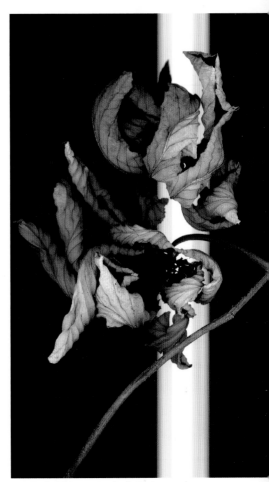

Figure 1: Fluorescent bulb with curled leaves

and which parts are not. Whatever your scanner's capabilities, be sure to consider them when creating a composition so that you are aware of which parts will be in and out of focus.

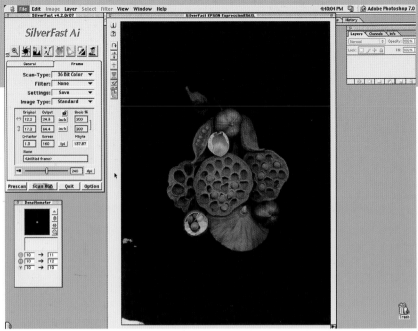

Figure 2: This is a prescan display of a subject without secondary lighting using LaserSoft's SilverFast Ai scanning software.

Clean the Glass

Before starting a scan, the glass will need to be cleaned. As with cleaning a camera lens, always blow off solid particles before cleaning with a cloth. Keep a bottle of glass cleaner nearby to deal with the inevitable dust and smudges that accumulate during the process. Make sure to always spray glass cleaner onto your cloth and not directly onto the scanner. My most frequent cause to clean is the pollen buildup that comes off of the organics I work with. Sometimes I will leave the pollen on the glass if I think it adds to the image, but most of the time it ends up looking like unintentional dust-spots. While it is certainly easier to correct these spots using image-processing software than it is with traditional photographic materials, it is still very time consuming. Therefore, the cleaner you can get your scanner, and consequently your scan, the happier you will be. In addition, grease smudges, from your hands, can be very difficult to fix later, even with image-processing tools. This is particularly true when they are over a detailed part of your subject. In short, there will always be at least some retouching to do, so

help yourself out by minimizing the work you have ahead of you: Keep the glass as clean as possible!

Arrange Your Composition

Now that you've removed the scanner top (or opened it as wide as possible), cleaned the glass, and considered which parts of your composition you want in sharp focus, the next step is to start arranging the still life. Make sure to think ahead about the types of materials that are going to be placed on the scanner. If you are using anything that could harm the glass, such as anything sticky, moist, or sharp, put down some clear acetate to protect the scanner before beginning to arrange your objects. Also, be aware of the weight of the

objects. The glass will only hold so much before it cracks, and this is an expensive repair.

The most difficult part of building a still life composition is that you are working upside down and backwards, akin to a large format camera. Sometimes, depending on the orientation of your scanner, the top ends up as bottom and vise versa. So things can get very confusing when trying to move objects around. It is here that the pre-scan function (see figure 2) becomes very useful to help you arrange your objects. It will allow you to see exactly what you are doing while you are thinking about and creating your composition.

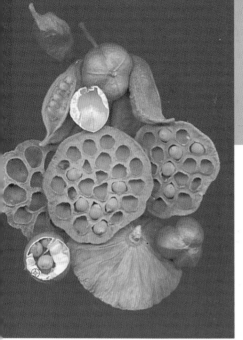

Figure 3: This is a full subject scan of seeds with room lights on.

EXPERIMENT WITH LIGHT

I usually start with the room lights on to see what that extra ambient light is going to do for my image (see figure 3). Some images have ended up with the ceiling as the backdrop, and I would not have seen this option if I had turned the room lights off for the original pre-scan. As I said before, the scanner can see out-of-focus objects very far away, such as the ceiling, but only if they are well lit. Conversely, an object almost completely disappears into darkness within a few inches if it is not sufficiently illuminated (see figures 4 and 5).

The next step is to turn the room lights off so that the only light hitting the composition is the scanner light. This will create black negative space behind the object (see figures 6 and 7). Almost all of my early scans used

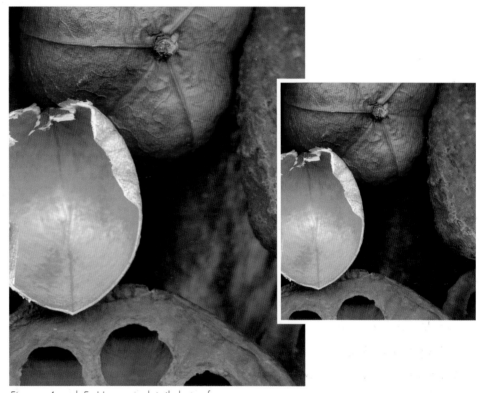

Figures 4 and 5: Here are detail shots of the same arrangement used in Figure 3. Figure 4 (on the left) is with secondary light; Figure 5 (on the right) is without secondary light.

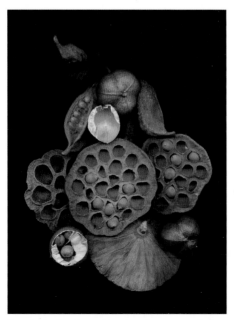

Figure 6: Seeds scanned without room lights.

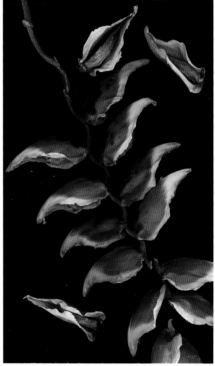

Figure 7: Heliconia scanned without room lights.

this type of dark background, as I enjoyed the starkness of the black and thought it worked well with the dried organics. This is the most basic setup for a three-dimensional scan— an open cover with no light except that coming from the scanner. I very quickly moved away from solely using this stark type of background and started experimenting with a variety of backgrounds to make the scans even more interesting. In my recent work, I rarely leave the negative space of the background in my compositions as all black.

I do, however, love the look of images produced just with the scanner light. It is a look I cannot get through any other photographic method. But in order to create the three-dimensional quality I strive for in my work, I need to add supplemental lighting. Scans done with just the light from the scanner are very flat. Adding a small amount of side lighting helps to introduce the illusion of depth (see figure 8). This can be done easily using any household light source. For example, I have used clamp on lights from the hardware store, reading lamps, desk lamps, and the modeling lights from my strobes.

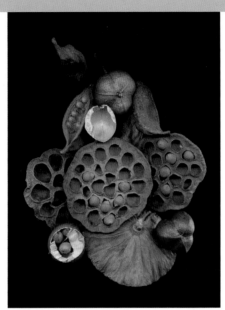

Figure 8: The seed arrangement from Figure 6 with added secondary lighting.

Note: A flash cannot be used as a secondary light source for scanner art since a constant light source is necessary during the whole scanning period.

I have found that I usually get better results when just one part of the still life is illuminated by one supplemental light source at a time. Otherwise, you risk overwhelming the scanner light with too many supplemental lights. In addition, if I want more dimensionality, I move the single supplemental light to different angles, do another scan and combine the two scanner images later using image processing software.

Combining Different Scans

One of my favorite Photoshop tools is Layer Masks. I almost never add two layers together without using a mask to hide the unwanted parts of the upper layer. By using a mask to hide those areas instead of deleting them, I can continue to work on blending my layers until they are perfect.

In the example entitled Seeds, shown here (see figures A, B, and C, above) and throughout this chapter, I combined three scans of this particular arrangement to make the final image. One scan was done with the supplemental light pointed up at the backdrop (figure A), one with the light coming in from the right side (figure B), and one with the light coming in from the top left (figure C).

In this case, once I was satisfied with my composition, I created each of the three scans while being very careful not to move the objects on the scanner bed, alter my color and contrast controls, nor to change my selection lines in the pre-scan dialog box (see figure 9). This way, I was able to drop each of the three scans into a file as its own layer and they lined up almost perfectly. I say "almost" because when you change the light hitting an object it changes its shape and, as a result, the layers will not match exactly when combined. Therefore, you will have to do some manipulation when lining up the parts of the different scans.

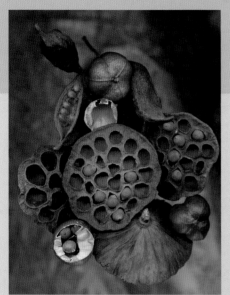

Figure A

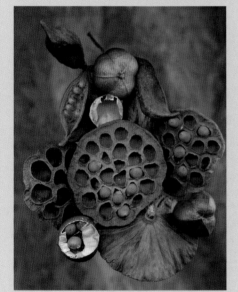

Figure B

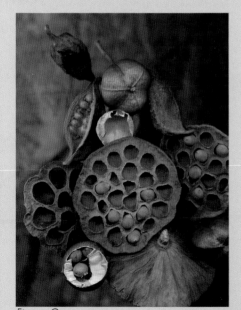

Figure C

Figure 9

Figure D

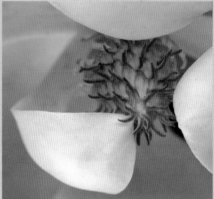

Figure E

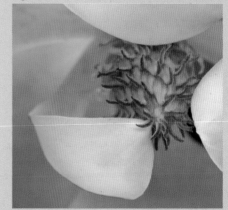

Figure F

I always bring in more of each scan than I know I really want. I then make a rough selection of the desired area and choose Layer > Add Layer Mask > Reveal Selection. This gives me a basic mask to work with. Then, with a large, usually soft-edged brush, I start adding to and subtracting from the mask until the edges of the two layers blend seamlessly. If I want areas of the mask to only partially cover the information on the upper layer, I paint with various percentages of grays to create a semi-transparent mask.

In the case of Magnolia (see figures D, E, and F), a more subtle combination occurred. The only things I wanted to change were to add light to the stamens and to tone down the lower left leaf. As you can see from the Layers Palette (figure D), I have a second layer of just the stamens that were lit from right side. I have added a layer mask to blend the edges of the center pod so that only the lit stamens remain. I then added an unlit leaf from another scan, masked it, and then lowered the opacity to 50% so that it toned down the highlight without removing it completely.

LIGHTING AND COLOR CORRECTION

In general, household bulbs produce a warm Kelvin temperature that is directly proportional to their wattage. The lower the wattage, the closer to red the light will appear. Higher wattage bulbs produce orange or yellow coloration. You can color correct for this in your imaging software by using the Levels, Curves, or Color Balance control panels.

The problem here is similar to shooting slide film with mixed light sources. That is, the scanner and the household bulb are lighting the still life with two different Kelvin temperature sources. The scanner light is balanced for white light and the supplemental light is warm tungsten. In order to completely correct the image you will have to selectively remove the red hue of the supplemental lighting. You can also buy daylight-balanced photofloods from a photography store and that will solve this problem, but I tend to like the added warmth the supplementary tungsten light adds to my images, so I only remove coloration on a case-by-case basis.

I can control the exposure of my supplemental lights by moving them closer or farther away from the scanner. I have also found that using a strobe's modeling light has the advantage of allowing you to adjust the intensity of this continuous light source by using the tracking function (found on the control panel of most studio strobe units), which is a slider arm that increases or decreases the brightness of the modeling light as an indication of comparable changes in the strobe output.

I do not perform a lot of color correction in the pre-scan stage. The reason has to do with the fact that these critical decisions are being made using an image that has less information than does the final scan. The pre-scan that I would be using to alter the color and details is just a thumbnail scanned at screen resolution (approximately 72 ppi). I prefer to make those kinds of changes once the final scan is imported into my image-processing software and I am viewing the entire 240 ppi image. This gives me the full amount of resolution information to work with and, as a result, I have found the changes to be more accurate.

On the other hand, I do make sure that I am starting with a good scan. This means that I have adjusted for good shadow detail and good highlight detail for every scan during the pre-scan stage. I usually do this by picking what I want to be my blackest black and clicking on that pixel with the Eyedropper tool. I do this on the scan with the black background and then I do not change anything for any subsequent scan. This way, no matter what I do—adding lighting, adding a backdrop, moving objects around, etc.—I will have similar histograms, i.e., the black point in each scan will be the same, and the individual scans will be much easier to combine.

A FEW TIPS

One trick that I use to make life easier when it comes time for image-processing my scans is to select a slightly larger area to scan than I think I will need for the final image. I then work with my backdrop and move around my objects without reselecting the scan area. This way when I get ready to combine the different scans (see page 147), the file size is consistent and the objects combine easier.

I also make the file size slightly larger than I am going to need. The largest height that I print the series of images seen in this chapter is 22 inches (55.9 cm). I have used printers with maximum width print sizes from 13 inches (33 cm) to as wide as 44 inches (111.8 cm). I print out my images at a printer resolution of 240 dpi, so I select a scanning resolution of 240 ppi at a height of 24 inches (61 cm) so that if I decide to crop my image later, I have some extra inches to work with. In the setup illustrated in figure 10 (below), the selected scanning area is actually 11.6 inches (29.5 cm) long, so by setting the scanner to record the setup at a length of 24 inches (61 cm), I am scanning the arrangement at 207%. In this case, the final print will be more than twice the size of the actual objects.

SELECTING A BACKDROP

The next step is to decide what to use for the backdrop. An advantage to the limited vision of the scanner is that very interesting backgrounds can be created with fairly mundane objects. I have used paper, plastic, tulle, gingham, printmaking rags, the ceiling of the room, and many other things as backdrops for my organics. Again, the farther I pull the backdrop away from the glass, the more I can throw it out of focus and distort its look. The key is the lighting. As long as the background is well illuminated, it can be moved farther and farther away from the glass until the desired look is achieved.

Figure 10

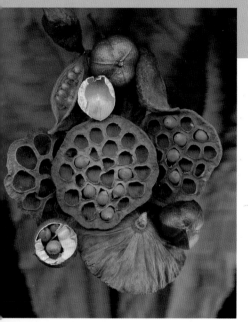

Figure 11

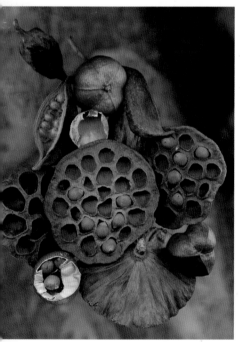

Figure 12

I have never built a standard backdrop holder for use with the scanner, although I originally imagined building one out of Tinker Toys. Instead, I tend to use whatever objects are around to hold up my backdrop—paper towel rolls, glass cleaner bottles, even wine bottles (see figure 10 on page 149). This method of using whatever's available actually proves to be quite beneficial since having objects of differing heights holding up the backdrop for each arrangement makes it easier to create varying looks.

In the example shown in figure 10 (on page 149), I started out with some very old, very large leaves as the background. To hold the leaves in place, I used a piece of clear acrylic sheeting placed on top of wine bottles above the scanner. The results of the scan can be seen here in figure 11 (above). I didn't like the texture of the leaves, so I switched to a piece of artist's paper I had that is a cutout of, oddly enough, leaves. For this backdrop, I removed the plexi-glass but kept the wine bottles. A little bit of sticky tack on the top of each bottle works great to hold paper or fabric in place above the scanner while allowing you to make undulations in your background material so that it works with the subject (see figure 12).

As you may have noticed, I favor building a final image by using several scans that I later combine to create the finished piece. I often make very small refinements in both lighting and arrangement to achieve a final result that I like. For the Seeds image. I made one scan with extra light pointed upwards at the backdrop to get detail in the paper, a second scan to light the right side of the image and make the seed pods in the back appear more clearly in the image, and then a third scan with the light coming in from the top left to illuminate the open seedpod and give added definition to the back of the top pod. To achieve the finished product, I combined these three scans, removed the dust spots with my image-processing program, cropped the file, and, in this case, rotated the image a little bit.

I have done a lot of experimentation with the best way to scan different objects with secondary lighting to produce effects from the subtle (figure 13, Hibiscus) to the more dramatic (figure 14, African Tulip). As a result, I am able to develop a new technique whenever a new object will not cooperate with an old technique. For example, there are times when laying an object flat on the scanner bed

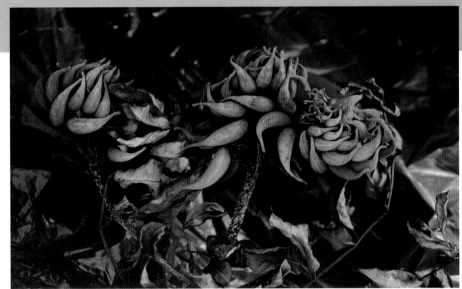
Figure 14

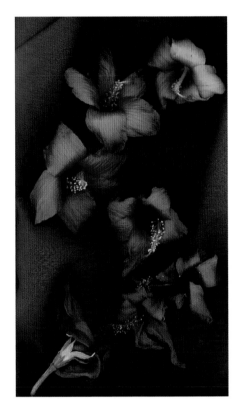
Figure 13

doesn't work. This usually occurs
when the organics I'm using are too
heavy and, therefore, flatten them-
selves out when placed on the scanner.
My solution to this is to stand the scan-
ner up vertically.

Be careful if you try this! Some
scanners will work just fine in this
position. In others, however, the belt
that controls the moving CCD array
is not strong enough to work against
gravity, so you should be extremely
careful when choosing this option. I
first tried this technique with the
Shaving Brush arrangement (figure 15).

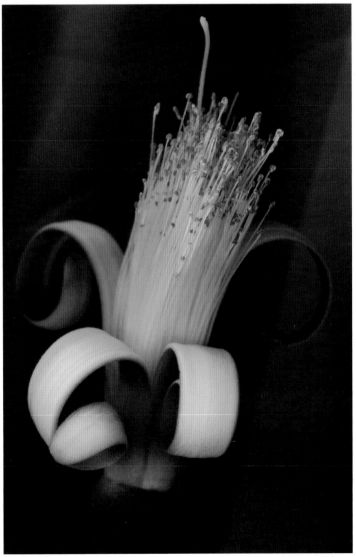
Figure 15

The stamens were not strong enough to stay together when I first tried placing the flower down on the scanner bed, and the beautiful curve of the leaves flattened from the weight of the flower itself. So, in order to get the look I wanted, I had to experiment.

I put the scanner up on end, used an A-clamp to hold the stem of the flower, set the clamp up in front of the scanner glass, and hung a backdrop behind it to hide the room. I placed a light on the right side of the arrangement, crossed my fingers, and made my pre-scan. It worked! I then had to work to get the look I wanted from the backdrop, (i.e., moving it farther away to soften the detail of the fabric). I also had to move the supplemental light around to create the side lighting I wanted and to control how much light was hitting the backdrop. Finally, I had to adjust the shaving brush flower until I had the play between the fabric and the organic just right... and voila! I had my image.

The organic I used in figure 16 (above) posed a new problem for me. It was approximately 5 x 5 x 11 inches (12.7 x 12.7 x 27.9 cm) and

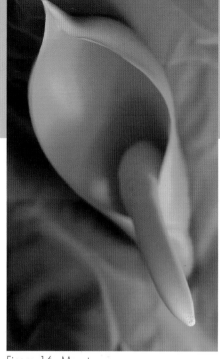
Figure 16: Monstera

weighed several pounds. The stamen could not support the weight of the hood nor would it balance in the position seen here. In addition, this pod blooms and then seeds within about an hour so I had very little time to make the scan before the stamen basically exploded. My solution here was to tie a cord around the stem of the plant and the backdrop, run it up to the ceiling lights of my room and tie it off. In this way, the plant was suspended and I could adjust the height until it was just resting on the glass. When you look closely at the image, you can tell that only the tip of the stamen and the tip of the hood are actually touching the scanner glass since only these two points are in perfect focus. The rest of the plant blurs out, as it is farther away from the glass.

ORGANIC STUDIES

My "Organic Studies" project started when my grandmother passed away and continues on today. People had given her incredibly exotic flowers to brighten up her room when she was sick. The day she died, my father, while cleaning up her room, picked up all of the wilting flowers and tossed them into the trash. I pulled them out and hung them to dry. I did not know what I would do with them at the time but I knew they were important to save.

The project started as a way to memorialize my grandmother who, as she wasted away from cancer, became more and more beautiful even as she became more and more frail. Something about the way the flowers became more and more beautiful as they wilted and dried was important to me. I needed to show that this beauty was a direct result of death and decay and so I set out to immortalize the flowers from her room. Heliconia (figure 7, on page 145) is the first image that came out of this memorial project.

My "Organic Studies" project continues to evolve, usually because I have been out walking around and I

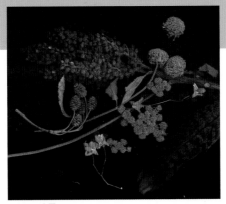

Figure 17

come across an object that just has to be scanned. Of course, this happens quite often, and I cannot always run home and scan immediately, so I have a roomful of organic materials just waiting for their turn on the scanner. The following are some of the organics I have scanned over the years, and an explanation of the challenges of each image.

Kirksville

My first year teaching was very frustrating, as I had no time to do my scans. One day I was sitting in my office and I decided to just start building a still life from the organic material I had been collecting all semester. I felt that if I had something built then eventually I would find the time to light and scan it. Over the next few days, the still life got more and more complex as I kept adding more of the material I had collected. I think I was worried that if I did not scan it all at once, it would not ever get done, so I felt like I needed to use it all in one shot.

When I finally got the chance to sit down and scan my "masterpiece," I found it ugly, busy, cluttered, and

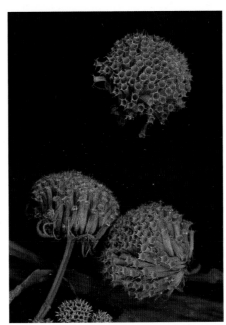

Figure 18: Kirksville without room lights

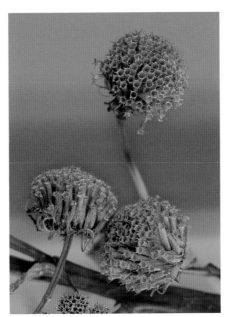

Figure 19: Kirksvill with room lights

unappealing (figure 17)—very unlike the aesthetic I was used to. I had spent too much time haphazardly throwing organics onto the glass and not enough time looking at what I was doing. The great part about having the pre-scan feature is that sometimes I can see immediately that an image is not going to work. This saves the time it would take waiting for a high-resolution scan to be completed before reworking the piece. The pre-scan is comparable to a Polaroid test shot that a studio photographer would use. I knew right away that the composition was not going to work, but after a few minutes of staring at what I had, I noticed a tiny area of the composition that did work. That is another great thing about a pre-scan. Sometimes I find a small, workable part of an image buried in a larger scan. I can then forget about the rest of the image and just scan in the part that works (figures 18 and 19). This is a case where I had to let the scanner interpolate up since the area I ended up scanning was only about an inch long (2.54 cm). I ended up with a 21-inch (53.3 cm) 300 ppi file.

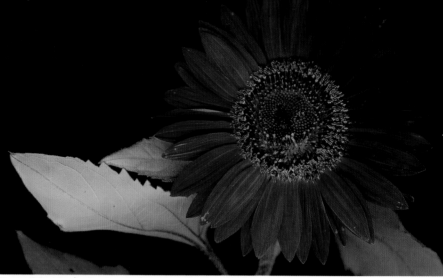

Figure 20: Moulin Rouge, with no supplemental lighting.

Moulin Rouge

The scans for my Moulin Rouge piece were made over a period of three days. I started with a freshly cut sunflower that I bought at the farmer's market in town. The interesting thing for me is that when I find something I know I want to scan, everything else disappears; I needed to get home to scan that sunflower!

I originally scanned it with no lighting (see figure 20)—really just a test run without much thought put into it. I just plopped the flower on the scanner and ran a scan. I did this once with the room lights off (Figure 20) to achieve a black background, then again with the room lights on (figure 21) which resulted in the red background. Somewhere along the way, I decided that I did not want to add an extra background to the sunflower since it was so graceful on its own.

I spent three days scanning the sunflower, and it changed every day, with every scan. It was on the third day, when the sunflower had wilted in such a way that I no longer liked the look of the flower (figure 22) that the breakthrough occurred. I flipped it over. First, I scanned it without supplemental lighting (figure 23) and then with a single light source to the

Figure 21: Moulin Rouge, with supplemental lighting.

left of the sunflower (figure 24).

I lived with these two scans for a couple of days before realizing that I had been wrong about the sunflower not needing a background. By that time, however, it was too late to scan it again, as it had shriveled up completely. I was very attached to the look of the final scan (figure 24), so I had to come up with a new solution. Since I had never scanned an organic and a background separately before, so I tried a lot of different things. In the end, I came across a scan of my hair that I had done quite

a long time prior to this project (figure 25). I liked the way the wavy hair complemented the graceful, blowing look of the sunflower.

The next step was to make a detailed selection of the sunflower using image-processing software so that I could insert the hair file behind it. I use Photoshop's alpha channels to make my masks so that I can save them along the way and change them easily if I am not happy with the way a selection looks. The hair, unfortunately, was too distracting (see figure 26), so I went into the Levels tool and then used hue and saturation to tone it down to a place where I felt the two files blended well and complemented each other to create the finished piece (figure 27).

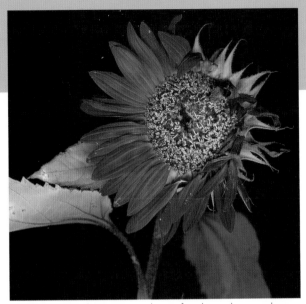

Figure 22: Moulin Rouge, wilting after three days, with room lights on.

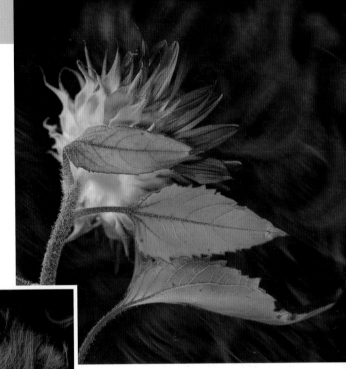

Figure 23: Moulin Rouge, with the flower turned over and no lighting.

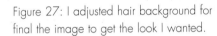

Figure 26: The hair background file combined with Figure 24 using image-processing software.

Figure 27: I adjusted hair background for final the image to get the look I wanted.

Figure 25: A hair background from another file.

Figure 24: Moulin Rouge, with secondary side lighting.

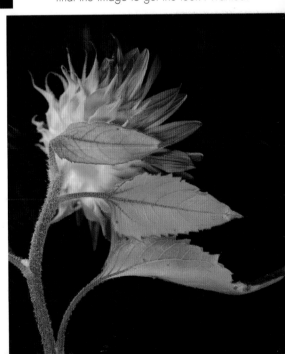

New Harmony

New Harmony is named after the town in Indiana where I saw my first magnolia blossom. I was much more drawn to the dried plant than the fresh blossom, but later, interestingly enough, when I moved to Kentucky and began seeing magnolias everywhere, I did do a scan of a fresh blossom.

The finished piece came about after almost seven versions were printed and I had lived with them for quite some time. As usual, I started with the quick plop onto the scanner to see how the object scanned (figure 28). I then started adding petals to use as a backdrop for the seedpod. I really enjoy using pieces of the object as its own background, as seen in figure 29. I felt that this composition was too messy and crowded, so I started taking petals away again (figure 30). Still was not happy with the image, I started playing with the background color using my image-processing software and came up with the variation seen in figure 31. After stopping there and living with the possibilities on my

wall for months, I ended up combining parts of two different files to create the finished composition.

I started with a close-up scan of the pod with dried petals as the backdrop (figure 32). This did not feel complete since the top of the composition looked chopped off. I could not go back and scan the same composition again since it was months later, but I did have another file that had the completed top, but was unsatisfactory at the bottom. So, I increased the canvas size on my first file to allow room for the completed leaves. I then selected the part of the second file that I wanted to combine with the first (figure 33). Once the two parts were together, I worked to blend the edges and create a smooth transition from one image to the other. You can see the final product in figure 34. The lesson here, for me, is never to be worried about saving too many different versions of a scan since I never know what I will end up using.

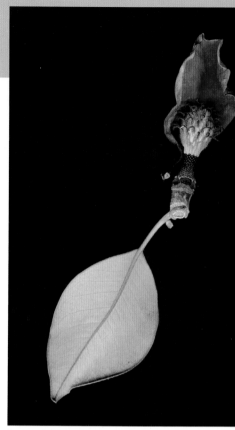

Figure 28: New Harmony—A magnolia blossom with a leaf and no lighting.

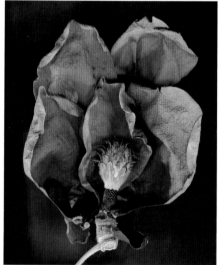

Figure 29: A detail of the magnolia blossom with petals and secondary lighting.

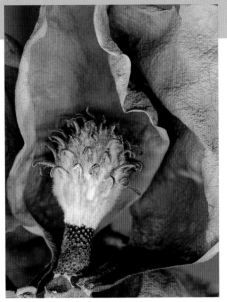

Figure 32: A closer composition.

Figure 33: Petal sections selected to be used in the final image.

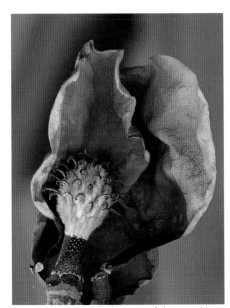

Figure 30: I removed some of the petals.

Figure 34: New Harmony—the final image, with added petal sections.

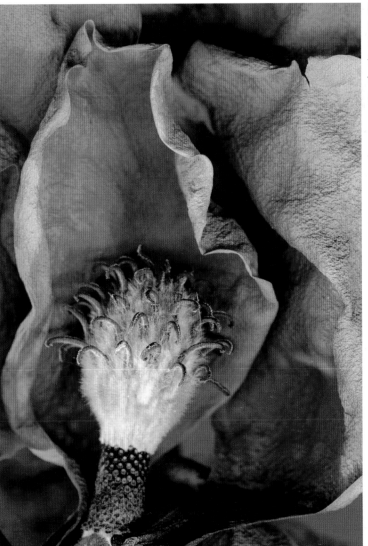

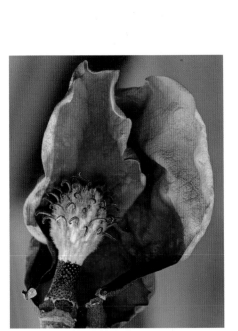

Figure 31: I experimented with changing the background color using image-processing software.

A

Adding a Background Scan to a Subject Scan

When working in Photoshop, layer masks and alpha channels are two of your most powerful tools. When adding a background to Moulin Rouge (see pages 154-155), I first had to make a very detailed selection of the sunflower. In this case, since the background is so even (image A), I was able to make a good initial selection using the Magic Wand tool (image B). I then used the quick mask tool to clean up the selection using a hard-edged brush (image C). (If you use a feathered brush, pixels get partially selected and the mask is less accurate.)

I magnify the image to at least 300% or higher when making a selection so that I can get into all of the nooks and crannies of the subject. It takes patience, but the results are worth it. Along the way, I save my selection as an alpha channel (image D), and save my file often. That way, if the computer crashes, or I accidentally deselect, I do not lose the work I have done so far.

In this example, once I had saved my final selection as an alpha channel, I attached it to the hair background using a layer mask (image B). I then feather the mask by using Gaussian Blur on the layer mask (not on the image—on the mask; see image F). The intensity of the blur will depend on how large the file is and how detailed the mask is. This is another wonderful reason to use alpha channels; the selection is permanently saved, so if the mask is too blurred you can just reload the alpha channel and try again. You can see the final results in image G.

B

C

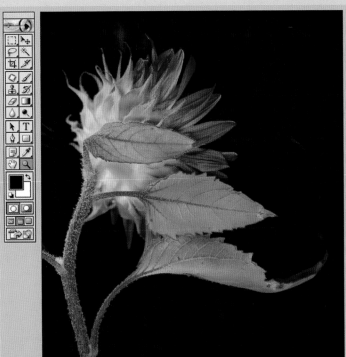

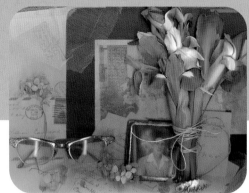

Iris © Renée Bair

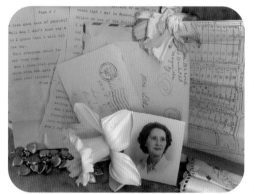

Lillian © Renée Bair

Old Doll © Renée Bair

CONCLUSION

Several of my students have applied the various methods I described in this section to very different subject matter. For example, Renée Bair, one of my BFA students, began experimenting with scanner art while taking my digital photography class. Renée created three-dimensional dioramas with multiple objects and scanned them in, usually with the scanner up on its side (as described on page 152). The examples of her work shown here serve to illustrate how each photographer finds his or her own form of expression when using a scanner as a close-up camera.

Every work of art takes time to create, and scanner art is no exception. The creative process takes planning, patience, and repeated trials. Creating a scan requires experimentation with composition, lighting, and backdrop manipulation. In addition, becoming proficient with your tools—both image-processing software and the scanner itself—is necessary to perfect the creation of successful images. Don't be discouraged when the first try is unsatisfactory, or the results are unexpected. No image is unsuccessful, rather, each should be thought of as a building block to the next scan. Who knows? Something you scan today might end up being part of an image you create years from now! Be creative and have fun; there is no end to the possibilities.

Figure 35: Japanese Hats

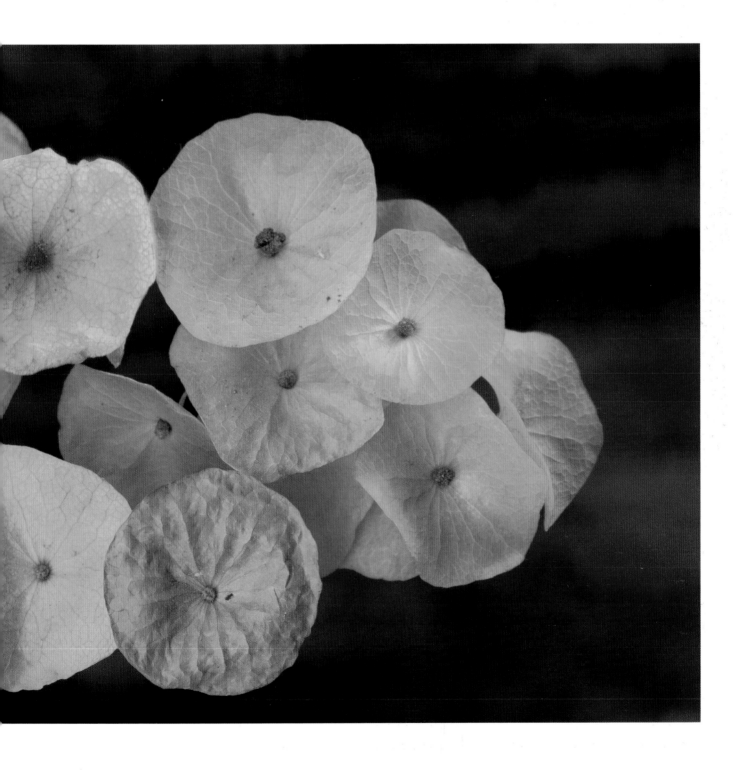

© Joanne Urban

The Black-and-White Scan Photography of Joanne Urban

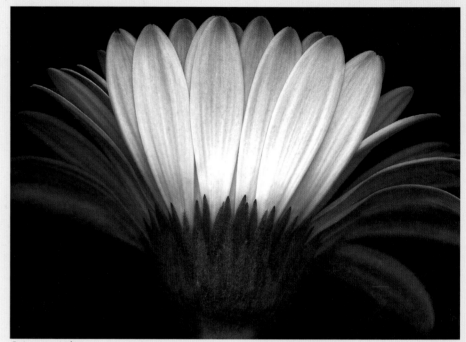

© Joanne Urban

As does Ruth Adams, fine art photographer Joanne Urban uses a flatbed scanner to produce images of three-dimensional subjects. Joanne, however, does not use any external lighting. In addition, she works only in black and white, producing her final images on an inkjet printer with special third-party monochrome pigment inks. This approach is a logical outgrowth of her early career in fine art silver halide photography that includes work as a professional black-and-white darkroom printer. The soft, ethereal beauty of Joanne's images are thus the result of a history of working with black-and-white materials combined with the sensitivity this fine art photographer has for her subjects. As one art critic declared, Joanne has taken "black-and-white floral photography to new heights." Indeed, her scanned images certainly have the large format quality that is so closely associated with the best of this kind of photographic work.

Q & A WITH JOANNE URBAN

Q: How did you get started in photography, and why did you choose to work only in black and white?

© Joanne Urban

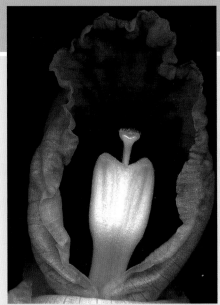

© Joanne Urban

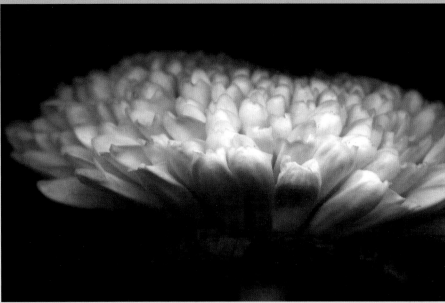

© Joanne Urban

A: Fifteen years ago, I discovered photography quite by accident. I needed an art elective for my college program, and for some reason decided to take Photography 101. I did not own a camera. I bought an old second-hand manual camera, went to class, learned exposure, and developed and printed my first roll of film—it was black-and-white film. You might say I fell into the Dektol developer and haven't climbed out since.

I fell in love with black-and-white photography and pursued it in the wet darkroom with traditional silver prints, also learning most of the old processes, including platinum print-

ing. I am now mastering Jon Cone's Piezography carbon inkjet print process in the digital darkroom. For me, nothing compares to a beautifully rendered black-and-white image, be it a still life, a portrait, or a landscape. It takes my breath away every time.

Q: Your black-and-white compositions are deceptively simple, yet they reveal unique qualities about the subject. How do you go about producing such results?

A: I am currently studying the shape, texture, and mystery of the flowers, seedpods, and shells that I

find at home in Florida. We look at them everyday and don't really "see" them. I believe that a black-and-white rendering reveals the mystery, the very essence of the subject. Thus, it is the means by which I am able to show the viewer what I see. Black and white makes me pause and really look at the subject. I am not distracted by pretty colors. Rather, I am seeing the subject "itself" revealed.

Q: How do you scan your subjects?

A: I lay the object on my flatbed scanner and scan in RGB mode in

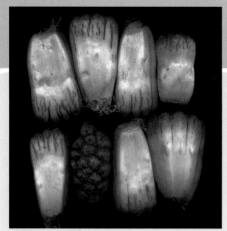

© Joanne Urban

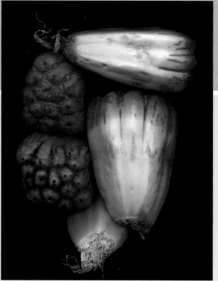

© Joanne Urban

© Joanne Urban

an attempt to get the most detail. The scanner cover is left open and I turn off all the room lights. This gives me the deep, black background I prefer around my subject. Because of the scanner's shallow depth of field and the one-directional light source, I usually turn and move the object many times and scan from different angles to find the one that best reveals what I want to say. I am often pleasantly surprised at the effects of trying these different angles. In doing this, I realize that each scan is one-of-a-kind because I cannot go back and recreate the exact same arrangement or position. The scans are imported into Photoshop where they appear as color images. Depending on the subject, I generally use one of two methods of converting these RGB images to black and white. Using Hue/Saturation (Image > Adjust >

Hue/Saturation), I desaturate each color, adjusting the dark/light slider for each until I am close to the look I want. I will then use Levels and Curves to fine-tune the overall contrast. As a second option, I may use Calculations (Image > Calculations). This allows me to incorporate any of the various modes (normal, multiply, soft light, etc.) by percentage of intensity. This method provides an almost endless means of converting to black and white.

Regardless of the method I use, my intent is not to obtain a "true" or "correct" rendering of the subject when going from color to black and white. Instead, I work to obtain results that reveal how I feel about the subject. I then do any necessary cleanup with the Clone, Patch, or Healing Brush tools. I do not remove or change any details in the subject but only clean up dust or

loose pollen, etc., that may have fallen onto the scanner glass when I laid the flower down. I usually do not sharpen the image. Rather, I leave it as it comes off the scanner. I find that even minimal use of Unsharp Mask makes the image look, for me, unnatural. I don't use Photoshop to manipulate my subject. What you see is what you get.

Q: How do you make your final prints?

A: I use Jon Cone's Piezography pigmented inks and an Epson 1160 printer (which is a four-color CMYK 1440 x 720 dpi printer). The Piezography ink set consists of a black ink cartridge that replaces the Epson black ink and a three-shades-of-gray cartridge that replaces the standard color cartridge. I print on watercolor papers

and my images are generally square, at 8 x 8 inches (20.3 x 20.3 cm), or rectangular at 7 x 9 inches (17.8 x 22.9 cm). I mount my prints on 16 x 20-inch (40.6 x 50.8 cm) board with a mat. The large mat area surrounding the image gives a breathing space while drawing you to the image.

The Piezography inks give me a rich, subtle gradation of tones with detail in the blacks and whites. I can see into the shadows, which is important to me, and even pure white areas do not look blown out. On the watercolor papers, the Piezography ink prints remind me of photogravure or platinum prints. Even though I am out of the wet darkroom and not currently printing in platinum, I am still a major

fan of the alternative processes. As you can see, my digital methods are really not too complicated. I prefer it that way so I can let the subject speak for itself.

For more information on Jon Cone's Piezography ink system, go to: www.coneeditions.com.

© Joanne Urban

© Joanne Urban

© Joanne Urban

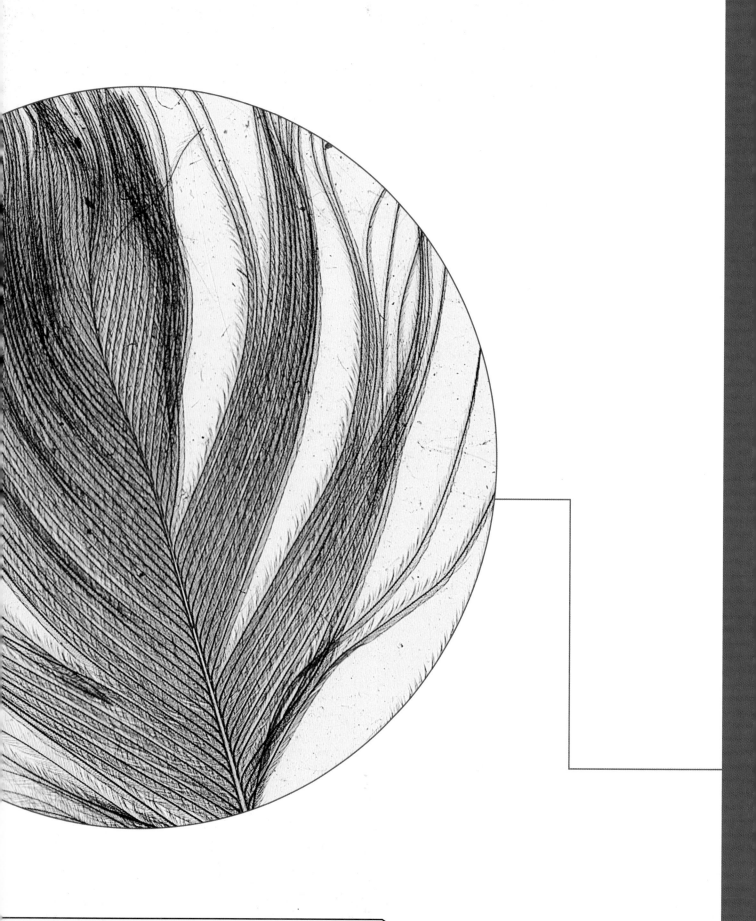

7 COPY STANDS
AND COPY
CLOSE-UP
TECHNIQUES

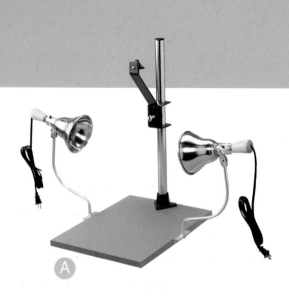

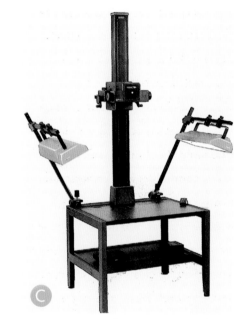

In the movies, the act of copying documents is always connected with espionage and fraught with the tension of possible discovery and inevitable near death experience from a barrage of bullets. The hero glances around the ballroom before slipping upstairs to search for the designs of a super powerful rocket that could change the outcome of the war. He ducks into one of the rooms and soon uncovers the plans in a secret drawer only he could find. He snaps on a desk lamp, carefully unrolls the plans, then pulls out his miniature camera to quickly photograph them before the security guard walking down the hallway checking the rooms gets to his. Just as the hero finishes up, the guard opens the door to the room only to see drapes fluttering in the breeze.

The reality, however, is that one of the most useful and practical techniques in photography is not nearly so glamorous. Copy stand work involves copying everything from old photographs, paintings, and posters, to written documents and other assorted flat things. Although you may find occasion to sneak out of dinner parties to copy super secret rocket plans, you will more often need to reproduce old family photos and documents such as awards, discharge papers, letters, and the like for family members and friends. While a flatbed scanner can certainly handle some of this work, a camera is often better suited—and a camera on a specially designed piece of equipment called a copy stand is the ideal choice.

Copy stands range from a basic tabletop designs, such as these two-light and four-light models by Testrite (Image A and Image B), to large, elaborate models such as this free standing model by Kraiser (Image C), which is capable of handling larger originals. (Photos courtesy of Testrite Inc. and HP Marketing Inc., respectively.)

CAMERA VS. SCANNER

Although our daring spy did not make use of a copy stand, he did understand some of the advantages of a camera over a scanner. For him, the primary advantage may have been that the camera fit into his tuxedo pocket better than a scanner would, but in more practical terms, one of the biggest advantages of a camera over a scanner is that it can photograph documents of any size. Most scanners are limited to items that are 8.5 x 11 inches (21.6 x 27.9 cm) or smaller.

It is possible to scan larger originals in sections, as I did with the historic main street photo on page 137, but this can often be cumbersome and is certainly time consuming. Another issue is that many originals are framed or mounted so you can't place them in close contact with the scanning bed. Plus, stamps, coins, and other small originals elude enlargement from the scanner, which cannot be adjusted to give higher resolution for a small area. With a camera, you simply focus closer to use all of the pixels on the sensor to capture the subject.

There are times when a copy stand is a better choice than a scanner because of the delicate nature of the original. In this case, the old journal could not be opened and placed flat on a scanner bed for fear of damaging the spine. The book was opened in a safe "L" shape and held in this position while a single page was copied.

In terms of lighting, whether it's the desk lamp used by our spy or special lighting equipment with filters, a camera allows you to easily use a variety of lights and lighting techniques. Whereas the typical arrangement with the scanner cover closed is limited to only one type of even lighting. Finally, cameras are fast and scanners are slow. For example, first you must load the original into the scanner and pre-scan it. Then you crop and adjust it, then make the full resolution scan. With a copy stand, you can work as quickly as it takes to place an original on the baseboard, align it, and click the picture. This can be a definite advantage when you need to copy a large number of originals, such as 30-40 old photos in a photo album.

With a copy stand and camera, you can easily position your light sources to produce a variety of effects. Typically, a copy stand has lights on either side of the subject set at a 45° angle to the object on the baseboard to produce an even field of illumination. However, you can lower the lights to create shadows and reveal texture in your subject, such as with an oil painting or the relief in a woodcut or needlepoint. You can also use "under-over lighting"—that is, lighting an original from beneath, through a translucent panel in the baseboard, or from above with a light box placed on top of the baseboard. This is then combined with the regular copy stand lighting.

A

B

C

D

The Copy Stand Advantage

Coming in very close to isolate a portion of an original is very easy on a copy stand where, unlike a scanner, all the megapixel power of the camera sensor can be focused on a smaller section of the subject. Image A shows the full picture of a 1910 class trip to Washington D.C.; the students are posed with then United States Senator William H. Taft (later President Taft). In image B, a small section was extracted using the close-focusing power of a 105mm macro lens to isolate the senator with a few students. The same procedure was followed in image C and image D, where the details of an 1870's United States 50-cent paper currency was enlarged to show the details within the official seal.

Another advantage of the copy stand over the scanner is its ability to accent textures by changing the lighting angle or turning one side off and using a reflector to control the size and density of the texture shadows. This can be rather dramatic, as seen in the textures and contours of this woodcut, first photographed with both lights at 45° (image E), which then become much more prominent when one light is lowered closer to the baseboard and the other is replaced with a reflector (image F). In

image G and image H, the same procedure was used except the lights were kept at the normal 45° angle and one side of lights was turned off. A white reflector was then used to bounce some of the light back to the subject for a more subtle recording of texture.

In image I, combining the light from a copy stand with a lighting tent and the magnification of a 200mm macro lens make possible the recording of small shiny objects such as these South African Krugerrands. They have been recorded with excellent detail and just enough shine on the surface to give a realistic representation.

Finally, the distracting reflections from glossy originals can very often be mitigated or removed completely by using double polarization (see page 177 for details). In image J, the breakdown of an old photograph's chemistry has produced "silvering" of the surface that reflects the copy lights in the picture on the left. Combining a lens polarizer with polarizing materials over the light sources completely blocks the reflection, as seen in the picture on the right.

E

F

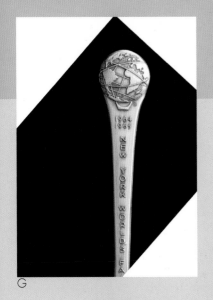

G

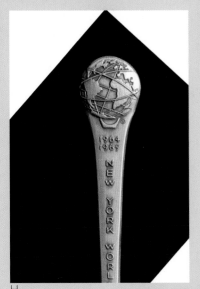

H

I

J

ANATOMY OF A BASIC COPY STAND

In its basic form, a copy stand consists of a rail with a cradle that holds the camera parallel to the baseboard and positions it to give the correct perspective of the subject. Lights on both sides of the baseboard are set at a 45° angle to provide even illumination.

Manufactured copy stands come in two basic forms: either as a complete unit composed of a rail attached to a base (usually with a set of lights), or a type in which the rail unit is wall mounted without an attached base. The price of commercially made stands runs from just under $100 to several thousand dollars. The differences between low cost stands and the higher priced models comes down to the quality of the machining of the moving parts, with the better made models having a superior feel and finer adjustments, as well as a greater maximum height range and larger baseboards. More expensive models also have useful extras such as the ability to mount polarizing and diffusion filters over the lights.

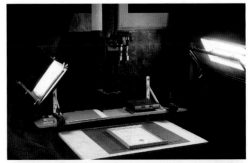

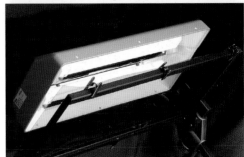

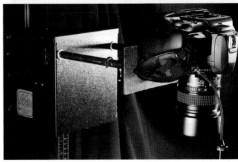

My present copy stand is a Bencher M2 wall mounted unit using color corrected Kaiser fluorescent lights fitted with (when necessary) polarizing filters. This copy stand has an extension feature on the camera cradle to center the camera over larger originals. Note the use of a cable release and lens hood.

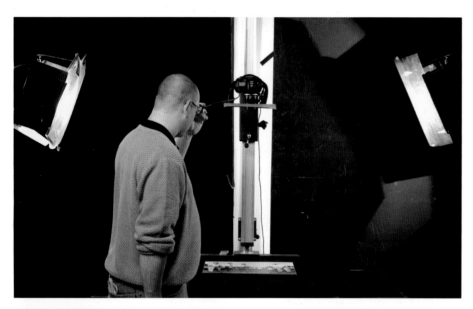

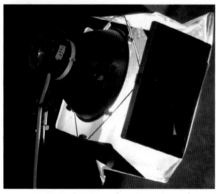

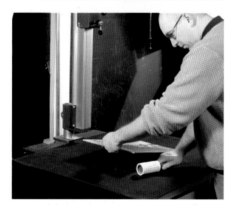

This extra large Polaroid copy stand photographed at On Location (a professional studio and lab in Poughkeepsie, New York) uses studio strobes with a modeling light for composing, plus polarizing filters on the lights and camera to handle glare. A piece of black cardboard mounted on the lens reduces the chance of any reflections showing up on shiny surfaces, and the photographers always have a lint roller handy to keep the fabric over the baseboard clean.

Another useful feature found on higher-end stands is the ability to adjust the center of the camera position relative to the center of the original. This allows you to move the camera further away from the rail so that it can always be placed out over the center of larger originals. Other specialized features include built-in lighting under the baseboard and an extra tall main rail so you can raise the camera high enough to copy large originals.

While a copy stand represents a useful tool, it requires a dedicated space (or at least a storage space) when not in use. If this is impractical, then consider a homemade copy stand based on a freestanding easel, available from most art supply stores. Combined with a piece of black foam core as a non-reflective background, and with the camera mounted on a tripod, this makes for a cheap and easily stored combination that uses daylight as the light source. One point to remember is to always make the plane of the camera parallel to the plane of the easel. Although direct sunlight delivers vibrant repro-

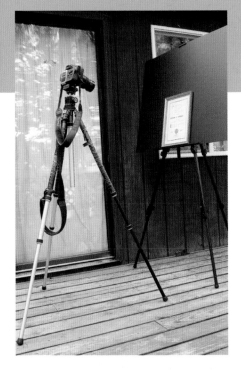

You can make your own copy stand by combining a picture easel and a camera on a tripod in natural light. A piece of black foam core can serve as a background, and the type of light used will depend on the surface qualities of the original. In most cases, setting up the easel in a shade area or using a diffusion panel (held just out of camera range between the subject and the light source) in direct sunlight will produce very good results (see pages 90-91 for more about diffusion panels). Be sure to set the camera parallel to the easel and to use a gray card with the camera in manual mode, or the exposure compensation function in automatic exposure mode to set the exposure.

ductions, you have to be careful of reflections from glossy and semi-glossy surfaces. A polarizing filter on the camera may help, and you can also try diffusing the light. (See pages 90-91 for more about light diffusion methods.) Alternatively, wait for a cloudy day, or just shoot in the shade.

LIGHTING FOR COPY STAND WORK

Here are four things to consider with any copy stand lighting arrangement:

1. The color balance of the light
2. The full, even illumination of the baseboard.
3. The exposure method.
4. Problems associated with subject reflections and lens flare.

Let's take a look at these points.

Lighting for Color Balance

Other than natural daylight, copy stands use one of three types of lighting: tungsten/halogen "hot lights," color corrected florescent tubes, or electronic strobes. Each of these lighting sources has certain advantages and disadvantages. Regardless of the light source, however, copy work requires two lighting methods for two different purposes: lighting to compose and focus on the original, and then lighting for exposure.

The advantage of tungsten hot lights, color-corrected fluorescent lights, and sunlight is that they are all continuous light sources suitable for both focusing and exposing the pic-

The high levels of heat from tungsten copy stand lights can be dispersed by the use of fans. Also, a high/low switch (seen on the right side of the baseboard) allows the lights to be kept on a low intensity for composing and focusing and then switched up to full intensity just long enough to make the exposure.

ture. In addition, they reveal unwanted surface reflections and lens flare. Lasting a fraction of a second and used only to take the picture, electronic strobe units do not reveal such flaws before you take the picture. Most electronic strobe units, however, include tungsten modeling lights to use during focusing so you can check for unwanted reflections.

One disadvantage of tungsten lighting is excessive heat. Heat from tungsten lights can quickly build up, making it necessary to turn off the lights periodically. I don't suggest working "in the buff," but extended periods of copying with tungsten lights will seem like desert hiking, so you may want to keep a towel

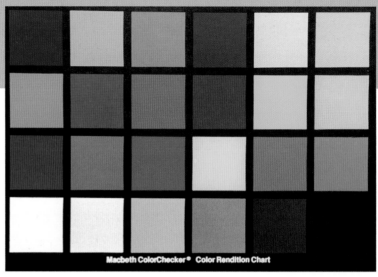

A chart such as this MacBeth ColorChecker test target is really helpful for establishing the correct color balance when working with any of the standard copy stand light sources.

handy to wipe away the sweat. Some tungsten light copy stands come equipped with a "high/low" switch so you can use the lower setting for focusing and the high position for the actual exposure. Heat build up is even more of a problem when you place filter sheets over hot lights—the heat can damage them. One solution is to mount two small fans directed at the lights to disperse the heat above the filters (see the photo on page 173).

Whichever type of lighting you use, be sure to make good use of your camera's white balance function, as explained fully on pages 80-83. It will provide several options for adjusting to the color balance of a given light source. Select the camera white balance setting that best matches the copy stand lighting, or use your camera's custom white balance function, if available, to manually dial in the correct color balance.

Even Lighting Coverage

Proper exposure in a typical copy stand setup assumes that you evenly illuminate the original from edge to edge. You achieve this by setting the lights at a 45° angle to the baseboard, equidistant from the center of the table. An easy way to check that your lights are evenly placed is to stand a 3 x 5-inch (7.6 x 12.7 cm) card on the center of the baseboard and compare the density of the shadow areas on each side of the card. A more accurate way is to measure the light across the field with an incident light meter. Light fall-off up to one-third of a stop is acceptable. If you lack an incident meter, take a properly exposed picture of a newspaper spanning the whole baseboard and

examine the results in the computer for light fall off. Also, perform this test with the camera at different height settings on the rail to see if there is a point when significant fall-off occurs.

Correct Exposure Methods

The usual procedure when using a copy stand is to first focus and compose the picture with the original in place. Now place the camera in manual exposure mode at its lowest ISO rating for the best quality. Hold a gray card over the original and set the camera to its sharpest aperture, typically two to three stops below its maximum aperture (or about f/8). Set the shutter speed for correct exposure.

Gray cards represent the middle reflectance between white and black. Since all colors fall between white and black, an exposure reading based off of middle gray will capture all colors at their correct exposure levels. If your subject is larger than a typical 8 x 10-inch (20.3 x 25.4 cm) gray card, use more cards to fill the screen. A less expensive alternative is to buy a piece of matte poster board that is as close to a middle-gray as you can find. Take a reading from this board and compare it to a standard gray card. Write down the correction factor (-1/2 stop, +1 stop, etc.) in one of the corners of the board as a reminder. Apply this correction to your camera each time you use the poster board. Or, if your camera has a spot meter setting, use it to measure the center of a gray card to set exposure.

You can also use these exposure methods when working with natural light. If your source is electronic flash, take an incident reading with a flash meter. With the shutter speed set for its top sync speed (typically 1/60 second or 1/125 second) adjust the exposure to the f/stop indi-

cated by the meter reading. If you are focusing very close to the subject, you need to increase exposure to make up for the loss of light. The most accurate way of determining a flash exposure under these conditions is to run some tests with the camera at different close-up distances, bracketing your exposures. In other words, record the height of the camera in the picture frame while shooting under- and overexposed frames in one-half stop increments. Then, view images in the computer (the best method) or on the camera's histogram (second best method) to find the setting that produces a good exposure. A good sequence to use is to expose one frame at the meter's indicated exposure setting, then reduce the aperture by one-half stop, then one stop. Follow this immediately by opening up the aperture by a half stop, and another full stop for a total of five frames. Once the test results are established, jot down the correct exposure f/stop information on your copy stand rail at the appropriate heights with some tape, along with the ISO rating used for the test.

Dealing with Lens Flare, Glare, and Direct Reflections

Photographic lenses are designed to precisely redirect light through the various lens elements and focus it on the recording sensor. Lens flare occurs when light enters the lens and bounces around, uncontrolled. This can cause a variety of digital artifacts, such as overexposed spots and lower contrast. Since this uncontrolled light usually comes when a light source hits the front of the lens directly, the best protection against flare is a lens hood. Another source of flare is strong reflections off the subject that cannot be blocked with a lens hood. As pointed out earlier, glare is polarized light coming off of a smooth surface. You can use a polarizing filter to remove or lessen this type of reflection, however direct reflections are not affected by polarizing filters. The only way to reduce a direct reflection on a copy stand is to change the usual 45° angle placement of the lights. Typically, this means raising or lowering the lights until the direct reflection is reduced while maintaining even coverage.

Cameras and Lenses

The optimum camera and lens combination for copy work is a D-SLR equipped with a 50-60mm macro lens. This combination avoids the need for parallax correction. That is, correcting for when the view through the viewfinder is significantly different than what the lens sees with the macro providing a continuous focusing range down to 1:1. You can also use a normal lens (a lens within the 45-55mm range) with either a close-up filter attached or an extension tube or a zoom lens with a "macro function," but neither will provide the continuous focusing range that a true macro lens delivers. Another option is to use a compact digital camera in close up mode, or equipped with a supplementary close-up lens to capture very small objects. Generally speaking, you can use the autofocus mode with whatever camera you are using. Plain subjects without contrasting areas such as lines and patterns, however, may cause focusing problems. In such cases, switch to manual focus.

Of critical importance with a com-pact digital camera is the ability to either operate in manual mode or to lock accurate exposure settings into the camera when in program or auto exposure mode. In other words, you have to be able to set the camera for the exposure of a gray card and retain those settings when you remove the gray card.

If your camera operates only in an automatic or program exposure mode, then you need a way of maintaining the exposure settings from the gray card reading when you take the picture. Typically this means showing the camera the gray card and then pressing an exposure lock button to hold those settings. If your camera does not have a means of holding the gray card reading, then exposure will be based solely on the reflective values of the subject. This may or may not yield a correct exposure, and you will have to use the camera's exposure compensation function to adjust the exposure according to what you see in the computer or on the camera's histogram as displayed on the LCD monitor.

Some Useful Accessories

You should use a cable release to ensure that when you push on the shutter release button no movement is transferred to the camera. Most D-SLRs have this feature, but few compact digital cameras do. Alternatively, you can set the self-timer on the camera. Admittedly, when photographing a large number of originals, the several extra seconds added to each exposure when using a self-timer can become annoying.

I also use a small level to make sure that the camera is level to the baseboard. And, as pointed out above, a lens hood is really a necessity for controlling flare from the copy stand lights. Also, avoid using white or other reflective surfaces on the baseboard since these surfaces might lower contrast by producing a generalized flare. The best baseboard choice is a matte black surface, such a sheet of black background paper, flat black foam core, or black cloth. For that matter, if your copy stand is a wall mounted unit or is placed close to a painted wall, fasten a black cloth on the wall to eliminate reflections or color contamination.

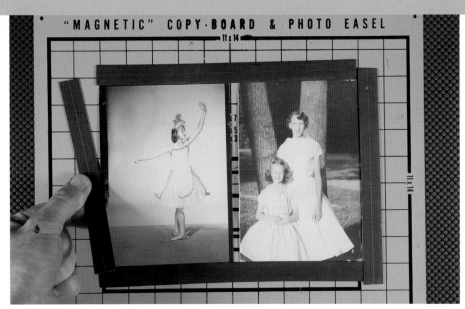

Old snapshots often have curled edges that need to be held flat. A metal board with a set of magnetic strips to hold down small pictures works very effectively. This model shown here is made by Testrite Inc., and uses flexible metal strips.

Many types of flat work, particularly traditional photographs, have a curl that needs to be controlled. Metal copy boards offer magnetic tabs to safely hold down edges. Some photographers use adjustable blade darkroom easels to hold down the sides of a curled original. An alternative is drafting tape that can be removed from most surfaces without damage. Other alternatives include thin metal strips that have enough weight to hold the edge down. If you use larger weights, such as wooden blocks, be careful that they don't cast a shadow over the photo.

A polarizing lens filter along with a sheet of polarizing filter material in front of the copy stand lights represents the ultimate in dealing with glare. This combination is called "double polarizing," and is best used with a D-SLR. Mount the filter material a few inches in front of the lights and attach a polarizing filter on the camera lens. Rotate the camera's polarizing filter until the glare disappears or greatly lessens. Be aware, however, that this setup reduces the light intensity by several stops and may darken the viewfinder image so much that manual focus becomes difficult. Also, keep in mind that removing reflections completely may cause the subject (such as an oil painting) to look unnatural, as most shiny subjects reveal at least a little glare. Instead of eliminating all glare and reflections, adjust the camera's polarizer to allow enough glare that the result looks realistic (see the coins on page 171, for example).

There are two types of polarizing filters: circular and linear. Only circular polarizers are compatible with modern D-SLR autofocus and autoexposure systems. Linear polarizers interfere with the autofocus and/or metering systems of D-SLRs. Unfortunately, using any polarizer with a non-SLR camera presents some difficulties if the camera does not have TTL metering. So, if at all possible, always use a D-SLR when using double polarization.

A handheld light meter is always a useful accessory in photography. For work on a copy stand, an incident meter is the most useful since it measures the light falling on a subject (versus a reflected meter that measures the light coming off a subject). An incident meter should give you the same reading that could be obtained

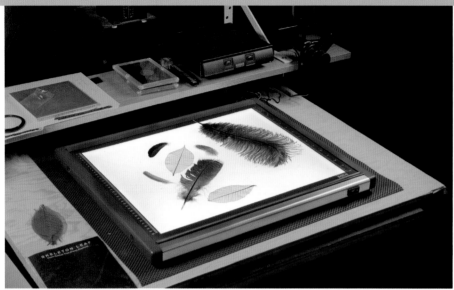

Under-lighting can be added to a copy stand by placing a light box on the baseboard and combining this with the main copy stand lighting. This image shows my 20 x 14-inch (50.8 x 35.6 cm) Gepe light box combined with color corrected fluorescent lighting. Both light sources have approximately the same Kelvin temperature.

THE MULTIPLE-FUNCTION COPY STAND

from a camera reading of a gray card, unless your camera lens is focused very closely (in the 4:1 range and closer). Remember, almost all means for close-up work—from macro lenses to extension tubes (though not close-up lenses)—will reduce some of the light getting into the camera. Incident meters, as mentioned above, are useful tools for measuring the distribution of light across a field.

You can expand the function of a copy stand in several ways. For example, you can use a small silver or bright white reflector with lighting from only one side of the stand to create "textured lighting." That is, turning one light off and replacing it with a reflector as fill creates a side-light that draws out texture. Control the amount of fill by varying the distance of the reflector to the subject. Be sure to take your gray card reading with the fill reflector in place. In other words, place it in the same light in

which the picture will be taken.

Under lighting is another extension of the copy stand's traditional function. The easiest way to do this is to place a small light box on the baseboard. If the light box does not have even lighting, add a piece of "milk glass" (white diffusion glass), available from most glass shops. Bring your light box along and see what thickness and density will give you an even field of light as measured across the surface with an incident light meter. Under lighting works best with transparent or translucent subjects, but you can also use it to produce silhouettes of an opaque subject. Keep in mind that light tables are all balanced for near white light Kelvin levels. Thus, if your white balance is set for a copy stand with tungsten lighting, this will produce a blue cast in the under lighting.

Since the under lighting is really a background light, this part can be isolated and corrected in an imaging program. The florescent lights on my

copy stand and the under lighting from a Gepe light box (see the image on page 178) are both very close to 5,000 Kelvin. As a result, there is no problem balancing the two sources. Conveniences such as this, along with the low heat of the continuous florescent lights, convinced me to switch from tungsten lighting.

Finally, with diffusion material, you can convert a copy stand into a lighting tent. Drape vellum paper or diffusing fabric around the baseboard and attach it to the camera body with a few tabs of drafting tape. The copy stand lights are then turned into a wrap-around shadowless source for very shiny objects. Alternatively, you can place a commercially available light dome on the copy stand. Circular openings in the lighting dome give you access to the subject at different angles.

All in all, the copy stand represents a versatile piece of equipment for the serious close-up photographer. On the other hand, you can also use an easel and tripod as a cheap and easy-to-store substitute for photographing a number of different subjects. In the end, it all comes down to needs and resources.

FEATHERS AND
FICUS LEAF SKELETONS

II have always been fascinated by the intricate and delicate network of structures that are revealed in close-up photographs of feathers and Ficus (Rubber Plant) leaf skeletons—that is, Ficus leaves that have been stripped of their pulp material to reveal only the skeletal structure of their veins. These two subjects appeal to me both as documentary objects and as opportunities for creating images in which their characteristics are accented and contrasted in different ways. In particular, I like to juxtapose the intricate but different types of detail that each has using varying light and filter treatments. In the examples shown in this section, I used a number of bird feathers found during country walks, as well as dyed decorative feather samples and Ficus leaf skeletons, both purchased at a craft shop. My first goal was to investigate the remarkable structure of each of these subjects using moderate to macro close-up methods. I made all the photographs except image G on a copy stand.

Establishing Shots

Image A contains one untreated black-and-white feather along with four dyed decorative examples, while image B is of a single Ficus leaf skeleton. Each image was shot on a copy stand, making use of even lighting. The feathers measured about 10 inches (25.4 cm) long, and the leaf was about 6 inches (15.2 cm). I used a 60mm macro lens on a full-frame D-SLR (a D-SLR with a sensor the size of a strip of 35mm film) to achieve a moderate close-up to reveal the overall structures of these two different subjects.

B

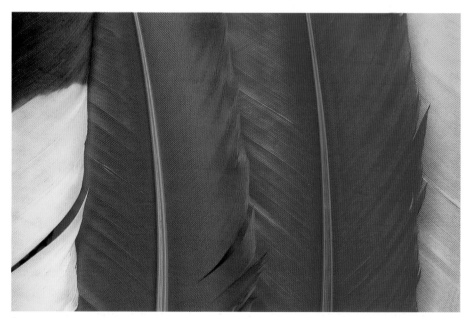

A

Moving in for Details

In these two frames, I moved in closer to show more of the detail that each had to offer. I used a 105mm macro and a smooth black ceramic tile as the background for the ivory colored leaf (image C). This was about as close as I wanted to get for the leaf. Moving in any closer would not reveal any more detail, and I felt that this close-up of about a 1:5 magnification ratio revealed enough of the leaf's structure. But the feathers (image D) had much more detail to explore.

C

Coming in Really Close

In these images, my purpose was to disclose as much of the intricate framework of different feather structures as possible. Thus, in image E, I used a 200mm macro focused at its closest focusing distance to capture the remarkably uniform arrangement of individual barbs radiating from the main shaft of the red decorative feather. This is a 1:1 magnification. The copy stand provided even lighting and the 200mm focal length gave me enough working distance so as not to block the light. I used a sim-

ilar arrangement for image F, but this time on a feather measuring only 4 inches (10.2 cm), coming in even closer with the use of extension tubes. This produced approximately a 2:1 magnification ratio for this subject.

Finally, to really show off the tiny feather-like structures on each barb radiating from the main feather shaft, I chose an even smaller feather, tiny enough to fit into a 35mm glass slide mount. I then scanned it in a 35mm film scanner to produce image G.

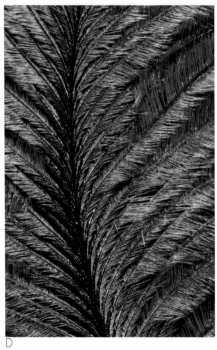

D

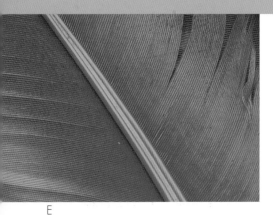

E

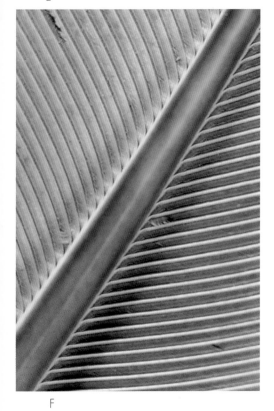

F

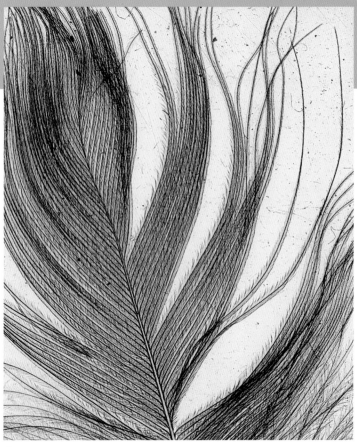

G

Creative Interpretations

Having satisfied my curiosity about the structures of these subjects, I now turned my attention to a more creative interpretation. In image H, shot on the copy stand, I used the speckle pattern in a blue ceramic floor tile as

background with two blue cards positioned on either side of the feather. This arrangement reflected blue into the very delicate and light-colored edges of the feather.

For image I, I arranged four 5-inch (12.7 cm) Ficus leaf skeletons in a fan pattern over two much smaller Ficus leaves on a copy stand with under lighting. I added a grain-like pattern in Photoshop (Filter > Noise > Add Noise) along with a coffee graduated filter effect from nik Multimedia. The final edge effect was obtained using the #AFO24 edge from Volume #1 of the Photo/Graphic Edges program by Auto FX Software.

In image J, I again employed under lighting but in a much simpler treatment to play off of the wonderful patterns within a series of different Ficus leaf skeletons. I added the color using the tint function in Adobe Photoshop.

For image K, under lighting on a copy stand was used to capture arrangements of Ficus leaf skeletons and the single feather originally used in image H. This time, however, the goal was to introduce soft and halo filter effects; I used a Nikon Soft #2 plus a Tiffen Pro-Mist #3 on the camera lens. The final image was completed by overexposing by 1 stop. I then photographed the head sections

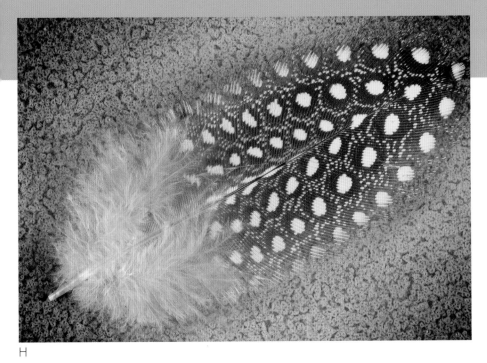

H

of a small Ficus skeleton for image L
at about 1:2 magnification, convert-
ed the image to black and white,
and added a sepia tone using
image-processing software. The film
edge effects for both image K and
image L were dropped in using the
Auto FX Dream Suite; I used the
4 x 5 Film Frame selection for image
K, and Film Frame Art for image L.

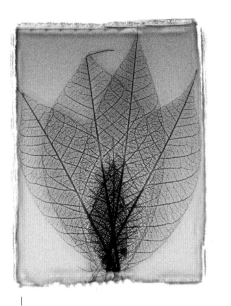

I

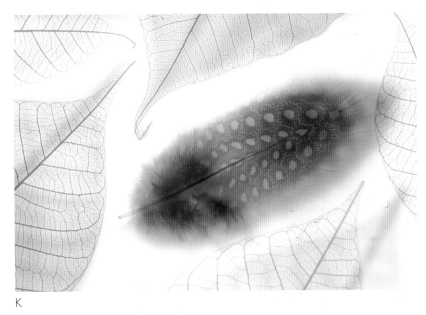

K

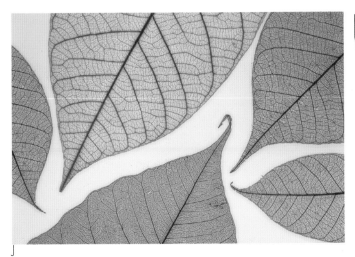

J

L

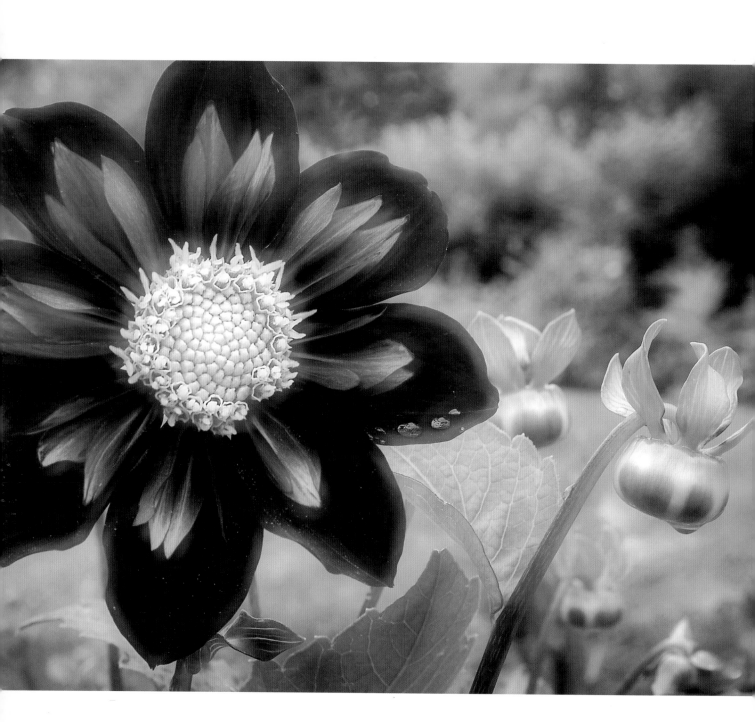

APPENDIX

The Internet has emerged as an excellent resource for photographers, providing the latest information on equipment and techniques. Listed below are the links for close-up hardware and software mentioned and/or pictured in the text. Many more options can be found by doing a search using any of the popular Internet search engines, and information on specific camera models can be found at the manufacturer's website.

SOFTWARE

- Adobe Photoshop and Adobe Photoshop Elements: www.adobe.com
- Convert to B&W Pro: www.theimagingfactory.com
- Color Mechanic: www.dl-c.com
- Digital ICE, Digital GEM, Digital ROC, and Digital SHO: www.asf.com
- ImageAlign: www.grasshopperonline.com
- nik Color Efex Pro: www.nikmultimedia.com
- Ozone: www.digitalfilmtools.com
- Photo/Graphic Edges, DreamSuite, and Mystical Lighting: www.autofx.com
- PhotoKit and PhotoKit Sharpener: www.pixelgenius.com
- SilverFast: www.silverfast.com
- VueScan: www.hamrick.com

EQUIPMENT

- AlienBees: www.alienbees.com
- Benbo tripods: www.patersonphotographic.com
- Bencher copy stands: www.bencher.com/photo
- Century close-up lenses: www.centuryoptics.com
- Cloud Dome lighting products: www.omegasatter.com
- Epson scanners: www.epson.com
- Gepe light boxes: www.hpmarketingcorp.com
- Gitzo tripods: www.gitzo.com
- Imacon scanners: www.imacon.dk
- Infrared camera conversions: www.irdigital.net
- Kaiser copy stands and table-top studios: www.kaiser-fototechnik.de
- Lastolite Cubelite: www.lastolite.com
- Lumiquest light modifiers: www.lumiquest.com
- Macbeth ColorChecker: www.gretagmacbeth.com
- Manfrotto tripods: www.manfrotto.com
- Microtek photographic equipment: www.microtekusa.com
- Novoflex: www.novoflex.de
- Really Right Stuff: www.reallyrightstuff.com
- Testrite copy stands: www.testrite.com

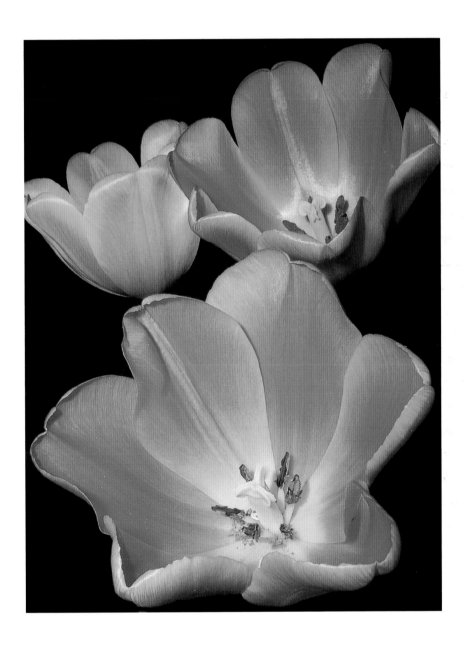

INDEX

A

Adobe Photoshop 146, 154, 158, 164, 185

Adobe Photoshop CS 82

Adobe Photoshop Elements 185

ambient light (see lighting, available light)

artificial light (see lighting, artificial light)

autoexposure 60, 177
autofocus (AF) 52, 53, 60, 68, 176, 177
available light (see lighting, available light)

B

backup images (see protecting images)
bellows 53, 54, 57-58, 99

bounce flash (see flash, bounce)

built-in flash (see flash, built-in)

bracketing exposures 100, 175

C

camera types
 compact digital 28, 38, 39, 40-49, 50, 64-69, 83, 84, 92, 94, 103, 106, 107, 114, 176

 digital SLR (D-SLR) 20, 21, 30, 38, 39, 40, 44, 48, 50-51, 56, 60, 68, 76, 83, 92, 95, 106, 107, 114, 118, 176, 177, 180

CCD sensor (see sensor, CCD)

cleaning 129, 134, 144, 172

close-up lens (see lens, close-up)

close-up mode 46, 48, 49, 56, 68, 84

close-up lens (see lens, close-up)

color balance 80, 81, 82, 148, 173-174

color content 73, 77-78, 83

color correction 80-83, 148

color temperature 80. 82, 100, 102

contrast 33, 56, 73, 78-79, 86-87, 88, 89, 90, 94, 98, 99, 101, 102, 103, 104, 106, 107, 108, 110, 112, 129, 130, 131, 136, 146, 164, 175, 176